MADE IN THE
AMERICAS

The New World Discovers Asia

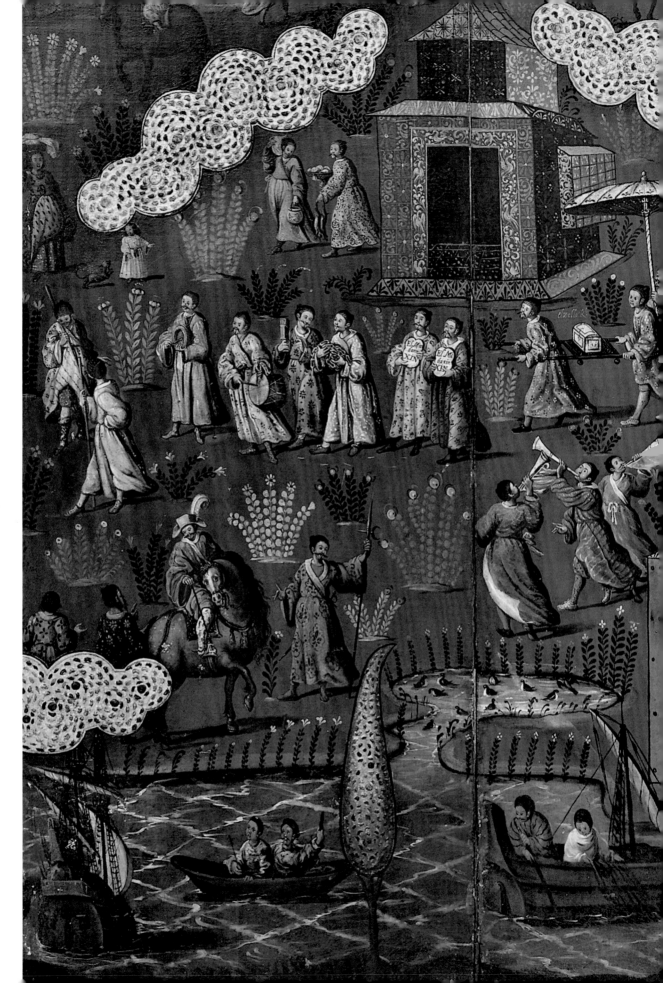

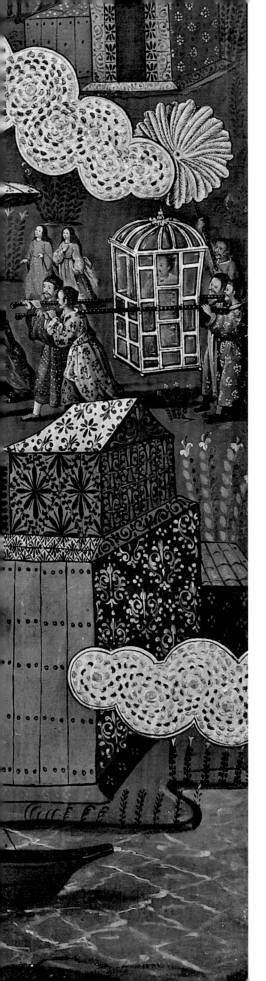

MADE IN THE AMERICAS

The New World Discovers Asia

DENNIS CARR

with contributions by
GAUVIN ALEXANDER BAILEY
TIMOTHY BROOK
MITCHELL CODDING
KARINA H. CORRIGAN
DONNA PIERCE

MFA PUBLICATIONS
Museum of Fine Arts, Boston

Contents

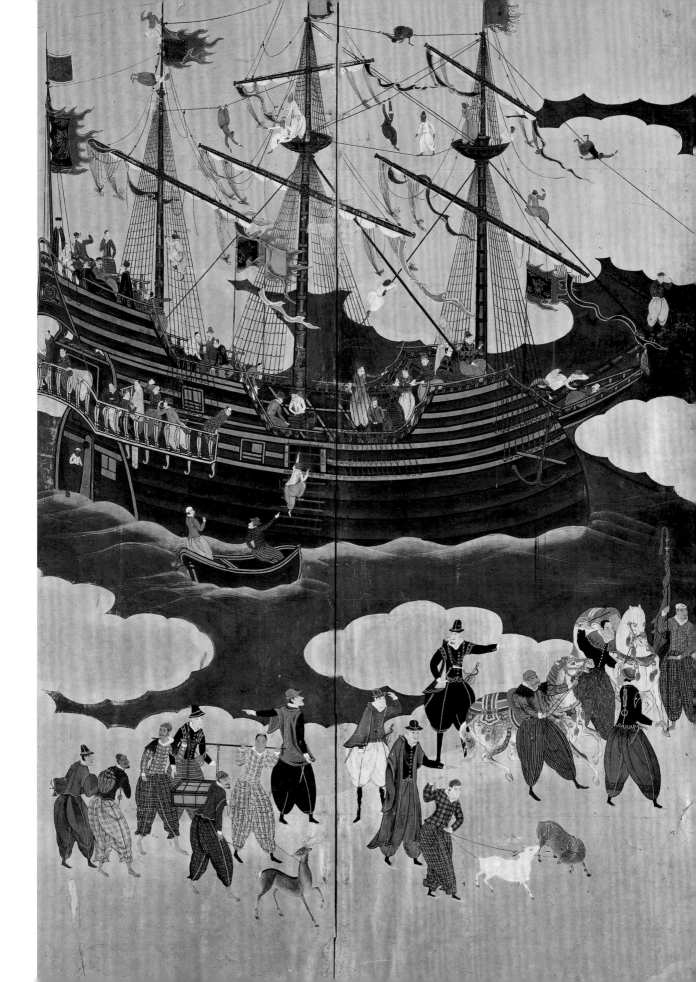

Director's Foreword

THE OPENING OF global trade in the sixteenth century brought cultures together in ways and on a scale never before seen. As residents of Asia, the Americas, and Europe encountered each other, a lively interchange developed, spurred by trade in precious, fragile, and beguiling objects that crossed the oceans. Beginning in the 1500s, European outposts in the New World, especially those in New Spain, became a major nexus of the Asian export trade. Artists from Peru to Canada, inspired by the sophisticated designs and advanced techniques of these imported goods, combined Asian styles with local traditions to produce unparalleled furniture, ceramics, textiles, silverwork, paintings, and architectural ornaments.

Made in the Americas carries forward the MFA's renewed vision of the art of the Americas, which explores the development of artistic production across the hemisphere from a cross-cultural perspective. We are also fortunate to be able to draw on the Museum's collection of Asian art, one of the largest and most comprehensive outside Asia. The exhibition was made possible with generous support from the Terra Foundation for American Art, and in part by the National Endowment for the Humanities: Celebrating 50 Years of Excellence, with additional support provided by The Huber Family Foundation and the Jean S. and Frederic A. Sharf Exhibition Fund. Generous support for this publication was provided by the Andrew W. Mellon Publications Fund. We are grateful to all who have made it possible for us to bring to life the rich cultural heritage of the Americas and to reveal the spectacular arts of the first global age.

MALCOLM ROGERS
Ann and Graham Gund Director
Museum of Fine Arts, Boston

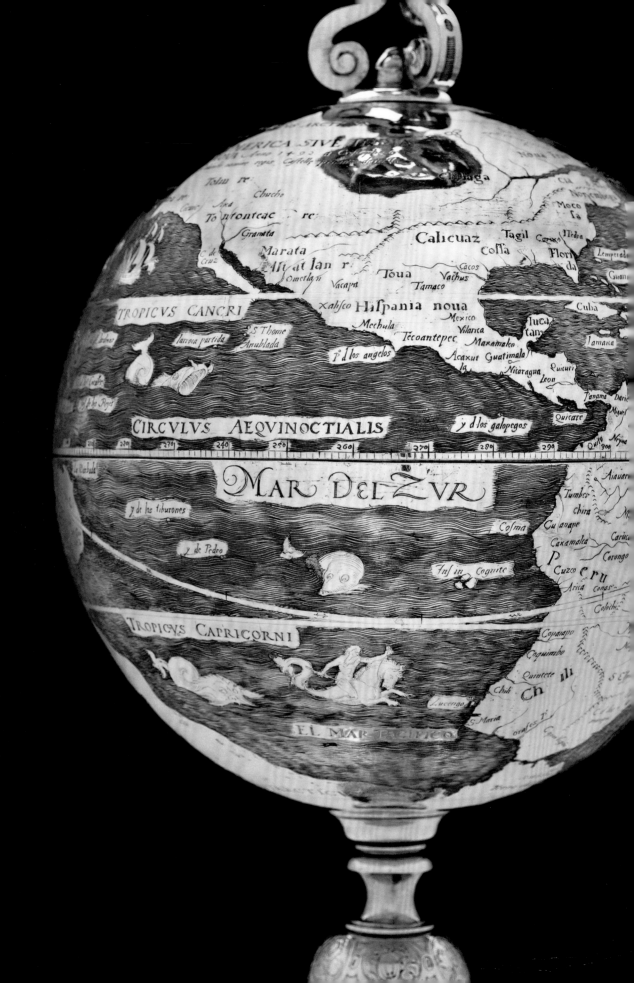

Prologue:
COMING ONTO THE MAP

TIMOTHY BROOK

THE WORLD as we know it did not exist before the six-
teenth century. It existed only in parts. Not until the
sixteenth century did cartographers in Europe begin
to gain access to knowledge on the scale needed to
model the world as we now see it. The agents of this
transformation were navigators, who were able to travel
far enough east and west to stretch the world into new
shapes. These voyages to the Americas and Asia ushered
in the first age of globalization, when the world's major
landmasses and civilizations learned of each other for
the first time and became linked in a worldwide web of
exchange. It was a shockingly new vision of the world.
On medieval maps Europe was more or less alone in
the world. It was taking to the oceans that brought the
Americas and Asia onto the map.

Christopher Columbus is universally renowned for
captaining the first Spanish voyage to America, in 1492.
But the important year is the next one, 1493, for that is
when he arrived back in Europe and reported his discov-
ery to his patrons, the king and queen of a newly united
Spain. Columbus told them not that he had discovered
America, but that he had arrived in Asia. China had been
his goal, and on that basis he had convinced his royal pa-
trons to fund the expedition by claiming he would reach

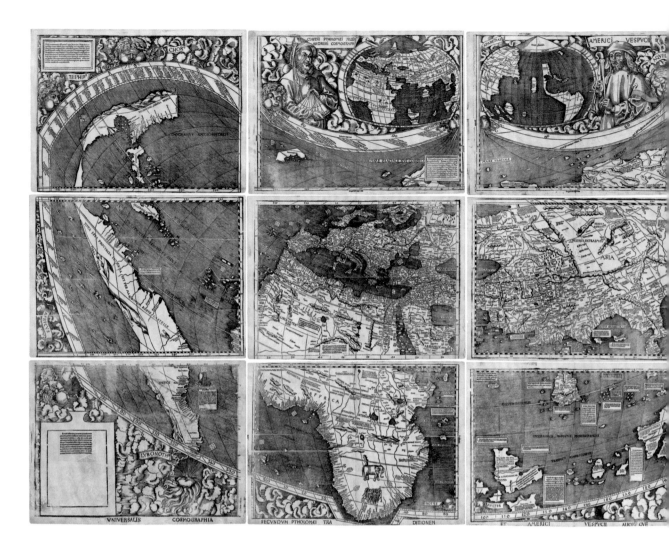

China and open trade with the richest empire in the world, the realm of Marco Polo's heroic Great Khan.

Columbus's mistake was both innocent and calculated. He was innocent in not knowing that the earth was as large as it turned out to be and not realizing how far he would actually have to sail to reach Asia. He knew Japan would be the first landmass in his path before arriving in China, so where else could those islands be but off the coast of Japan? He was calculating in persuading his royal patrons to continue supporting his expensive venture. He had to assure them that China was close and that he would surely attain it when he returned, bringing infinite wealth to their deserving majesties. It worked: they gave him the funds to go back that September. In his wake followed others, including Amerigo Vespucci, for whom America is named. The newly arrived Europeans soon determined that beyond the Caribbean Islands lay a vast barrier of land extending as far south and north as anyone could sail, and it wasn't Asia. The only way to China was to go through it or around it. Both solutions would be tried.

As this new knowledge arrived in Europe, Europeans needed a new picture of the world.[1] Martin Waldseemüller, a geographer working near Strasbourg, brilliantly provided one when he engraved and printed an enormous twelve-sheet map of the

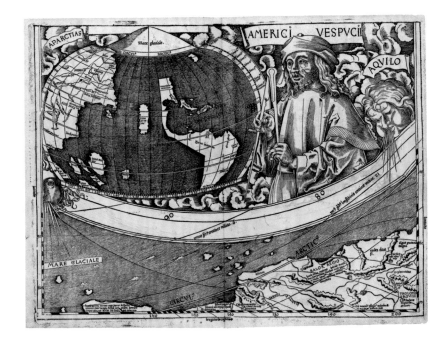

1. Martin Waldseemüller (1470–1519). *Universalis cosmographia* world map, St. Dié, France (?), 1507. Woodcut; 12 sheets, overall: 128 x 233 cm (50⅜ x 91¾ in.)

2. Cartouche of Amerigo Vespucci from the Waldseemüller map

world in 1507, now owned by the Library of Congress (fig. 1). The design looks back to the second-century works of the Egyptian geographer Ptolemy, but its content belongs to later centuries. The Asian portion belongs to the thirteenth century, for there one can find such place names as Chatay (Waldseemüller corrected it to Cathay in his next world map), Mangi (an uncomplimentary term for southern Chinese people), Quinsay (a mangled version of Xingzai, or Transit Residence, the formal title given to the southern city of Hangzhou), Iava (Java), and Zipan (following the Chinese pronunciation of Japan), all places described in Marco Polo's *Travels* (about 1298), a copy of which Columbus carried with him on his first voyage. If the right end of the map is of the thirteenth century, the left end is thoroughly of the sixteenth, for down it snakes the newly discovered landform. Waldseemüller christened this wraith *America*, and he placed the name roughly around the modern-day country of Paraguay. The land beyond the Andes he labeled *Terra ultra incognita*, and, being a fan of Vespucci, Waldseemüller inserted the explorer's portrait in a cartouche at the top of the map, along with a minimap of "his" continent, beyond which lie Zipan and Chatay (fig. 2).

Waldseemüller's map was the first to include both Asia and America in the same frame. In fact, he placed them much closer to each other than they are in reality. China

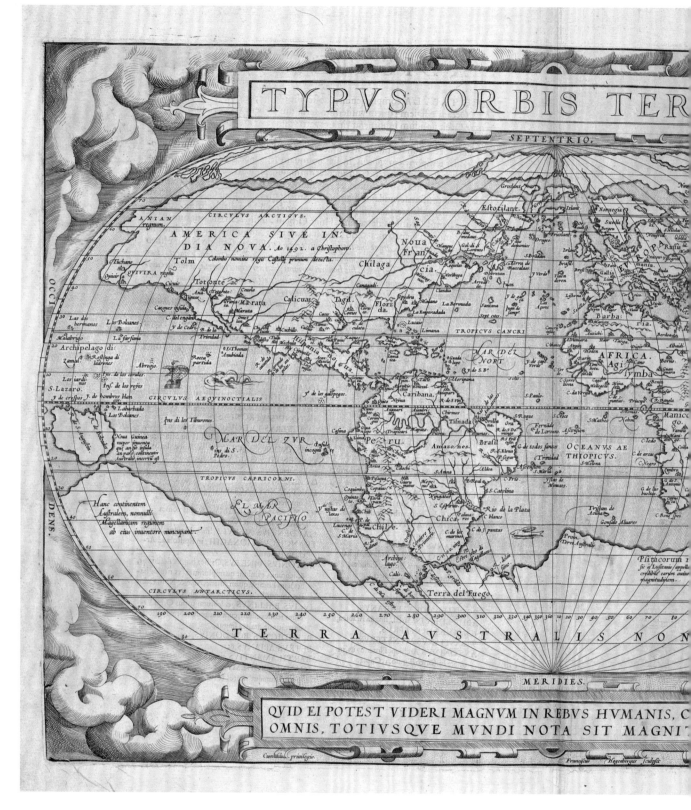

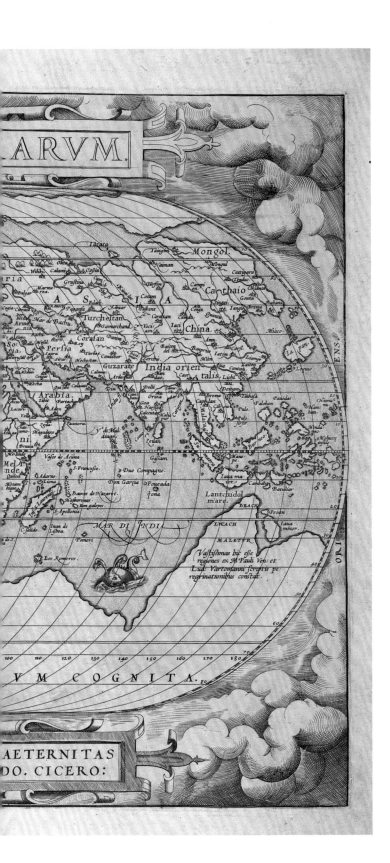

ARVM.

AETERNITAS
DO. CICERO:

VM COGNITA.

3. Abraham Ortelius
(1527–1598). *Typus orbis
terrarum* world map,
Belgium (Antwerp),
1570. Engraving

seems just a short sail westward past the
undulating coastline of terra incognita. Such
was the link between these two places in the
European imagination for the first decades
after discovery. Waldseemüller was not the
only mapmaker to do this. Italian mapmak-
ers as late as the 1560s showed Japan just
off the western coast of the Baja Peninsula.
This design appears in a large-scale map by
the mathematician and cosmographer Fra
Egnazio Danti, hand painted about 1564 in
the Sala della Guardaroba at the Palazzo
Vecchio in Florence. Other cartographers
actually showed the two continents run-
ning together, as did Oronce Finé in his
famous cordiform (heart-shaped) map of
1536, which peels the world into segments
like an orange, and Girolamo Ruscelli in his
much-reprinted 1574 double-hemisphere
map that shows Asia and America as a
single continent arching across the North
Pacific. Ruscelli's is a late example, and it
was already being surpassed by Abraham
Ortelius, whose pseudo-cylindrical *Typus
orbis terrarum* (a *mappa mundi*, or map of the
world) of 1570 severs the continents (fig. 3).

13

COMING ONTO THE MAP

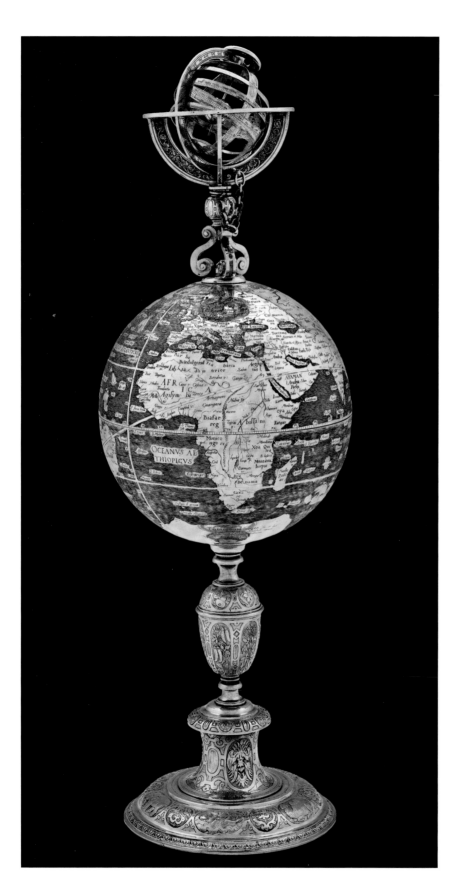

14

4. Abraham Gessner
(1552–1613). Double cup,
globe, and armillary
sphere, Swiss, 1580–90.
Silver, partially gilded,
50.5 x 16.8 cm (19⅞ x
6⅝ in.)

5. Detail of globe, showing
the Pacific Ocean

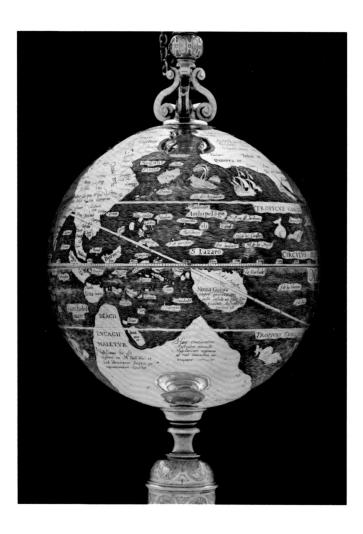

So they appear engraved on a spectacular silver double cup in the form of a globe with
armillary sphere, produced in Zurich in 1580–90 (figs. 4 and 5).

A map has no reality in itself; it simply reflects the world image in the cartographer's
mind at the time he drew it. From the sixteenth century that world image regularly
changed, often in fits and starts, as more people experienced more of the world. The
arrival of Miguel López de Legazpi in the Philippines in 1565 was one of those fits and
starts. Within eight years regular trade in valuable trade goods such as porcelains, silks,
and spices between Acapulco and Manila commenced, and the age of the Manila galle-
ons—the annual voyage of Spanish commercial fleets from Asia to the Americas, which
lasted until 1815—was born. One tangible result of this trade was that exotic products
from all over East and South Asia flooded colonial markets in the New World—in the
Spanish viceroyalties of New Spain and Peru, the Portuguese colony of Brazil, and the
British colonies on the Atlantic Seaboard—exciting the tastes of colonial citizens eager to
show off their deep pockets and worldly interests by consuming the new luxury imports.
Another result was that the shape of the world as the Spanish imagined it changed. A
fanciful map from 1761 entitled *Aspecto símbólico del mundo Hispánico* (Symbolic Aspect
of the Hispanic World) shows the Spanish Empire in the guise of the allegorical figure

of Hispania, dazzling in finery and overlaid on a vertical map of the world (fig. 6).[2] Her head forms the Iberian Peninsula, labeled with the names of the Iberian kingdoms, including Castile, Aragon, and Granada; her mantle is the Americas; and the creases of her dress chart the routes of the galleons (here, vertically) to Acapulco, Mexico, from the Philippine archipelago at her feet. A compass hangs from her necklace, made of a chain of treasure galleons, and her scepter doubles as the equinoctial line, atop which a Spanish royal standard flutters exultantly. The map envisions a robust global empire, and it situates the Philippines at the base of Hispania as the foundation on which Spain's world dominance quite literally stands. The illustration was published in Manila by the Tagalog artist and engraver Laureano Atlas and prepared by a Jesuit priest, Vicente de Memije. Both men, possibly motivated by different impulses, were invested in resituating their distant colonial outpost, on the fringes of Spain's vast empire, as a critical entrepôt and thriving center of cultural exchange. Indeed, Manila was no colonial backwater but one of the richest cities in the Spanish Empire. So, too, was Acapulco on the other end of the Pacific and, deeper inland, Mexico City.

Memije and Atlas's map is for us much as it was for the viewers they made it for: it demands we reorient our gaze, toward the Orient, as a driving force in the early development of the Americas. The essays in this book take up that task, charting a transpacific history that considers the cultural and commercial exchanges that took place far from Europe, between seemingly peripheral regions in the New World and Asia that found themselves at the heart of a growing network of goods and people circulating the globe. Inscribed on the Solomonic columns that flank Hispania is the slogan taken from the coat of arms of Charles V, *Plus ultra*, or "Ever onward." To understand the rich material history of the Americas in this period, we too must look onward, beyond conventional narratives of European influence and toward America's key role in the more expansive, multicultural world stretching from China to Europe in the early modern period.

6. Vicente de Memije, preparer (active 1761), Laureano Atlas, engraver (active 1761). *Aspecto symbólico del mundo Hispánico* (Symbolic Aspect of the Hispanic World), Manila, 1761. Engraving, 59 x 98 cm (23¼ x 38⅝ in.)

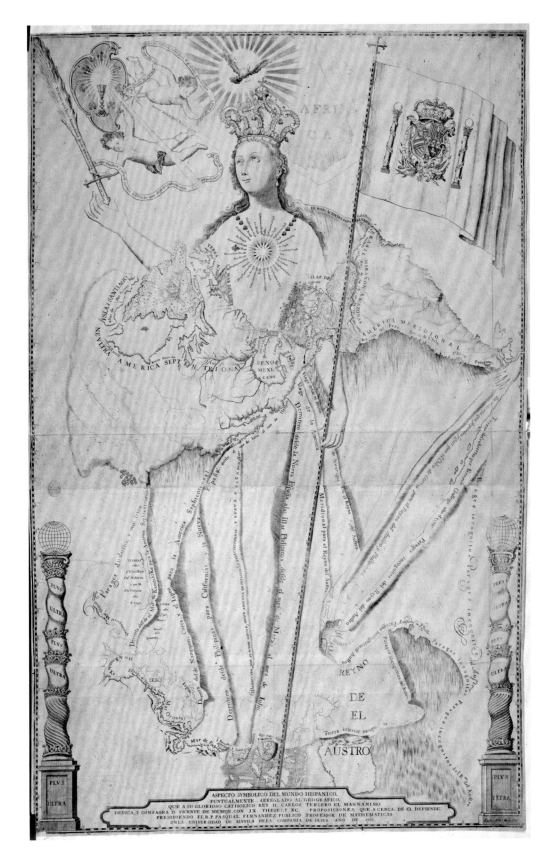

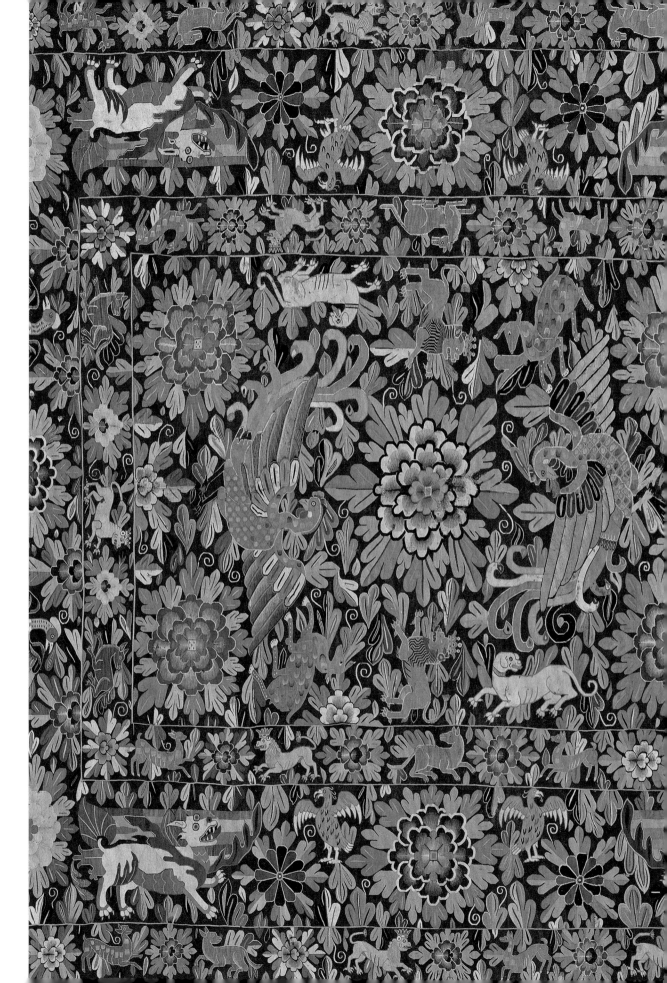

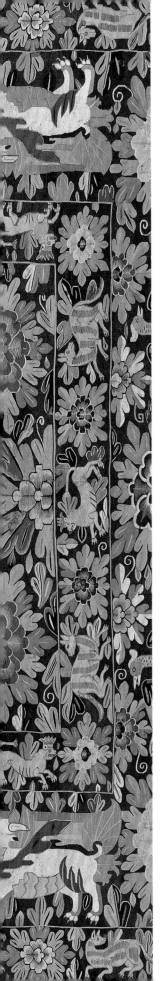

Introduction:
ASIA AND THE NEW WORLD

DENNIS CARR

IN 1604, the poet Bernardo de Balbuena wrote of
Mexico, "In thee Spain and China meet, Italy is linked
with Japan, and now, finally, a world united in order
and agreement." Balbuena's poetic verse sums up the
geographical and cultural situation of the Americas—
located between Asia and Europe—during the first
era of global contact and trade. Within decades after
the Spanish conquest, Mexico had become a hub of
global commerce, a linchpin between Asia and Europe.
Balbuena catalogued the wonders that could be found
in the flourishing markets of the capital, Mexico City,
goods and curiosities collected from across the globe:
finely woven silk textiles and porcelains from China, del-
icately painted screens and luxurious lacquerware from
Japan, carved ivories from India and the Philippines,
spices from the Moluccas, precious stones and pearls.[1]

The colonial Americas existed, and in fact pros-
pered, as a result of the emergence of the global mer-
cantile system in the sixteenth century. Situated at a
nexus of major global trade routes, Americans in this
period had access to a fantastic variety of goods at an
almost unprecedented level in history. From Rio de la
Plata to Nouvelle-France, from Mexico City to Boston,
the possession of these goods, indeed the flaunting of

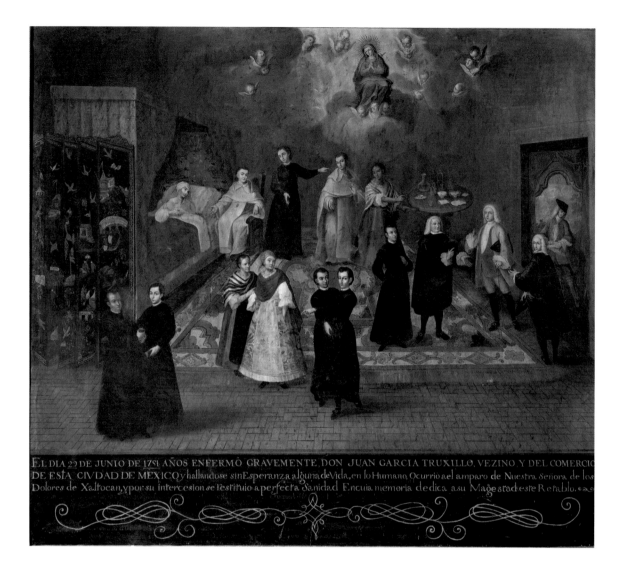

7. José de Páez
(born in 1727). Ex-voto
with the Virgen de los
Dolores de Xaltocan,
Mexico City, 1751.
Oil on canvas, 210 x
205 cm (82⅝ x 80¾ in.)

them, expressed one's participation in this larger system. To surround oneself with such worldly trappings not only was de rigueur for colonial citizens, but also expressed the commercial power of their European mother country in this age of globalization. By decorating their houses with a mix of exotic goods from around the world, including those from Asia, Americans ventured beyond their status as second-class colonial citizens and claimed direct links with the sources of their trading prowess and commercial prestige.

In 1648 an English visitor to Mexico City, Thomas Gage, recorded with astonishment the amount of imported Asian goods he saw there, which included carriages grander than those seen anywhere in Europe—"for they spare no silver . . . nor the best silks from China to enrich them"—tradesmen wearing hats decorated with imported pearls, and women's gowns with sleeves fashioned of fine China linen and colored silks.[2] In 1696, the wealthy Margrieta van Varick of New York owned objects from the farthest reaches of the Dutch world: "East India" cabinets, Japanese boxes, Chinese

porcelains, Near Eastern carpets, and imported textiles from India and Europe. Doña Rosa de Salazar y Gabiño of Lima, Peru, had an assortment of exotic-looking *enconchado* (shellwork) furniture in the eighteenth century that included cabinets and tables veneered in luxurious mother-of-pearl and tortoiseshell. The ex-voto painting of the bedroom of Don Juan García Truxillo, a merchant of Mexico City, painted about 1751, shows what is possibly an Asian folding screen, a locally painted chinoiserie-style headboard, a costly imported carpet, and fine porcelains and glassware arrayed on a table (fig. 7). Even more modest families in places such as New England possessed imported luxury objects; by 1770, some 70 percent of household inventories in Boston recorded some type of imported porcelain.[3]

Within only a generation of initial European contact and colonization of the Americas, goods from Asian ports were crisscrossing the continent in enormous quantities by means of Spanish and Portuguese traders. These ships brought trade goods collected from all over East and South Asia to ports in the Spanish viceroyalties of New Spain and Peru and the Portuguese colony of Brazil, returning laden with silver from the abundant mines of Latin America. The effect of the importation of Asian goods into the Americas was immediate and widespread, among both the European colonizers and the indigenous populations, who readily adapted their own artistic traditions to the new fashion for Asian style. The search for faster sea routes to Asia had led to the original "discovery" of America by Spain in 1492, and the enduring desire for Asian luxury goods would have a powerful influence on the culture and consciousness of the Americas for the next three centuries.

In 1565 the first Spanish ships sailed from the recently founded colony of the Philippines bound for Acapulco, on the Pacific coast of Mexico. This ship was followed by many others, and in 1573 regular trade began between Manila and Acapulco, establishing the route of the famous *Galeón de Manila* or *Nao de China* (Manila galleon), which lasted for nearly 250 years. The annual sailings of the Spanish trade fleets across the Pacific brought mind-boggling quantities of Asian products to the Americas, probably more than ever reached Spain.[4] For the Spanish, Manila provided a gateway into the vast regional trading networks of East and Southeast Asia, a market that was already being tapped by Dutch and Portuguese traders, soon to be followed by the British East India Company in the early seventeenth century.

After arriving in Acapulco, Asian trade goods were shipped overland to Mexico City and sold in the city's large Parián market in the center of the capital. This direct access to goods from across the globe gave Mexico City, the largest city in the Americas at this time, a distinctly worldly and cosmopolitan feel. Some Asian goods from Acapulco stayed in Mexico City, while others headed eastward to Veracruz on the eastern side of Mexico, where they were loaded on ships bound for Spain or were taken overland thousands of miles southward to the Spanish viceroyalty of Peru.

The Portuguese participated in the Asia trade even earlier than the Spanish. By the mid-sixteenth century Portugal had already established a robust trade between its territories and trading partners in India, China, Japan, and the so-called Spice Islands (Moluccas). Pepper was among the largest export products, along with fine blue-and-white porcelains from the Chinese kilns of Jingdezhen, exported through the port of Macau. A Dutch word adopted to describe this early underglaze blue-decorated porcelain, *kraak*, is thought to come from *carraca* (carrack), the name for the Portuguese merchant ships, often larger than a galleon, that plied the Asia trade. Portugal was importantly also the first European power to break into the Japanese market, setting up

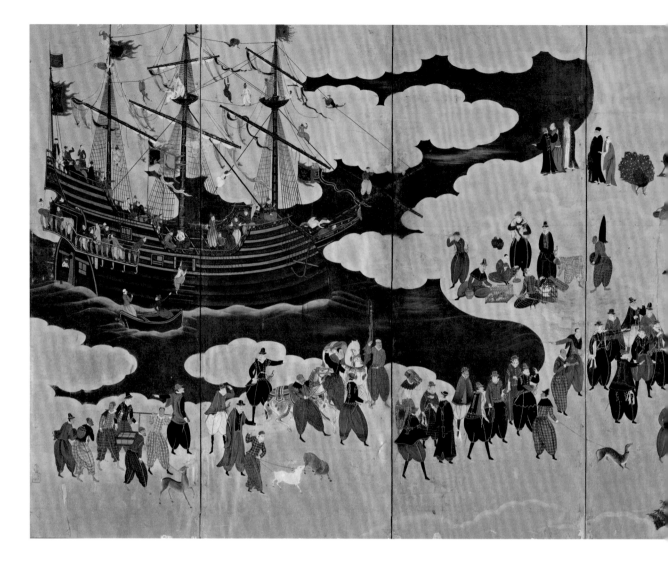

trade relations in 1543. An early Japanese screen shows the entrance of Portuguese trad-
ers in Japan (fig. 8). Ships returning from Asia were notoriously overladen with goods:
crates had to be piled high on the decks, lashed down with nets and rope, or suspended
over the ships' sides. Although most of the early trade was intended for Portugal, begin-
ning during the sixteenth century and increasingly by the late seventeenth century, these
lumbering Indiamen came to stop in Brazil on their return trip around the Cape of Good
Hope, where they refitted for their onward voyages and engaged in the less-than-legal but
highly profitable trade in Asian goods. Chinese ceramics were especially prized in Brazil;
they were traded for gold and diamonds, as well as for chests of sugar, tobacco, hides,
and timber extracted from Brazil's dense forests.[5] So much porcelain had entered Brazil
by the eighteenth century that the roofs of some buildings in the city of Cachoeira, in
Salvador de Bahía, were tiled with imported blue-and-white ceramics.[6]

　　Like the Portuguese government, the British Crown did not officially permit direct
shipments between India or East Asia and their colonies in North America. For the most
part, Asian products were imported via England, save for those brought by the occasional

8. Kanō Naizen
(1570–1616). *Southern
Barbarians Come to
Trade*, Japan, about
1600. One of a pair
of six-panel folding
screens; ink, color, gold,
gold leaf on paper, 160 x
360 cm (63 x 141¾ in.)

rogue ship or privateered foreign vessel in the Atlantic.[7] Nonetheless, the British colonies
up and down the Atlantic Seaboard and in the Caribbean had access to significant quan-
tities of export products, in particular Chinese porcelains.[8] The colonists also imported
prodigious quantities of Chinese tea and sipped it down with abandon just as it was
becoming fashionable in Europe. Even broken objects such as "China bowls" were care-
fully repaired and preserved, some passed down in families for generations.[9] The New
England Puritan minister Edward Taylor mused on "a piece of China Clay / Formd up
into a China Dish compleat," in a poetic verse in July 1718: "We gaze thereat and wonder
rise up will / Wondring to see the Chinees art and skill."[10]

Imported Asian objects captivated the Western imagination for their fine quality,
exotic imagery, and technical sophistication. They were also often expensive, fragile, and
hard to obtain. The insatiable European taste for exotic products from the Orient cul-
minated in an intense interest in Asian art and culture, known as *chinoiserie*, that swept
Britain and the Continent between 1670 and 1830—as well as Europe's colonies in the
Americas. What began as a fad among the European nobility soon spread more widely

throughout European culture and almost immediately to the Americas, which were themselves receiving prodigious quantities of Asian imports. The European chinoiserie style reached not only the large metropolitan areas in the Americas but also far into the hinterlands, places such as Pátzcuaro, Mexico; Sabará, Brazil; and Edward Taylor's isolated hamlet of Westfield on the western frontier of Massachusetts. Many locally made objects were produced in an Asian style, both to compete with Asian products and to satisfy demand when the expensive imports were in short supply. Chinoiserie style affected design and artistic production in the Americas just as powerfully as the earlier direct trade with Asia.

This book explores a revealing aspect of America's relationship with Asia during the colonial period, from the beginnings of European contact in the sixteenth century to the end of European imperial rule in each region. The cultural remnants of Asia are indelible in the Americas, from the demographic effects of years of immigration to shared loanwords and foodways. Yet what stands out are the artistic products made in the Americas in an Asian style and those strongly influenced by European ideas about Asia. Folding screens made in Mexico in imitation of imported Japanese screens, blue-and-white ceramics copied from imported Chinese porcelains, and locally woven textiles made to replicate fine silks and cottons imported from China and India were as much a part of the material culture of the early Americas as were imports from Asia. These objects express their colonial owners' desire to surround themselves with vivid expressions of worldliness that projected wealth and prestige in their domestic, public, and religious

lives. Their fabrication and decoration also reveal the blending of exotic styles with local materials and indigenous artistic techniques that so distinctively marks the material culture of the colonial Americas. By exploring the histories of these visually powerful and stylistically complex objects, we can see how numerous artworks produced in the Americas in this period not only resulted from but also consciously expressed the newly globalized world in which they were made.

Exploring artistic production across North, Central, and South America requires that we take a hemispheric view of the colonial Americas, in order to understand how global interactions shaped the colonial experience in each of these regions. Even though separated by great distances and ruled by different, often competing European powers, these far-flung regions simultaneously were linked by and participated in a global trade that included Asia as a major source of goods.[11] The history of the Americas has long been written as a series of encounters between Europe and the New World; however, these objects encourage us to look westward across the Pacific to Asia as a dynamic partner in the development of the Americas—and not just after the American Revolution in the late eighteenth century, but at the time of the first major European settlements in the hemisphere, in the sixteenth century.[12]

Among the earliest objects made in the Americas in a distinctly Asian style were the large-scale folding screens—called *biombos* in Spanish—that were based on imported Japanese examples. Brought aboard the Manila galleons as trade goods, Japanese *byōbu* screens (*byō* meaning "wind" and *bu*, "break") also were given as gifts by traveling Japanese emissaries, such as Hasekura Rokuemon Tsunenaga, who visited Mexico City in 1614 and later took screens to the court of Philip II in Spain.[13] The importation of these exotic screens spawned a wide variety of imitations in New Spain that feature captivating scenes of daily life in the viceroyalty, along with allegories, military conquests, city maps, and diplomatic meetings. Though *biombos* were made predominantly in Mexico, rare examples from the eighteenth century survive from other regions of the Americas, including Colombia.[14] One of the earliest surviving Mexican screens, thought to date to the mid-seventeenth century, shows the *plaza mayor* (main plaza) of Mexico City, the viceregal palace, and several stalls of the city's central market, where Asian goods were bought and sold (fig. 9). This screen incorporates elements familiar from Japanese screens of the period, such as "golden clouds" decorated with thin sheets of gold leaf and raised patterned ornament (similar to Japanese *moriage*). The bird's-eye perspective of this screen also recalls the roughly contemporaneous *Rakuchū rakugai zu* (Scenes in and around the Capital) screens, which present similar views of the city of Kyoto, the former imperial capital of Japan. In portraying Mexico City laid out before the viewer in the same way, this screen visually merges two great capital cities of the era, one of the Americas and one of Asia, expressing more than simple trade links or commercial connections. Tucked behind golden clouds, Mexico City becomes itself an exotic landscape, associated visually with the Orient and bustling with signs of imperial power and market culture.

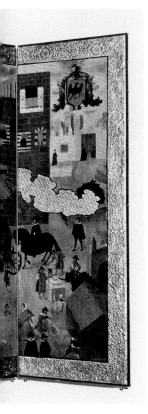

9. *Palace of the Viceroys* biombo, Mexico City, mid-17th century. Oil on canvas with gilt decoration, 1.84 x 4.88 m (about 6 x 16 ft.)

26

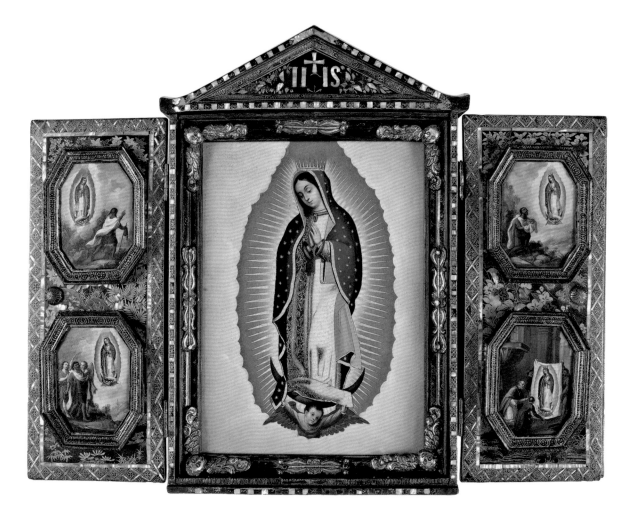

Ill.mo Sr Dn Pedro Luis de Ozta y
...squiz Obispo de Calaorra y la Calzada,
...oncedio, Cuarenta dias de Yndulgencia,
a todos los que Rezaren una Salbe delante
de esta Ymajen de Na Señora de Guadalupe
de Mejico, en Mondragon el dia Quinze
...e Nobiembre de Mil Setecientos Ohenta
y Seis

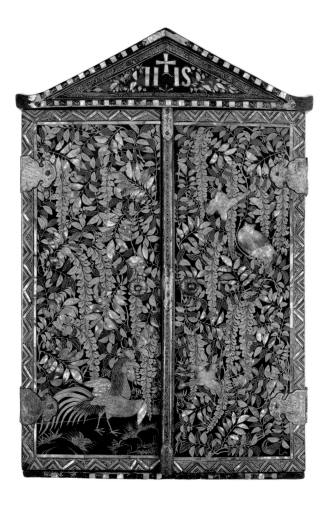

10. Altar with images of
the Virgin of Guadalupe,
Japan, late 16th century,
and Mexico, 18th century.
Lacquer and mother-of-
pearl over wood, with
added paintings in oil on
copper, and silver mounts;
open: 44 x 59 x 5 cm
(17⅜ x 23¼ x 2 in.)

That Mexico was receiving Japanese goods at an early date is evident in a remark-
able *namban* lacquerwork altar exported to Mexico in the late sixteenth or early seven-
teenth century (fig. 10). Sometime during the eighteenth century, an artist in Mexico
augmented this altar with five oil-on-copper paintings of the Virgin of Guadalupe, the
patron saint of New Spain. By 1786 this composite object had traveled across the Atlantic
to Spain, where it was in the possession of Bishop Pedro Luis de Ozta y Múzquiz in
Mondragon. A period note on the back of the altar reads: "The illustrious Sr. Don Pedro
Luis de Ozta y [Mú]squiz, Bishop of Calahorra y la Calzada, granted forty days of indul-
gence to those who say a Hail Mary in front of this image of Our Lady of Guadalupe of
Mexico, in Mondragon this 15th day of November of 1786."[15] This altar traces a major
global trade route of the era—from Japan to Manila, to Mexico, and to Spain—through
the physical accretions it accumulated at each stop. Like it, many objects of the early
modern period were often in transit, moving with increasingly peripatetic individuals,
exchanged by traders, and sent as prized gifts across oceans.

Luxurious Chinese silk textiles also made their way to viceregal Peru in the sev-
enteenth century, where indigenous artisans highly skilled in textile weaving created
a group of striking textiles that blended local weaving traditions with the style of the
Chinese imports. These textiles incorporate traditional Chinese figures, such as peonies,
paired phoenixes, and the *qilin* (a mythical auspicious creature), that are found on export

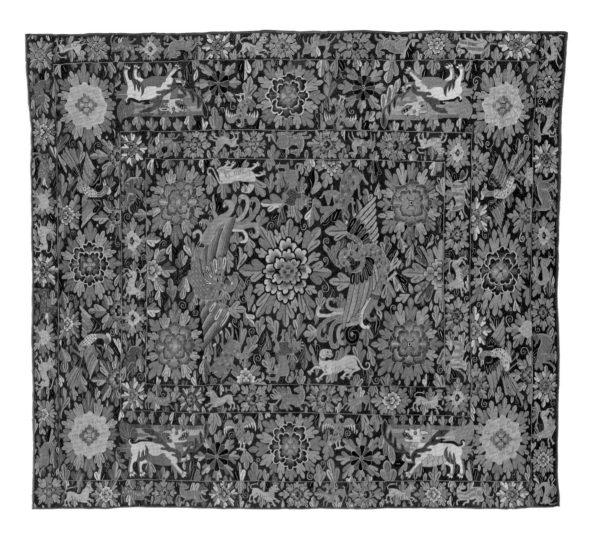

textiles of the early seventeenth century.[16] For instance, a Peruvian example with an extraordinary mixture of styles relates most closely to a Chinese export textile that was donated to a temple near Kyoto, Japan, in 1616, and other similar examples (figs. 11 and 12).[17] In Peru, indigenous weavers carefully copied the format of the imported textiles and added European symbols, such as crowned lions and collared dogs, and their own indigenous fauna to the composition, including alpacas (or perhaps vicuñas) and viscachas, silky-furred rodents native to the high altitudes of the Andes. Andean weavers may have associated the phoenix motif with the condor, an Inka imperial emblem of enduring significance in the region, and the prominent red of the background would have resonated with both cultures: in China red represented good fortune, happiness, and auspiciousness, and in the Andes it symbolized luxury. The weave structure is not that of the embroidered Chinese silk textiles, called *kesi*, but of the traditional Andean technique of loom-woven textiles made from local camelid (llama or alpaca) fibers. The Peruvian example incorporates an even mixture of silk, most probably imported Chinese silk that also came aboard the Manila galleons either as raw thread or as finished textiles that were picked apart and rewoven into new compositions by local artists. The silk, next to the thicker, coarser camelid fibers, adds a luxurious sheen to

11. Cover, Peru, late 17th–early 18th century. Wool, silk, cotton, and linen, 238.3 x 207.3 cm (93⅞ x 81⅝ in.)

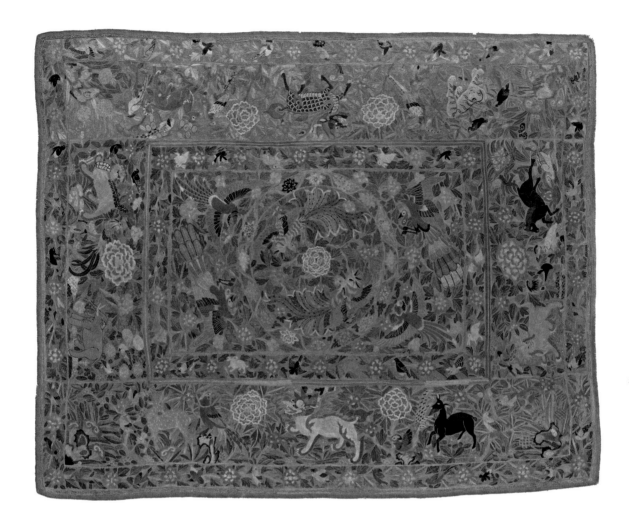

12. Panel with flowers, birds, and animals, China, 17th century. Silk, embroidered with silk and gilt-paper-wrapped thread, 254 x 203.2 cm (100 x 80 in.)

the tapestry. The red and purples of the textile are produced by cochineal, a valuable brilliant carmine dyestuff made in Peru from cochineal insects harvested from cacti.

To the southeast of Mexico City, along the trade route that brought Asian goods overland from Acapulco, a ceramics tradition flourished in the town of Puebla de los Ángeles from the late sixteenth century based on imported Chinese blue-and-white porcelains. In Mexico the native craftsmen did not have access to the fine white clays and kaolin needed to create true porcelains, so they covered earthenware pottery with a thick, white tin glaze, in much the way potters did in Delft in the Netherlands and Talavera de la Reina in Spain, and decorated it with expensive cobalt blue (fig. 13). The early guild agreements among the potters in Puebla in the mid-seventeenth century indicate that they were explicitly trying to replicate Chinese export porcelains, which by then had a sizable market in Mexico. Many examples refer to the Chinese origins of this style of pottery, with designs featuring painted Chinese characters and versions of Asian decorative motifs; they also adapt traditional Chinese forms, such as broad-shouldered jars (*tibors*), gourd-shaped vessels, and thin-necked wine jars, that were imported into New Spain on the galleons. In some of these ceramics, the local artists replaced Chinese figures with local imagery, switching out Chinese phoenix-

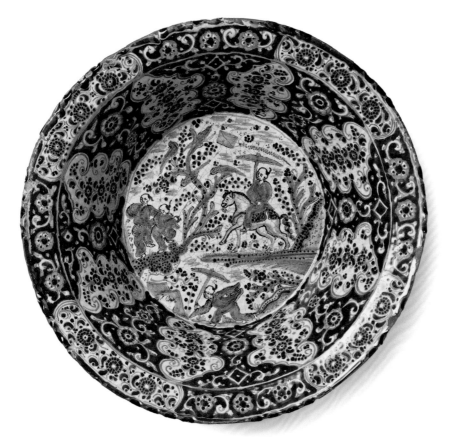

13. Attributed to the workshop of Diego Salvador Carreto (died in 1670/71), basin with landscape in Chinese style, Puebla de los Ángeles, Mexico, second half of the 17th century. Tin-glazed earthenware, 16.5 x 52.5 cm (6½ x 20⅝ in.)

es in favor of native quetzal birds or depicting the famous image of the founding of Mexico, an eagle atop a cactus (see fig. 35). A break in trade relations with China in the mid-seventeenth century, during a period of civil war in China, created an active market for the native wares in Mexico and allowed the flourishing Puebla industry to carve out its own identity alongside the trade in imports. Talavera pottery is still made in Puebla today, continuing a tradition that has lasted more than four centuries.

British craftsmen in North America made their own attempts at porcelain manufacture during the eighteenth century. The Englishman John Bartlam set up a factory producing soft-paste porcelain in the settlement of Cain Hoy, South Carolina, in 1765, making blue-decorated ceramics in the style of English and Chinese porcelains (fig. 14).[18] Unlike the Mexican potters, Bartlam used a specific technique of creating soft-paste porcelain, which was developed in Italy in the sixteenth century. Fine white clay had been discovered in the 1730s in the Carolinas, which allowed for the production of white-bodied ceramics with thinly potted sides and a smooth finish in the manner of the best Chinese imports.[19]

American craftsmen also produced many silver vessels in an Asian style, working in a material that was more widely available and especially prized by the Anglo elites. This production responded to the rise in popularity of tea drinking in the colonies, which surged in the first decades of the eighteenth century. To prepare and drink Chinese tea in the British fashion required specialized vessels, including teapots, hot-water urns, tea caddies, strainer spoons, creamers, and sugar bowls. Colonial silversmiths excelled

at producing elegant vessels based on Chinese and English prototypes. A silver bowl made in New York by Simeon Soumaine, a silversmith of French Huguenot descent, recalls the shape of traditional Chinese covered tea or rice bowls (fig. 15). A domed lid with a cylindrical foot sits atop a round bowl with a delicately flared rim. This silver vessel, however, was intended not for drinking imported Chinese tea, but for holding expensive and precious sugar, itself originally an import from Asia. Sugarcane was first cultivated on plantations in India and later in China by the seventh century. In the eighteenth and nineteenth centuries enterprising planters began cultivating this Asian crop on large plantations in the West Indies and other parts of the Americas, using slave labor. Sugar production fueled the economy of the Atlantic world in these years and drove the enormous increase in the importation of slaves from Africa.[20]

The vessel bears the cipher of Elizabeth Cruger (née Harris), the daughter of wealthy English residents of Jamaica. She returned to New York with her husband, Henry Cruger, the son of one of the leading Anglo mercantile families, in 1738, shortly after their marriage, and the couple likely commissioned the bowl from Soumaine.[21] In ordering such a container for sugar, they were choosing a hybrid design that represented a microcosm of the Atlantic world in this period. Even the precious metal itself was possibly a New World product, probably originating in the prodigious mines of Peru or Mexico, which supplied much of the world's silver from the sixteenth through the eighteenth centuries. Some of this New World silver ended up back in the Americas via Europe either as coins—the minted Spanish "pieces of eight," the era's most widely circulated currency—or as finished silver vessels that were melted down and recycled into fashionable new objects.

This interest in precious materials carried over to the furniture making of Peru in the eighteenth century, as demonstrated by a visually impressive group of viceregal furniture veneered with mother-of-pearl (fig. 16). For years this furniture was thought to have been produced in India or the Philippines and exported to Latin America as cargo aboard the galleons. Recent research and scientific analysis indicate, however, that much of it was made in viceregal Peru.[22] Such furniture is found in inventories of wealthy Peruvian households, described by the appraisers in

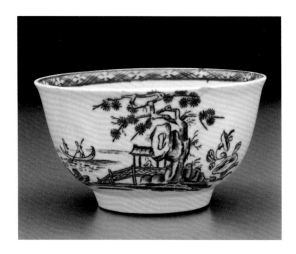

14. John Bartlam (died in 1788). Tea bowl, Cain Hoy, South Carolina, about 1765–70. Soft-paste porcelain, diam. 7.9 cm (3⅛ in.)

15. Simeon Soumaine (about 1660 or 1685–1750). Sugar bowl, New York, 1738–45. Silver, 10.6 x 11.9 cm (4⅛ x 4⅝ in.)

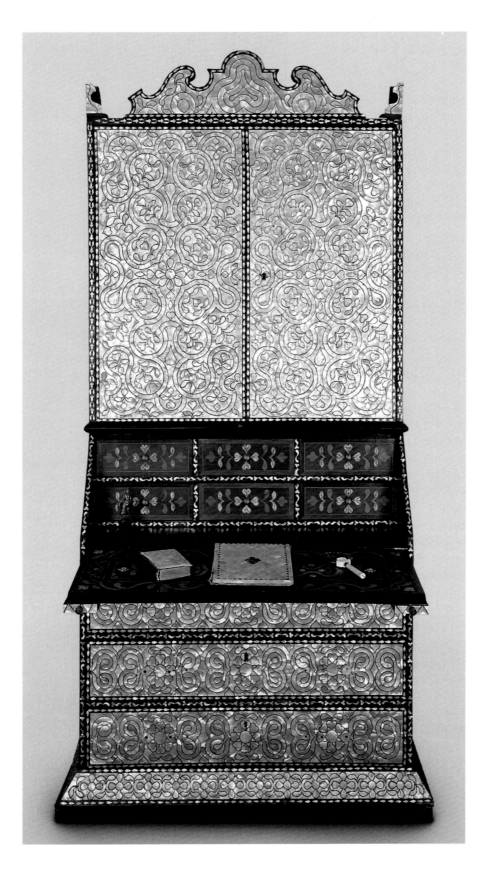

16. Desk and bookcase, Peru, 18th century. Wood, mother-of-pearl, bone, hardwood, cedar, metal, 226.1 x 113 x 58.4 cm (89 x 44½ x 23 in.)

17. Pair of writing cabinets, Peru, first half of the 18th century. Spanish cedar, mother-of-pearl, polychrome, iron, each: 33 x 33 x 33 cm (13 x 13 x 13 in.)

Spanish as *enconchado*. One can imagine the visual effect that this cabinet might have had in a wealthy household, as it recalled the elaborate Japanese shell-inlaid lacquers (*raden*) or fine inlaid furniture imported from India, Korea, and other parts of Asia (see fig. 36). Although somewhat rougher in style and execution, a pair of enconchado writing cabinets from Alto Peru (modern-day Bolivia) shows that this interest in shell-inlaid woodworking extended into the hinterlands of South America (fig. 17). Probably made by indigenous artists for the Jesuit mission churches in this remote region, these cabinets display a worldly, cosmopolitan flair that was typical of the religious order's establishments throughout the Americas.

Objects like these force us to reconsider the notion of artistic "centers" and "peripheries" espoused by early art historians of the colonial Americas. They considered Europe the artistic center and regarded the American viceroyalties (or colonies) as being on the periphery, producing art that was a degraded version of the European models.[23] Yet these regions found themselves connected with faraway markets, including those of Asia, and indeed had access to a wide variety of foreign goods and a mix of influences, not just those from the cultural centers in Europe. Rather than seeing these peripheral regions as cultural backwaters, more recent cultural historians have appreciated them as areas that received inspiration from many sources.[24] The structure of the colonial Americas, the vast distances involved, and the generally decentralized governance of far-flung population centers permitted influences from around the world to blend together. Materials and artwork from Asia, and even people (in the form of slaves), changed hands at several important sites of trade in the Americas. This cross-cultural exchange led to a proliferation of art made along a complex series of local trade routes that bears the imprint of the transoceanic trade. New lines of inquiry have refocused attention from the Atlantic world to the Pacific, and to the global circulation of goods and people that led to a more complex intermixing of influences in the colonial Americas.

To be a colonial citizen in the Americas was to be a global citizen. Households in this period frequently contained goods collected from across the world, testifying to the

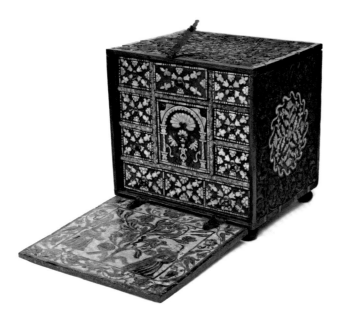
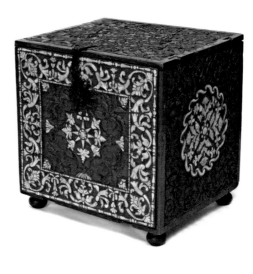

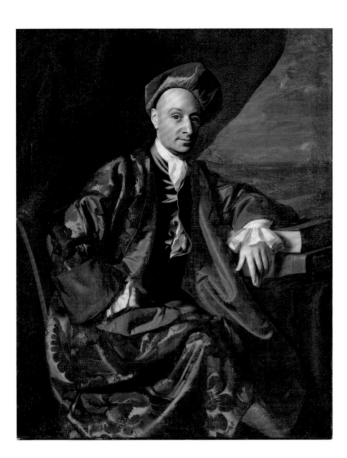

complex material lives of their owners. Like the *wunderkammern*, or curiosity cabinets, of the European nobility, these interiors brought together a menagerie of consciously selected rare and precious objects. In 1695 the possessions of the wealthy Marquesa Doña Teresa Francisca María de Guadalupe Retes Paz Vera of Mexico City included objects brought in by the Manila galleons, such as Chinese porcelains and ceramics, Chinese lacquer writing desks, filigree silver, cedar and sandalwood chests inlaid with bone, and a lacquer folding screen "from China," as well as objects imported from Europe and other parts of Latin America. She also owned objects made locally in an Asian style, including shellwork boxes, cabinets, and pictures, and a painting of Our Lady of the Assumption in "a rich false frame decorated with flowers, in imitation of lacquer from China."[25] Household inventories of this period sometimes distinguish between imported objects from Asia and those made locally in an imitative style (*achinado*), both of which were suitable for a fashionable residence. Even a single imported porcelain from China or a textile from India could speak volumes about the owners' wealth and worldview.

The 1769 portrait of the Boston merchant Nicholas Boylston by John Singleton Copley shows him dressed in a long, loose silk robe called a banyan or Indian coat (fig. 18). The term *banyan* originally referred to India traders or merchants of the seventeenth century, and by 1755 the word became synonymous with the loose-fitting, informal gowns Europeans brought back from India and the Far East. (The Dutch favored especially the Japanese *kosode*.)[26] Banyans, which became highly popular in Europe in the eighteenth century, were most commonly associated with men (and women) of leisure and mercantile, artistic, and intellectual pursuits. In Copley's portrait, the sitter is dressed in a banyan made of a rich brown damask of either European or Chinese man-

19. Attributed to José de Alcíbar (active 1751–1803). *De español y negra, mulato* (From Spaniard and Black, Mulatto), Mexico City, about 1760. Oil on canvas, 78.8 x 97.2 cm (31 x 38¼ in.)

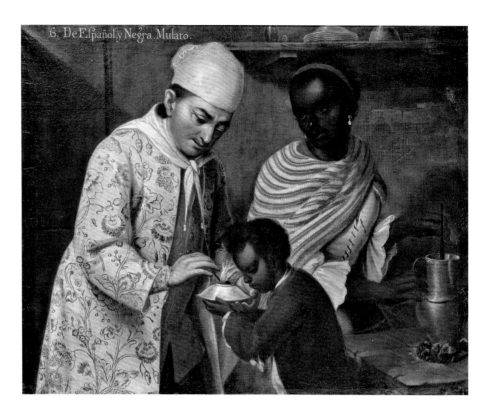

ufacture, and he wears a turban or soft cap in place of a wig. While Boylston is depicted self-consciously at ease and in casual attire and pose, the pile of account books resting beneath his arm and the view of the ocean in the background clearly refer to the far-flung mercantile empire—partly based on the transshipment of Asian commodities to the American colonies—that had created his enormous wealth. The prominent role of the banyan, a luxury good, in this portrait serves as both a marker of high economic status and a projection of the sitter's worldliness and refinement.[27]

The fashion for banyans and Indian coats spread throughout the European colonies, including those in New Spain, where a painting shows one of its subjects wearing a long patterned coat (fig. 19). Like Boylston, the gentleman, referred to in the painting's title as "Español" (Spaniard), wears the coat with a cap and a fitted vest. In this case, he is more likely a type rather than an individual, as this painting belongs to a series of *casta* (or caste) paintings showing the racial mixing that was a prevalent characteristic of colonial life in Mexico. The gentleman lights a cigarette in a brazier held by his son, while his wife stirs a warming pot of Mexican chocolate. The banyan shown in this painting is of the type of embroidered or printed Indian cotton or muslin that is often referred to in period inventories as *indianilla*. It is difficult to know whether this fabric was of Indian manufacture, a European copy, or of local origin; however, the garment clearly refers to the kinds of luxury goods imported into New Spain and to the wider European fashion for these Asian-style coats.

Aristocratic New Spaniards also clothed themselves in even more elaborate symbols of global trade. A portrait of a young and elegant aristocrat of Puebla, Mexico, painted about 1735, shows her wearing a fantastical embroidered dress with a mixture of

imagery from China, Europe, and the Near East (fig. 20). On the petticoat and the matching bodice can be seen a veritable inventory of exotic figures that were part of the European fad for chinoiserie: Chinese men in jaunty poses, exotic buildings, strange-looking animals, and oversized flowers and trees. In all likelihood, the fabric for young Doña María's dress was made in Europe or Mexico, and its imaginative combination of characters and imagery reflects a European taste for chinoiserie in the 1730s rather than a fashion for imported material from Asia. Nonetheless, her elaborate jewelry and the long strings of pearls on her neck and wrists were probably among the imported objects brought from Asia by way of Manila. Mexico had been the launching point for the colonization of the Philippines in 1565, and later it governed the colony under the umbrella of the viceroyalty of New Spain—thus, it was a colony that itself had a colony. This worldview is reflected in Doña María's marvelous dress.

The essays that follow address different aspects of this global story of trade and artistic influence. Karina Corrigan examines the production and shipping centers in Asia and the kinds of Asian export goods that could be found in the Americas during the colonial period. Jingdezhen, Zhangzhou, and Dehua in China, Goa in India, and Nagasaki in Japan were centers of production for goods that found their way to the Americas in prodigious quantities—many through the Spanish port of Manila, on the Portuguese carrack trade from India, or on ships of the Dutch and British East India companies. These goods were part of households throughout the Americas, and records of their contents document not just the fine underglaze blue porcelains that have survived for centuries, but also the more perishable silk and cotton textiles, spices, and teas that made up the largest portion of the trade.

Donna Pierce picks up this global story in Mexico, where goods from Manila arrived on the galleons in Acapulco, bound for Mexico City and beyond. Mexico City became in its day one of the largest and most cosmopolitan cities in the world. The Asian goods received there and carried to the farthest reaches of the Spanish Empire—from San Gabriel in modern-day New Mexico and St. Augustine, Florida, to Lima and Buenos Aires—inspired a multitude of imitations. Hybrid styles in ceramics, lacquerware, furniture, sculpture, and textiles combined the look of Asian imports with the ingenuity of native and immigrant craftsmen and the unique qualities of the local materials available to them.

Mitchell Codding focuses on one important aspect of this production: the lacquerware of western Mexico and South America (Peru, Colombia, and Ecuador), where two indigenous techniques of producing hard, shiny, and colorful lacquer surfaces—*laca* (or *maque*) and *barniz de Pasto* (or *mopa mopa*)—were transformed in the viceregal period by the introduction of Asian lacquerware and their European imitations. Extensive research and scientific analysis has revealed the methods and materials used to create these fascinating multicultural objects.

Gauvin Bailey explores the complex role of the global Catholic religious orders in the exchange of goods and ideas between Asia and their missions in the Americas. Jesuits, Franciscans, and other Mendicant orders promulgated positive ideas about Asia in the Americas and in turn celebrated their missionary successes in both continents. From early Jesuit writers such as Álvaro de Semedo, who published firsthand accounts of China, to priests and artists who commissioned artworks for mission churches in the Americas both from Asian and from Amerindian artists, these orders were responsible for some of the earliest and most protracted and profound interactions with Asia. Bailey also draws attention to Brazil and its trading partner Argentina, as well as to the far-flung mission churches of the Jesuits in Peru and Bolivia and of the Ursulines in New France, as further instances of the religious orders' participation in global cultural exchange.

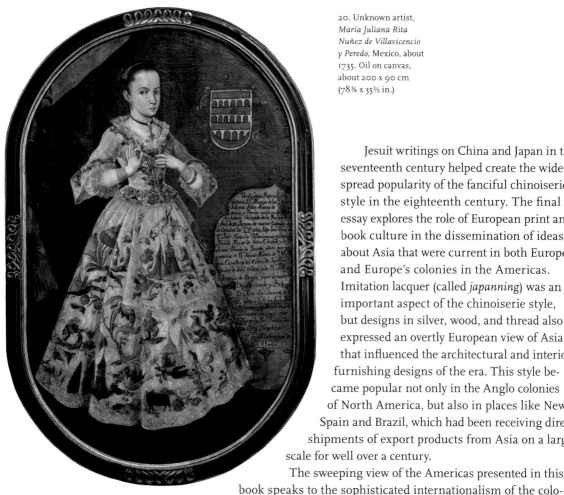

20. Unknown artist, *María Juliana Rita Nuñez de Villavicencio y Peredo*, Mexico, about 1735. Oil on canvas, about 200 x 90 cm (78¾ x 35½ in.)

Jesuit writings on China and Japan in the seventeenth century helped create the widespread popularity of the fanciful chinoiserie style in the eighteenth century. The final essay explores the role of European print and book culture in the dissemination of ideas about Asia that were current in both Europe and Europe's colonies in the Americas. Imitation lacquer (called *japanning*) was an important aspect of the chinoiserie style, but designs in silver, wood, and thread also expressed an overtly European view of Asia that influenced the architectural and interior furnishing designs of the era. This style became popular not only in the Anglo colonies of North America, but also in places like New Spain and Brazil, which had been receiving direct shipments of export products from Asia on a large scale for well over a century.

The sweeping view of the Americas presented in this book speaks to the sophisticated internationalism of the colonial Americas at an early date. The wealth created by the emergence of the global mercantile system in the sixteenth and seventeenth centuries gave elite Americans from across the hemisphere increased purchasing power to acquire precious imports from Asia that had until then been comparatively rare in the West. Once the trade was in full swing, even individuals of modest means could acquire Asian goods such as cotton textiles and ceramics, some of which became more affordable than those produced locally or shipped from Europe. Asian imports were widely available in the urban centers of the Americas as well as in the vast hinterlands of Spanish, Portuguese, British, Dutch, and other European settlements, wherever colonists settled along trade routes. The religious missions, especially in Latin America, expanded their reach even farther. The artistic responses to these goods in workshops across the Americas, and their use in homes and churches, transcend political boundaries in a way that encourages us to take a broader, hemispheric view of the history and culture of the colonial Americas. These settlements were closely bound to each other by their common taste for Asian imports and by their integral position in the transpacific and transatlantic trading networks. From archaeological excavations to household inventories to miraculously surviving objects, this book explores evidence of the wide-ranging exchange between Asia and the New World in the early modern period and the global circulation of goods that shaped the shared culture of the colonial Americas.

ASIAN LUXURY EXPORTS
to Colonial America

KARINA H. CORRIGAN

AMONG THE EARLIEST Asian goods in colonial America
were those imported into the viceroyalties of New Spain
and Peru. Many people living under Spanish rule in the
Americas had access to these luxuries, but some of the
most important imports were reserved for those at the
pinnacle of Spanish power. In 1590, García Hurtado de
Mendoza y Manrique was appointed by King Philip II to
serve as viceroy of Peru, the senior representative of the
Spanish Crown in one of the most economically import-
ant regions of the empire. The son of a nobleman, he was
married to Teresa de Castro y de la Cueva, who was of
equally distinguished Spanish and Portuguese ancestry.[1]
In a letter to the king's secretary, Viceroy Mendoza re-
marked that he had recently received "some curious and
attractive things for my household" from Manila.[2] This
large shipment of Asian luxury goods, which arrived in
Lima in 1592, included Chinese porcelain, among which
may have been a small Chinese porcelain plate, only eight
inches in diameter and with a delicately shaped border
(fig. 21). Discovered in 2004 at a small auction in the
Netherlands, this plate is possibly the earliest Chinese
porcelain decorated with a Spanish coat of arms: the de-
sign in the central reserve, painted by a Chinese artist
in pale shades of cobalt blue, is the combined arms of
Mendoza and his wife.

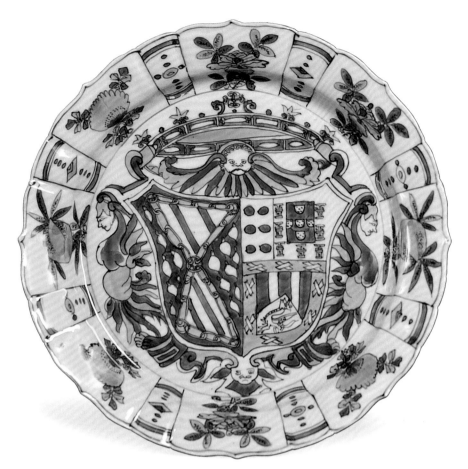

21. Plate with the arms
of García Hurtado de
Mendoza y Manrique
and Teresa de Castro y
de la Cueva, Jingdezhen,
China, about 1590–95.
Porcelain, diam. 20.3 cm
(8 in.)

As viceroy of Peru, Mendoza wielded ultimate authority over the export of precious American commodities—silver, cochineal, and other goods—to Manila.[3] None was more important than silver, which was discovered in large deposits in Peru and New Spain in the sixteenth century. Together the mines of New Spain and Peru, in particular the legendary mine at Potosí in modern-day Bolivia, produced more silver during the viceregal period than any other source in the world.[4] Silver was shipped across the Atlantic to Spain to fund its empire, but a significant portion of American silver was ultimately destined for Manila or China, where it was used to purchase Asian luxury goods for the colonies. In China this silver became important as a medium of exchange for large commercial transactions. Historically, Japan had provided much of the silver consumed in China, but with the establishment of a unified tax system in the 1570s, China's need for currency to pay the new levies became almost unquenchable. Silver from South America filled the emerging demand.[5]

Trade in the precious metal ultimately fueled the extravagant lifestyles of the elite in the capitals of Lima and Mexico City, where palaces were filled with Asian ceramics and lacquer, European furniture, carpets from the Middle East, and Indian and Chinese textiles.[6] As viceroy, Mendoza had a strong hand in the importation of foreign commodities. With his diplomatic ties to regional and global networks, Mendoza would have been well situated to commission porcelain with his family's arms from faraway China, as well as to order other luxury objects from around the globe.

The fine quality of the porcelain indicates that the plate was made by potters in Jingdezhen, the city in the southern province of Jiangxi that produced the bulk of China's

imperial and export porcelain throughout the early modern period.[7] As early as the fifteenth century, Chinese porcelain made in Jingdezhen was being widely exported to Japan, Southeast Asia, India, Persia (present-day Iran), and the Middle East. The first porcelains to arrive in Europe, brought principally via the Silk Route, had Chinese motifs and were prized particularly for their durability and translucency.[8] By the late 1500s Chinese potters were making porcelain intended for export to Europe and the Americas that combined Asian and European decorations.

Mendoza's plate is one of the earliest surviving examples of such hybrid porcelains. The typically Chinese-style border is divided into eight wide panels decorated with flower sprays, alternating with eight narrower panels.[9] This arrangement of radial panels is characteristic of *kraak* porcelain, named after the Portuguese ships (carracks) that brought it to Europe; plates shipped on the *San Diego*, a Spanish galleon that sank off the coast of the Philippines in 1600, have a closely related border design.[10] Kraak porcelain plates with European arms are extremely rare, and the Chinese artist who painted the Mendoza family arms struggled to adapt this unfamiliar design, slightly elongating the arms so that they entirely occupy the central space.[11]

The plate's design was executed entirely in underglaze blue, created by painting cobalt oxide onto the unfired porcelain before glazing. The method, typical of Jingdezhen wares of this period, was the most durable and least expensive method of ornamentation. Underglaze blue porcelain has always been the product of cross-cultural connections: cobalt oxides had first arrived in China from Persia, allowing for limited production of the wares. By the 1600s cobalt deposits were discovered in China, which ushered in the widespread expansion of underglaze blue porcelain production in Jingdezhen.

The manufacture of this plate in Jingdezhen was only the beginning of its remarkable journey. Brokers, organized into *hang* (guilds) as early as the twelfth century, served as intermediaries between the manufacturers and the Chinese merchants who came to Jingdezhen to buy ceramics. The finished product left the city the same way that the materials for porcelain manufacture were brought in: over water. Ceramics for export were packed and transported from Jingdezhen down the Chang (Yangzi) River to Lake Poyang, and from there on to the port cities of Guangzhou (Canton) and Xiamen (Amoy). When porcelain was transported over the more rudimentary land routes, it was typically carried by porters.[12]

From China trade goods were shipped to Manila, which came under Spanish control in 1571. In Manila the cargo of the ship carrying Mendoza's plate would have joined the silk, porcelain, lacquer, ivory, spices, and other luxury goods arriving on Chinese, Indian, and Portuguese vessels to be sold in the city's Parián market. Goods purchased in Manila for the Spanish and American markets were loaded onto Spanish galleons to make the five- to six-month passage across the Pacific to Acapulco—first heading north toward Japan, then following the trade winds east to the western coast of America (roughly near the present site of San Francisco), and then south along the coastline to Acapulco. The first two Spanish galleons to sail from Manila, in 1573, carried some 22,300 pieces porcelain bound for Mexico.[13] The Spanish galleon trade precipitated the expansion of Acapulco and transformed Manila, which had been an important entrepôt in the inter-Asian maritime trade for centuries, into one of the richest colonial cities of the period.[14]

After landing safely in Acapulco, Mendoza's armorial plate still needed to traverse thousands of miles of rough terrain to reach Peru. Carried by mules, it would have traveled to Mexico City before arriving in Lima. The plate's rarity and beauty—and its potent symbolism of Spain's newly expanded empire—would have certainly been appreciated at the viceregal court.[15]

But Chinese porcelain was not owned solely by the very wealthy and powerful in the Americas. Wares from Jingdezhen were shipped throughout the Americas in the late sixteenth and seventeenth centuries, from northern New Spain in the modern-day American Southwest through the Spanish and Portuguese territories in South America and the British, Dutch, and French colonies of North America, from Newfoundland to Florida and the Caribbean. Some of the earliest archaeological evidence of Chinese export ceramics in the Americas, dating to the last quarter of the sixteenth century, has been found, logically, in areas of Spanish occupation, including St. Augustine, Florida; Santa Elena, a site in South Carolina; and San Gabriel, in present-day New Mexico.[16] At a home in Old Panama City that was occupied as early as 1600 by Genoese slave traders, archaeologists recently uncovered Chinese export ceramics from the late sixteenth and seventeenth centuries.[17] The cargo of the shipwrecked *San Diego* galleon, which contained more than five hundred underglaze blue ceramics from Jingdezhen, including kraak porcelain dishes, cups and plates in a variety of patterns, covered boxes and jars, pear-shaped bottles, and round and elephant-shaped drinking vessels, testifies to the diversity of Chinese porcelains being exported from Manila around 1600.[18]

Ceramics whose provenance is unknown can still provide tantalizing clues to their histories. One intriguing group of porcelains is decorated in underglaze blue with an emblem of the Order of St. Augustine, a pierced heart, surmounted by a double-headed eagle. Large jars are the most common form, but a charger also bears this motif (fig. 22). The ceramics may have been made for the Augustinian monasteries in Macau, the Philippines, or Mexico. There is an intriguing iconographic link between New Spain and these ceramics: they all include an architectural facade that may represent the churches surrounded by a walled compound that are found throughout New Spain. Interestingly, four jars from the group are said to have Mexican histories.[19]

The Portuguese colony of Brazil had even more frequent contact with Asia than did Spanish America, through the Portuguese ships that stopped in Salvador and Rio de Janeiro on their way to Europe from the country's other colonies in India (Goa), Ceylon, Malaysia (Malacca), and China (Macau). At Brazilian ports Portuguese traders exchanged Asian goods for the supplies necessary for the long voyage east. Prodigious amounts of Chinese porcelain and ivory from Goa and Ceylon (now Sri Lanka) survive in Brazilian collections today. By some estimates, as many as ten million pieces of Chinese ceramics were imported to Brazil between the sixteenth and nineteenth centuries.[20] Brazil also supplied a thriving market for Indo-Portuguese and Ceylonese ivories, Asian textiles, and Japanese and Indo-Portuguese furniture in the Americas. Portuguese trade provided these Asian goods not only to Brazil, but to the nearby Spanish colonies of Argentina and Uruguay as well.

By the early seventeenth century, Chinese ceramics from Jingdezhen were also in use in the English, Dutch, and French settlements in North America. Whole and fragmented porcelains have been found at sites dating from this time in southeastern Virginia, including wine cups decorated with a narrow underglaze blue band that were unearthed along the James River and at the Jamestown fort.[21] An excavation at Ferryland in Newfoundland of a site dating to the second quarter of the seventeenth century yielded a closely related wine cup. This vessel probably belonged to the colony's founder, George Calvert, the first Lord Baltimore, who may have acquired it through his ties to the newly formed British East India Company.[22] Similar cups were recovered from the wrecks of the *Witte Leeuw* (1613) and the *Banda* (1615), Dutch East India Company vessels that sank off Africa's west coast and Mauritius, respectively.[23]

Many luxury goods transported from Asia to Amsterdam by the Dutch East India Company were reshipped across the Atlantic to colonial North America.[24] In 1684

Catrina Darvall of New York wrote to her sister Maria van Rensselaer in Albany that she was sending "two large porcelain jars."[25] Darvall could have purchased the jars locally: her contemporary Jacob De Lange, a New York barber-surgeon, owned more than 250 pieces of Asian "purcelaine," including 136 teapots, which he probably imported to sell.[26] Adolphe Philipse, the son of the New York merchant Frederick Philipse, had more direct access to imported luxury goods. In 1695 he requested that the captain of a ship owned by his father barter on his behalf in Madagascar for "a verry good Cabinet . . . Costs what it wil" and "So much good China Ware (of the best) as wil fit a Mantel peice."[27] Dutch merchants imported Asian goods into the British colonies as well: the Dutch ship *Peter and Godfrey* carried "14 China plates" and "1 China sett compleat" from Rotterdam to Newport, Rhode Island, in 1728.[28]

New Englanders with connections to the maritime trade, even those of modest social standing, were able to acquire imported goods. More than half of those who are recorded as owning porcelain in eighteenth-century Plymouth, Massachusetts, were either merchants or mariners.[29] Refined Chinese ceramics were also owned by colonial New England residents far outside the Massachusetts port centers of Salem, Boston, Plymouth, and Newburyport, turning up in a Hadley household in 1680 and a Sheffield home in the late eighteenth century.[30]

In Maryland, Edward Lloyd III of Wye House owned several hundred pieces of porcelain imported from China.[31] Decorated with multiple colors in a pattern sometimes erroneously referred to as "tobacco leaf" that actually depicts a custard apple or passion

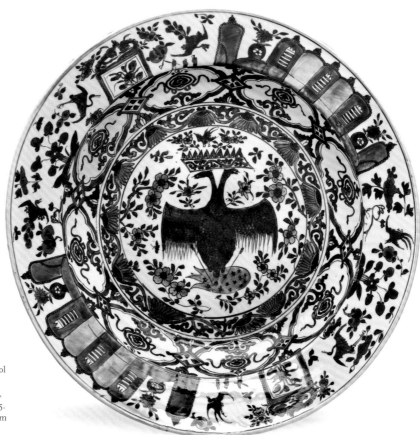

22. Charger with symbol of the Order of St. Augustine, Jingdezhen, China, about 1590–1635. Porcelain, diam. 50.8 cm (20 in.)

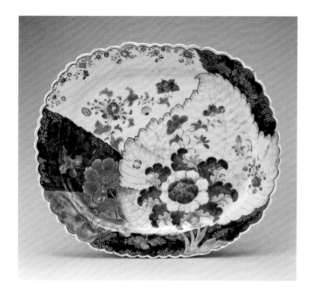

flower, they were some of the most expensive Chinese
export porcelain services imported to the Americas
(fig. 23).[32] Tea ware was owned by people from
across a broad economic spectrum in York County,
Virginia, which included the cities of Yorktown and
Williamsburg. Residents of this area, who began
drinking tea in significant quantities before the mid-
dle of the eighteenth century, also began acquiring
the necessary equipment from China for this pres-
tigious ritual.[33] They sometimes mixed Chinese and
European tea ware: one resident in 1734 recorded
owning "1 China bowl cups & Saucers & Six Earthen
Cups and Saucers." Such wares were also widely
available in Charleston, South Carolina, in the 1740s.
David Crawford advertised in the *South Carolina
Gazette* in 1749 that he had just imported for sale at
his store on Broad Street a "large assortment of China
ware as breakfast cups and saucers, dishes, plates,
and bowls of all sorts, tea and coffee cups and saucers,
also 3 Compleat sets of color'd china for a tea table."[34]

 Although the French East India Company
(*Compagnie des Indes*) was far less extensive than its
Dutch or British counterparts, Asian ceramics did
make their way to French settlements throughout the
Americas along various routes. At Old Mobile, a small
community in present-day Alabama that was inhabit-
ed only from 1702 until 1711, archaeologists have un-
covered more than five hundred shards from at least
forty distinct pieces of Chinese export porcelain. This
porcelain appeared in buildings throughout the set-
tlement, not just at the homes of wealthy merchants

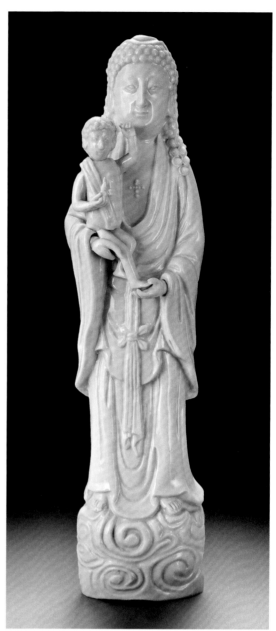

23. Platter,
Jingdezhen, China,
1755–60. Porcelain,
45.7 x 38.1 cm
(18 x 15 in.)

24. Madonna and
child, Dehua, China,
1690–1710. Porcelain,
h. 33.6 cm (13¼ in.)

or government officials. The quantity of Spanish colonial coins also found at the Old Mobile site indicate that the Chinese ceramics probably arrived through the Spanish colonial trade in nearby Pensacola, Florida, or on French ships that had ventured to Veracruz, Mexico.[35] Asian ceramics also appear in French Canada, among the possessions of Claude-Thomas Dupuy, the intendant in Quebec from 1726 to 1728.[36]

Although most of the Chinese porcelain exported to the Americas and Europe was made in the kilns at Jingdezhen, three other major kiln sites in China—Dehua, Zhangzhou, and Yixing—also produced ceramics for export. Dehua, in Fujian Province, less than seventy miles from the port city of Amoy (Xiamen), was an early center for Dutch trade in Asia. Porcelains from Dehua, sometimes called *blanc de chine*, are known for their sugary-white clay bodies, thick, smooth glazes, and refined sculptural forms. Individual components were made in small molds and were mixed and matched to create different figures and figural groups, using modular production techniques that anticipated the assembly lines of the European Industrial Revolution by nearly a millennium.[37] A Dehua specialty was large statues of Guanyin—the Buddhist Bodhisattva of mercy—and other Buddhist and Daoist religious figures. With adaptations such as the addition of a cross-shaped necklace and a Christ child figure, Guanyins could also become Madonnas for the local and export market (fig. 24). These figures, along with those of animals such as lions and elephants, were found in households from New York and Boston to Charleston.[38] Cups from Dehua were also a major export item. They may have served as wine cups in China, but Europeans used them primarily for tea, coffee, and chocolate—the last a delicacy introduced from Latin America. To serve this newly fashionable beverage, porcelain cups and saucers made specifically for chocolate were ordered in great quantities from Asia: more than nineteen hundred chocolate cups from Dehua were part of the cargo of a single ship, the *Dashwood*, which arrived in London from Amoy in 1703.[39]

Export porcelains made in Zhangzhou, sometimes called Swatow ware, are coarser, more heavily potted, and more loosely decorated than those made at Jingdezhen or Dehua. Zhangzhou wares were produced at kilns in Fujian Province from the mid-sixteenth to the mid-seventeenth century and widely exported to Southeast Asia and Japan. These wares appear to have been present in the seventeenth century throughout the Americas, including Panama, Mexico, Virginia, and even New York City: fragments of Zhangzhou porcelains were found in Manhattan during excavations at Hanover Square, a public common close to Wall Street dating to the 1630s.[40]

The potters of Yixing created refined unglazed stoneware (rather than porcelain) in earth tones. The earliest teapots exported to Europe and America, in the third quarter of the seventeenth century, came from Yixing.[41] A Yixing teapot with a press-molded Buddha lion and a freely rotating brocade ball on the lid once belonged to Joshua Ward of Salem, who died in 1779 (fig. 25). Ward's pot is virtually identical to Yixing teapots recovered from the wreck of the *Geldermalsen*, a Dutch ship that sank off the coast of Indonesia in 1752.[42]

In the late seventeenth and early eighteenth centuries, Western traders enjoyed access to a number of Chinese ports, but beginning in the 1750s an imperial edict limited all foreign trade to the southern port city of Guangzhou. Special industries and a large community of artists and craftsmen emerged at Guangzhou and in the surrounding countryside to cater to foreign markets. Lacquer artists, porcelain enamelers, silversmiths, painters, weavers, and embroiderers created luxury goods that united their artistic talents with the desires and demands of Western clients.[43] Although ceramics tend to survive in greater numbers, luxury export goods such as silk, cotton, lacquer, and spices imported from Asia typically represented a greater proportion of the cargoes shipped to the Americas.

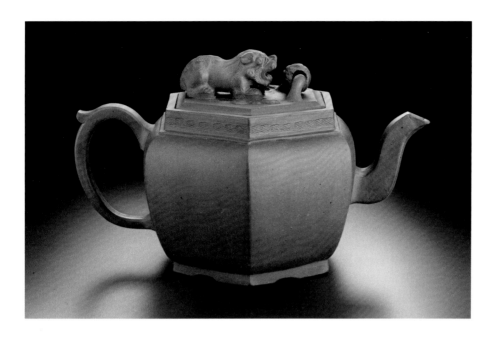

46 The Chinese silk industry expanded in the sixteenth century, as production of raw silk increased in rural areas and textile production developed in cities in the provinces of Jiangsu and Zhejiang. By the late sixteenth century the population in Suzhou (in Jiangsu Province), China's center of silk production, was close to half a million people. In the eighteenth century Guangzhou emerged as an important center for silk production in response to the seemingly insatiable foreign demand for silk thread and bolts of cloth. Silk production came to dominate the region's economy; farmers replaced many traditional crops with mulberry trees, whose leaves fed silkworms.[44]

Chinese silks, as well as Persian and Indian textiles, were valued in New Spain and Peru for their beauty and their affordability. In the Spanish American colonies, high shipping costs from Seville made Chinese silk much less expensive than Spanish silk: in Peru, Chinese textiles sold for less than one-eighth the price of Spanish cloth and sometimes even less than locally produced textiles. In 1602 it was noted that in Lima "the silks of China are much used in the churches of the Indian, which are thus adorned and made decent; while before, because of the inability to buy silks from Spain, the churches were very bare."[45] Viceroy Mendoza observed in a letter to Philip II that Chinese silks and other textiles were so cheap in Peru that even commoners used them for clothing instead of locally produced material. Beginning in the 1700s Chinese export shawls became popular in Spain and its American colonies; they were known as *mantónes de Manila*, reflecting the Philippine port's importance for the Spanish trade routes to China.[46]

Silk was also a highly prized luxury commodity in North America. A number of eighteenth-century American dresses made of Chinese silk survive, some with early provenances. Maria Lents Egberts of Albany, New York, owned a dress made of orange and gold Chinese export damask silk (fig. 26). The silk's scrolling peony or lotus design looks Chinese stylistically, but its width also identifies its origin: Chinese silk is typically wider—twenty-nine inches selvage-to-selvage—than cloth woven in Europe.[47]

Spain secured its access to Chinese luxury goods via the Atlantic Ocean and the galleon trade to Manila, but Portugal (and later the Dutch Republic, England, and other European nations) acquired these commodities by sailing in the opposite direction.

26. Gown and petticoat, Chinese textile, assembled in New York, 1740–60, remodeled 1770s. Silk damask, width of material: 74.3 cm (29¼ in.)

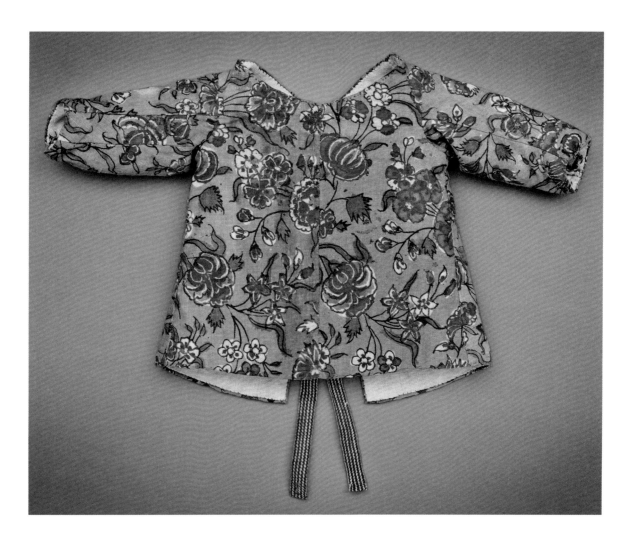

The Treaty of Tordesillas, signed by Spain and Portugal in 1494, effectively divided the globe into two spheres: Spain controlled lands east of the Cape Verde Islands, and Portugal controlled lands in the Indian Ocean from southern Africa to Southeast Asia. The Portuguese colony in India was founded in 1505 in Cochin and moved shortly thereafter to Goa. The Portuguese also established an important early colonial settlement in Macau in 1557 with permission from the Chinese. From these two principal settlements Portugal traded extensively throughout the region, also establishing trading enclaves in Ceylon (Sri Lanka), Malacca, and Nagasaki.

By the early seventeenth century Dutch and English traders had entered Asian waters in sufficient numbers to challenge Portuguese dominance in the region. Although Portugal maintained its presence in Macau and Goa into the twentieth century, the Dutch wrested control of Malacca in 1641, Ceylon in 1658, and Cochin in 1662. The port city of Batavia (Jakarta) in Indonesia became the central outpost of the Dutch East India Company in Asia. Unlike Spain in its direct control of expansive lands in the Americas, and Portugal in its control of those in India, China, and Africa, the Netherlands maintained an empire primarily of trade rather than land. Dutch East Indiamen took Asian luxury goods back to the Netherlands and to Dutch colonial settlements in the Caribbean and North America beginning in the 1600s.

27. Baby's jacket, Indian textile, assembled in the Netherlands, mid-18th century. Cotton, mordant- and resist-dyed, and painted, lined with linen, length 22.9 cm (9 in.)

The Dutch made the bulk of their profits with shorter inter-Asian journeys, dealing in iron and lacquer, but most significantly—and profitably—trading Indian textiles throughout Asia, where they used them to barter incrementally at each port. Jan Pieterszoon Coen, director general of the Dutch East India Company, wrote in 1619 that "[textiles] from Gujarat we can barter for pepper and gold on the coast of Sumatra; rials and cottons from the [Coromandel] coast for the pepper in Banten; sandalwood, pepper and rials we can barter for Chinese goods and Chinese gold; we can extract silver from Japan with Chinese goods . . . and rials from Arabia for spices and various other trifles—one thing leads to another."[48]

Painted and resist-dyed Indian cottons, with their vivid and durable colors, were coveted around the globe. Often decorated in sinuous floral-and-vine patterns, they were commonly known in English as chintzes, after the north Indian word *chitra*, meaning "spotted" or "sprinkled." Cotton was produced in villages throughout India. Local buyers often extended cash advances to spinners, weavers, and dyers to sustain these textile households over the months it took to produce cloth and ultimately served as intermediaries between makers and merchants. Most of the cotton produced for export was made in eastern India, near the Coromandel Coast, in three areas: Nagapattinam, close to the island of Ceylon; Madras, the earliest English settlement in India; and Masulipatam, the port from which most Indian textiles were shipped to the West.[49] Indian weavers produced export cottons with a wide range of quality and patterning. The Indian cottons from this time that have been preserved are typically of fine quality and highly decorated, although most of the exported cloth was plain, striped, or checked.

Cotton's role in the emerging global economy has been described as a "diamond-shape system" that linked India with Europe, Africa, and the Americas.[50] European merchants traded Indian cloth for enslaved workers in Africa, many of whom ultimately worked in the Peruvian silver mines that linked the Americas with the Philippines and China. Cotton production in India was thus intimately linked to the expansion of trade in the Americas. It is estimated that at least a third of the cotton exported from India by the Portuguese in the 1600s and 1700s was destined for Brazil and Spanish America.[51]

Throughout the seventeenth and eighteenth centuries, colorful Indian cottons were widely used for clothing, upholstery, and wall and bed hangings in Europe and its American and Asian colonies. A New York textile dealer's inventory in the late 1600s listed many items identified as "calico" or "chintz," including waistcoats, baby bibs, and bed clothing.[52] Easier to wash than wool or linen, cotton was a practical, if perhaps expensive, choice for children's clothing (fig. 27). Bed hangings from India made a particularly sumptuous statement in an era in which people welcomed guests to their bedchambers. For instance, Captain George Corwin, who sold imported textiles in Salem, Massachusetts, furnished one of the bedchambers in his home with Indian cotton bed hangings described as "2 pr. White Calico Curtaines, Valients [valances], tester Clothes & 6 Covers for Chaires," an early American example of textiles being used to unify a room.[53] A *palampore* (bedcover), elaborately embroidered in vibrant pink, green, red, and yellow silk, was owned in the eighteenth century by the Dix family of Boston (fig. 28).[54]

For Europeans and Americans who had developed a taste for porcelain but were unable to acquire it when turmoil in China in the seventeenth century limited exports, Japanese wares filled the gap.[55] Most of the ceramics exported from Japan were made in Arita, a major ceramic production center in Kyushu, and exported from Nagasaki. From the 1630s until the middle of the nineteenth century, only the Dutch and the Chinese were permitted to trade with Japan, so Japanese export porcelain and lacquer came to Europe and the American colonies via Manila or Batavia through the Chinese junk trade or directly on Dutch ships.[56] Japanese porcelain has been found in sites from this period

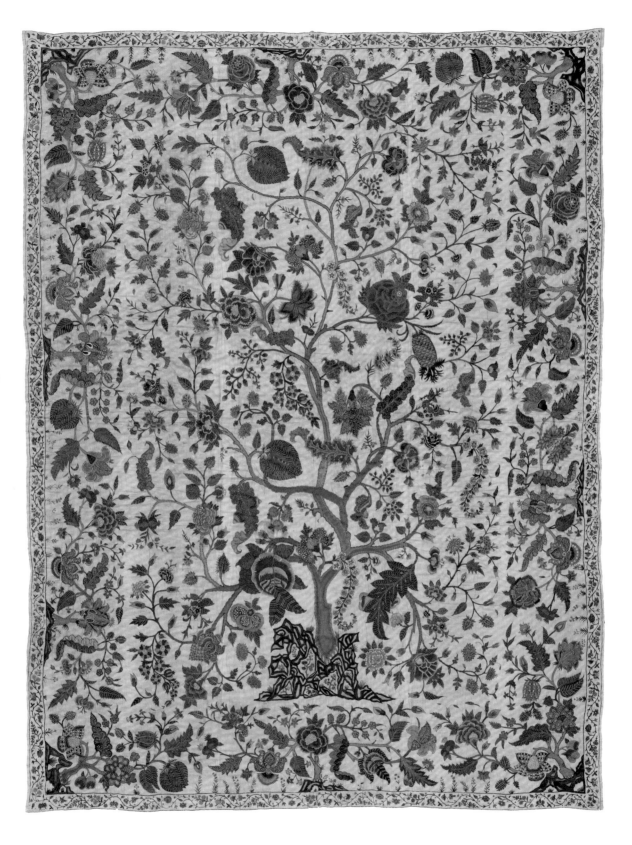

in Manila and the viceroyalties of Peru and New Spain.[57] Many colonial North American records include references to "burnt china," probably porcelain decorated in underglaze blue with overglaze red enamel and gold—a palette now known as Imari, after the Japanese port city from which most of the ceramics made in Arita were shipped. Both Chinese and Japanese potters produced ceramics in this palette during the late seventeenth and early eighteenth centuries, which makes it difficult to distinguish them in archival sources; in any case, the Japanese restrictions on foreign trade meant that most Imari palette porcelain in the Americas was probably made in China. Areas with strong Dutch ties were the most likely to have had Japanese ceramics.[58]

Americans were introduced to other types of Japanese luxury goods in the early 1600s, most famously with the 1614 arrival in New Spain of the Japanese samurai Hasekura Rokuemon and his entourage of 184 people (see fig. 38). The group, en route to Madrid and Rome on a diplomatic mission for the shogun Tokugawa Ieyasu, brought with it many Japanese works of art, including six suits of samurai armor and five boxes of Japanese screens. Ieyasu had previously sent ten screens to Don Luis de Velasco, viceroy of New Spain from 1607 to 1611, in acknowledgment of gifts he had received after the Spanish captain Rodrigo de Vivero and his shipwrecked crew were saved in Japan.[59] Japanese screens such as these inspired the indigenous tradition of *biombos* in colonial Latin America.

Another Japanese luxury good widely exported to Europe and the Americas was lacquer. Although lacquer was made throughout Asia, objects from Japan were recognized as being of the highest quality. A Dutch East India Company representative in Bantam, writing in 1609 about the earliest direct shipment of Japanese lacquer to the Netherlands, noted that "the lacquerware from China is usually of very poor quality [and] also very expensive," whereas that from Japan is "very beautiful and of good quality"; he added, "from that country one can easily obtain and have made those items that one might wish to trade."[60]

Japanese lacquerware produced for export in the sixteenth century is typically known as *namban* ware. *Namban* ("southern barbarian") was a term of derision for the early Portuguese traders who arrived from the south. Of the namban lacquer works produced in large quantities for household use, many were designed for the expanding Christian community in Japan, including such objects as portable altars and bookstands (see figs. 10 and 57). Whether Japanese lacquer made its way to colonial British America is difficult to establish. A Marblehead captain's 1695 inventory included a dozen "lackerd" chairs and couch, and a "Jappan case of drawers and table."[61] The early date and the description make it likely that this furniture was Asian lacquer rather than locally made "japanned" furniture. The New York resident Margrieta van Varick spent part of her life in Malacca, where she may have acquired pieces of true Asian lacquer, described in 1696 as "one Jappan wood dish," "four small Jappan boxes with beades & shells," and "2 wooden guilt East India trayes lackered."[62]

The Spanish galleon that brought Mendoza's Chinese export armorial plate from Manila most likely also carried nutmeg, cinnamon, cloves, cardamom, mace, and pepper from Indonesia and Ceylon. Spices, among the most important globally traded commodities, had first inspired Europeans to join the already complex networks of exchange in Asia. Imported spices, for those who could afford them, helped preserve foods and greatly enlivened their flavors. Because they were consumed, spices have left few physical traces, but we can imagine them back into being. Perhaps, after admiring their small, delicate plate and appreciating its long journey from Jingdezhen to Lima, García Hurtado de Mendoza y Manrique and Teresa de Castro used it to enjoy a vibrantly flavored meal.

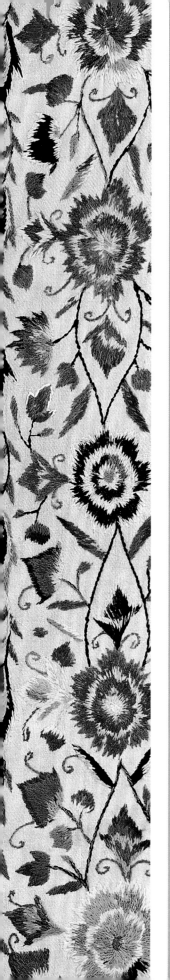

BY THE BOATLOAD
Receiving and Recreating the Arts of Asia

DONNA PIERCE

THE OPENING OF Spanish trade with Asia in 1565 placed
Mexico at the crossroads of global trade routes, as goods
traveled by sea from Manila to Acapulco and then made
the journey overland to Veracruz for shipment across
the Atlantic, or to Mexico City for local consumption.
This influx of luxury goods helped Mexico City gain
a worldwide reputation as one of the most beautiful
and prosperous cities in the New World. The British
Dominican friar Thomas Gage, who lived in Mexico and
Guatemala from 1625 to 1637, credited its wealth directly
to the thriving trade with Spain, Peru, the East Indies,
Japan, and China.[1] The exotic goods brought by this
trade were sold at a large market established in the main
plaza of Mexico City called the Parián, after the market
of the same name in the Chinese area of Manila. An
overview of the Plaza Mayor painted in 1695 conveys the
bustle and spectacle of the market, as well as the diver-
sity of people drawn to it (fig. 29). Written descriptions
of the time refer to most Asian trade objects generically
as "from China," or occasionally "from Japan," making
it difficult to discern whether they actually came from
one of the many other areas that supplied goods to the
Americas, including India, Southeast Asia, Malaysia,
Indonesia, and, of course, the Philippines, where a large
contingent of Chinese craftsmen had settled specifically
to produce goods for the galleon trade.

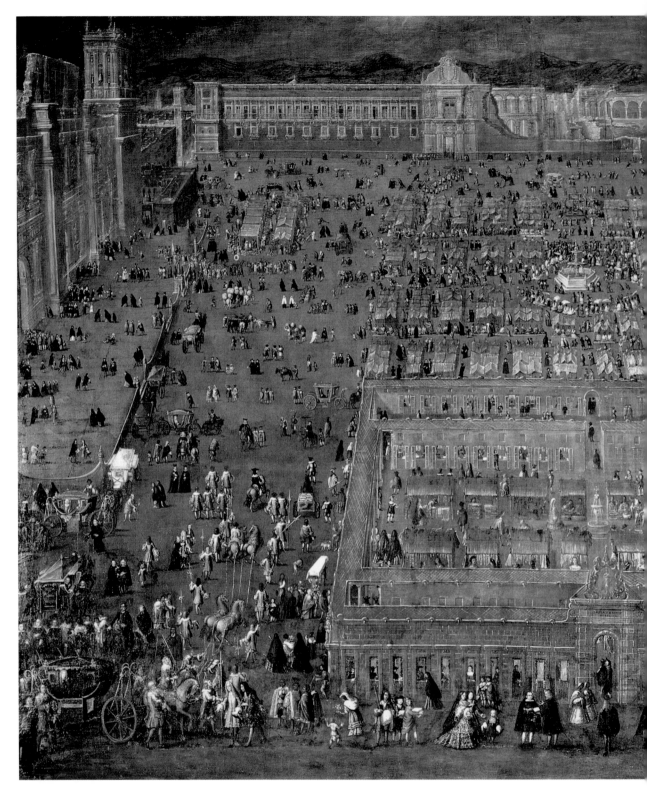

54

29. Cristóbal de Villalpando (about
1649–1714). *View of the Plaza Mayor,*
Mexico City, about 1695. Oil on canvas,
180 x 200 cm (70⅞ x 78¾ in.)

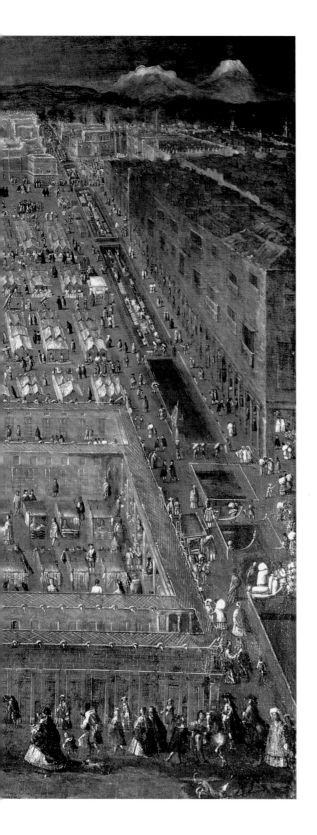

Mexico also quickly became the nexus of dealings in Asian goods among the Spanish viceroyalties. For instance, intercontinental trade between Mexico and Peru, which had begun in the 1530s, increased dramatically in the last quarter of the century as advances in American silver production fueled trade with Asia.[2] By the early seventeenth century, Asian products composed as much as 90 percent of the trade between Mexico and Peru. Because goods sent to Peru from Spain had to traverse a combination of land and sea routes, imports from Asia, which arrived directly by sea, were significantly less expensive. From time to time throughout the colonial era, Spain tried to prohibit direct trade between the different viceroyalties—particularly in Asian goods—but was rarely successful in enforcing these measures.[3] In 1594 the viceroy of Peru, the Marqués de Cañete, wrote to King Philip II that "Chinese merchandise is so cheap and Spanish goods so dear that I believe it impossible to choke off the trade."[4]

More of these goods may have stayed in Latin America than eventually landed in Spain.[5] The initial peak of Asian trade (1570–1620) coincided with the first silver booms in Mexico and Peru, which put money in the pockets of colonists eager to buy precious goods.[6] As a result, many Asian objects—porcelain, silks, spices, lacquerware, ivories, furniture and folding screens, and others—found a home in the Americas. The presence of these Asian goods is documented in travelers' commentaries and other documents such as estate wills and inventories from throughout the era. Colonial paintings also offer evidence of the persistence of the trade: for example, a Mexican still life from 1765 depicts a porcelain plate imported from China, on the lower shelf (fig. 30). Even religious paintings occasionally reflect aspects of international trade, such as a Mexican painting of the Christ of Chalma with Chinese porcelain jars flanking the sculpture, and a painting of Our Lady of Bethlehem, from Cuzco, Peru, with Chinese bowls and vases shown on the altar at her feet (figs. 31 and 32). Asian textiles and decorative objects also appear in portraits and *casta* (caste) paintings (see figs. 19 and 43). Their inclusion, particularly in portraits, reinforced the association between "foreign" objects and the social status of their owners.

Probably the most significant evidence for the presence of Asian goods in colonial Latin America is the number of local art forms produced in imitation of Asian arts, the sincerest form of flattery. Mexican households often contained a mix of Asian objects, products of Europe and

30. Antonio Pérez de
Aguilar (active 1749–69).
The Painter's Cabinet,
Mexico City, 1765. Oil
on canvas, 125 x 98 cm
(49¼ x 38⅝ in.)

other areas of the Americas, and pieces made locally by both Spanish and native crafts-
men.[7] A Mexico City household that was inventoried in 1645 included furniture con-
structed of luxury materials such as mahogany, ebony, and ivory from Germany, Cuba,
China, and the West Indies, along with a Turkish carpet and velvet pillows from China.[8]
This happy mix of local and imported goods was also found in colonial monasteries and
convents; Gage reported that the quarters of the prior of the Dominican monastery in
Veracruz contained "many pictures [and] hangings, some made with cotton-wool, others
with various colored feathers of Michoacán; his tables [were] covered with carpets of silk;
his cupboards adorned with several sorts of China cups and dishes."[9] Colonial house-
holds across the economic spectrum, and in the remotest areas of the viceroyalties, as-
pired to own Asian goods. In 1639 the Mexican painter Luis Juárez left to his heirs "eight
pillows of worked [embroidered] velvet from China."[10] Even lower-class families may
have had one or two pieces of lesser-quality porcelain, or articles of clothing made from
Chinese silk or printed cotton from India.

These imported status objects were displayed chiefly in two areas of colonial Latin
American homes: the *estrado* area of the salon, and the master bedrooms. The salon,
a long room usually located on the second floor next to the main balcony of the house,
served purposes similar to those of the Anglo-American drawing room.[11] At one end of
the salon was the estrado, an elevated dais area covered with elegant carpets, cushions,

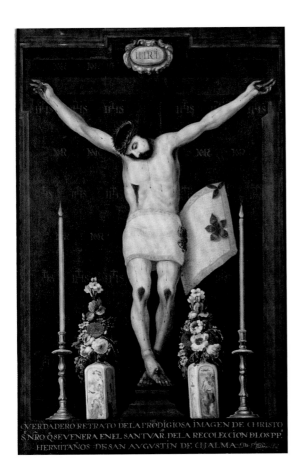

31. Pedro Calderón
(active early 18th cen-
tury). *Christ of Chalma*,
Mexico, about 1750. Oil
on canvas, 251 x 197 cm
(98⅞ x 77½ in.)

32. Unknown artist,
Our Lady of Bethlehem,
Cuzco, Peru, 18th
century. Oil on canvas,
154.9 x 101 cm (61 x
39¾ in.)

and small seating stools that was generally reserved for women. It was often furnished with low tables, small chests that held valuables or sewing materials, a brazier for warmth, and a folding screen (Asian or Asian-inspired) to retain heat from the brazier, block drafts, and provide privacy as well as decoration. A large estrado in the home of Francisco de Berroterán, Marquis of the Valle of Santiago and Governor of Caracas in the late seventeenth century, was furnished with twenty-four red velvet cushions with gold trim and two large cushions of red silk embroidered with gold and silk thread "from China," a damask drapery "from China" with gold trim, and several carpets.[12] Women drank chocolate, often from Chinese porcelain cups, and smoked cigarettes or dipped snuff while they visited in the estrado area. Preserving a Spanish Muslim custom of sitting on or near the floor, the estrado tradition seems to have been perpetuated in Spain and the Americas through the seventeenth and early eighteenth centuries to accommodate the elaborate hoop skirts that made it nearly impossible to sit in chairs that had arms or backs. Low settees or chairs were added to the setting in the later eighteenth century, when dress fashions changed. The estrado was not exclusive to upper-class homes; some version of it appears in middle- and lower-class homes as well, and even in convents.[13]

The salon often featured fine writing chests on stands, along with sideboards or cabinets furnished with a variety of high-end and imported decorative arts. Such

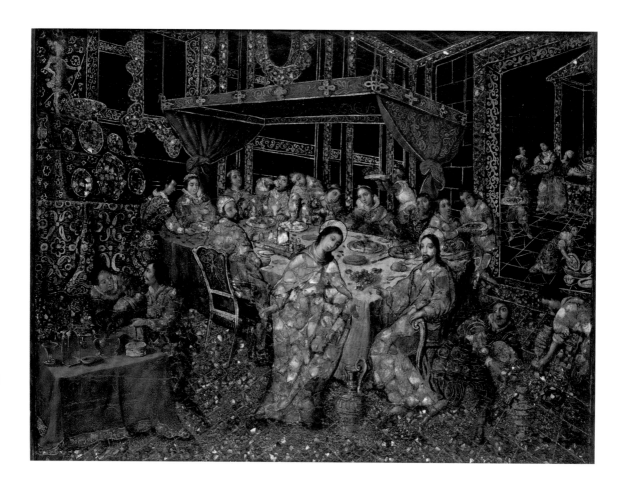

displays testified to a family's wealth and taste. Ostentatious arrangements of objects of silver, gold, crystal, lacquerware, porcelain, or majolica appear in colonial paintings, such as a 1693 depiction of the wedding at Cana set in a contemporary interior (fig. 33).

Separate dining rooms remained uncommon in the colonial era; instead, tables for meals were set up temporarily in various rooms depending on the occasion and the climate.[14] For formal occasions diners gathered in the salon; for less formal occasions, the table was set in the kitchen or in an outdoor portal or garden. The estrado area or the bedrooms could also be settings for meals. In 1640 one of the rooms at the Castle of Chapultepec in Mexico City was prepared temporarily as a dining room to receive the new viceroy, the Marquis of Villena, with the table "covered with a gauze tablecloth embroidered in gold, and set with the finest chinaware," and "two exquisite Chinese screens" set up to shield the accompanying musicians from view.[15]

Master bedrooms were the other favored location for imported Asian arts. In upper-class households the husband and wife each had his or her own chamber, whose beds were sometimes canopied with luxurious silks from China, or ornamented with lacquered headboards made in China or in imitation of Chinese examples. A Mexican household in 1650 owned "a bed of West Indian ebony with bronze fittings, three coverlets, and a Chinese orange canopy."[16] Such beds were not restricted to houses in the urban centers of Latin America; one appears in the bedroom of the wife of the governor of New Mexico, on the far northern frontier of New Spain, in 1662, furnished with "a

33. Nicolás Correa (born about 1670/75). *Miracle of the Wedding at Cana*, Mexico City, 1693. Mixed media with encrusted mother-of-pearl on panel, 58 x 75.5 cm (22⅞ x 29¾ in.)

bedspread from China of embroidered yellow silk" and a "canopy of silk from China."[17] Examples of elaborate eighteenth-century painted and lacquered headboards can be seen in paintings of the era, and the objects themselves survive in many areas, in particular in Mexico, Venezuela, and Ecuador (figs. 7 and 73).[18] *Biombos*, Asian-style folding screens, were common bedroom furniture, to provide extra privacy and to block drafts. In wealthier homes these were often imports from China or Japan; in more modest homes they were made locally in imitation of Asian examples. Carpets completed the bedroom ensemble—some locally produced, some made in Spain, and others imported from China, Turkey, or Egypt.

Along with the influx of imported goods, people from many parts of Asia also found their way to the Americas. Regardless of their origins or ethnicity, in Latin America they were generically referred to as *chinos* (Chinese) and were officially categorized as *indios*, affording them some of the same legal protections and privileges as Indians.[19] Some chinos, mostly men, chose to go to Mexico to make their fortunes, such as the Japanese merchants who settled temporarily in Mexico City and others who settled permanently in Guadalajara in the early seventeenth century.[20] A few galleon mariners, primarily from the Philippines, also may have settled in the New World.[21] Skilled carpenters could have found employment in Mexico as shipwrights, builders, or cabinetmakers.

Many more chinos arrived in Mexico involuntarily, as slaves packed aboard the galleons alongside other valuable commodities such as porcelain, silks, cottons, and spices, sent by their merchant owners on consignment for sale in Acapulco or Mexico City. Others were brought by traders to fulfill special orders by wealthy individuals, who often preferred Asian slaves as domestic servants. Records indicate Asian slaves entered the urban rather than rural economy of New Spain, with large numbers of chinos put to work in the *obrajes*, or textile factories, of New Spain, particularly in Mexico City, Puebla, and Querétaro. The work was grueling, but they benefited from their status as "indios" due to regular government inspections to prevent abuses against Indians.[22] Slave deeds indicate that chinos were especially numerous at obrajes that produced hats.

Some Asian slaves were owned by artisans, who likely trained them in various crafts although chinos were often prohibited by the guilds from working in craftsmen's shops.[23] For example, Asians may have contributed to Mexico's flourishing ceramic industries, particularly in Puebla. In 1662 Domingo del Rosario, either a *chino esclavo* (Chinese slave) or the son of a Chinese slave, was apprenticed to the Puebla potter Juan Gómez de Villegas.[24] The Puebla potter José de Escoto also owned two Chinese slaves, called Alejo and Gaspar, who may have labored in his pottery workshop in the late sixteenth century.[25]

Both enslaved and free Asians were employed as blacksmiths, carpenters, seamstresses, tailors, weavers, yarn spinners, barbers, goldsmiths and sword makers. They also sold textiles, including ribbons and clothes from China, on the streets of Mexico City and other urban centers. Others worked in stalls or shops, selling a variety of goods. Many of them probably arrived as slaves and then leveraged their skills to gain freedom and social standing. By the middle of the seventeenth century, it was common for Spaniards to manumit Asian slaves in their wills or for slaves to self-purchase their freedom. In 1672, slavery of Asians was prohibited by law.

Migrants from Asia to other areas of Latin America took a similar path, with some arriving as slaves or forced laborers, for instance those employed in the mines at Minas Gerais, Brazil, and others coming voluntarily as merchants or craftsmen. The Indo-Portuguese painter Jacinto Ribeiro immigrated from Goa to Brazil in 1720, and the

Sino-Filipino sculptor Esteban Sampzon lived in Argentina, where he worked in Buenos Aires and Córdova between 1780 and 1805.[26] Japanese migrants to the coasts of Peru and to Lima in the early seventeenth century seem to have come via the Philippines; some may have been slaves under the Portuguese, but became free in the Americas.[27]

The presence of Asian artisans may have contributed to the development of indigenous arts in the Americas, but the flood of objects that arrived aboard the Manila galleons undoubtedly had the greatest effect. The influx of porcelains into all areas of Latin America inspired many households to obtain at least one example. Even the humblest might have a piece or two of inferior quality, as shown in some *casta* paintings. Wealthy families accumulated huge collections, some commissioned with decorations of their titular coats of arms. On his death in 1779, the Viceroy of Mexico Antonio María de Bucareli y Ursúa had at least 1,117 pieces of fine Chinese porcelain in his possession.[28] In 1784 the Count and Countess of Xala in Mexico City owned hundreds of pieces of fine Chinese (and some Japanese) porcelain, much of it gilded, including numerous paired vases more than three feet high, as well as forty large jars of various colors and sizes.[29] They also had a ninety-piece coffee service, and soup tureens and vases in the shape of various animals. Porcelain did not appeal only to Europeans in America: as early as 1604, a native chieftain named Tonati purchased a set of Chinese dishes for his personal use. They were offloaded at the small port of San Blas (the first occupied stop of the Manila galleons on their way to Acapulco) and then transported to his home on the Nayar Mesa in a remote area of northwest Mexico.[30]

Chinese porcelain became the vessel of choice for consuming chocolate, a New World product, as a beverage. Chocolate drinking spread rapidly among Spaniards in the sixteenth century and then across Europe in the seventeenth century. Women appear to have been the main consumers, in both the kitchens of the Americas and the parlors of Europe. The beverage was drunk from handleless Chinese teacups, as well as from majolica cups made in imitation of them, coconut cups set in silver, and lacquered gourd cups known as *jícaras*. Monasteries and convents were not immune to the combined pleasures of porcelain and chocolate: when Mother Catalina de San Juan died in 1692 in the Conceptionist convent of Santa Inez in Mexico City, she had in her personal possession a small leather chest for storing chocolate, three saucers of Chinese porcelain, and twelve small and large cups of Chinese porcelain, along with four coconut shells mounted with silver feet, a small pitcher of Chinese porcelain, and two painted and lacquered gourd jícaras from Michoacán.[31]

Such fragile porcelain vessels made their way to every corner of colonial Latin America, including Mexico, Guatemala, Peru, Ecuador, Panama, Florida, Old Mobile (Alabama), New Orleans, New Mexico, Arizona, and California.[32] Many of these were of very fine quality, and one of this type clearly inspired the production of a majolica jar from Puebla (fig. 34). As early as 1601, Chinese porcelain had reached Ecuador, having arrived either overland from Lima or Cartagena or via the Ecuadorian port of Guayaquil.[33] Porcelains even arrived in New Mexico—one of the most remote and inaccessible areas of the Spanish territories, more than a thousand miles north of Mexico City and reached only by overland travel—shortly after its settlement in 1598.[34] Throughout the colonial period, Chinese porcelain continued to be found in private households in New Mexico, mostly in the form of plates and chocolate cups.[35]

The desirability of porcelain in the Americas led to the local production of imitation vessels of majolica earthenware. *Mayólica* pottery, covered with a hard, shiny glaze made from lead and tin, had been invented in the Middle East and introduced along with

34. Jar with floral pattern,
Puebla de los Ángeles,
Mexico, early 18th
century. Tin-glazed
earthenware, 49 x 35 cm
(19¼ x 13¾ in.)

35. Jar (tibor), Puebla
de los Ángeles, Mexico,
about 1700. Tin-glazed
earthenware, 30 x 27
x 27 cm (11¾ x 10⅝ x
10⅝ in.)

the potter's wheel to Spain by Muslims in the eighth century. In turn, Spanish ceramic artists brought majolica production to the Americas in the sixteenth century; thriving industries developed in Mexico City and Puebla, and in Lima and Cuzco in Peru.[36] Pigments embedded in the glaze enabled potters to create colorful decorations on their vessels. The most popular type beginning in the 1600s was blue-and-white majolica that imitated Chinese porcelain, particularly that made in the ceramic factories of Puebla.[37] Local majolica artists adopted and adapted Asian motifs into their own work, creating a delightful hybrid style. For example, on Asian vases birds are depicted flying with outstretched wings or perched with folded wings; on some Pueblan vases, the bird is perched but spreads its wings. The Mexican artist who decorated one vase converted the Asian tree branch into a Mexican nopal cactus, reminiscent of the Aztec symbol of Mexico—an eagle with spread wings perched on a cactus and holding a snake in its mouth (fig. 35). Mexican artists adopted Chinese motifs of people strolling in landscapes, but they filled in the serene space of Asian examples with dense, random vegetation that dwarfs the figures.

In the same colonial houses where porcelain and pottery were displayed, the most ubiquitous form of furniture was the chest: large or small, elaborately decorated or plain, with interior drawers or not, portable or mounted on stands, with drop-front lids for writing and high arched tops for extra storage. All of these types were made locally in Latin America, but the most prized examples were imported from Germany, Holland, Spain, Italy, or Asia. A chest in a Mexican household in 1688 was described as "a little Chinese lacquer trunk, of half a *vara*, with its lock and key," and similar objects

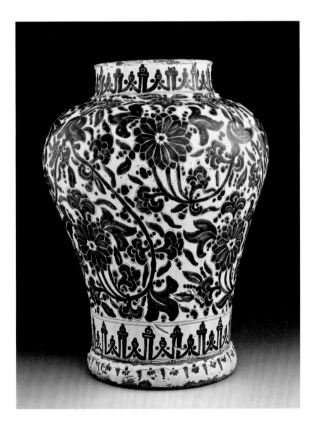

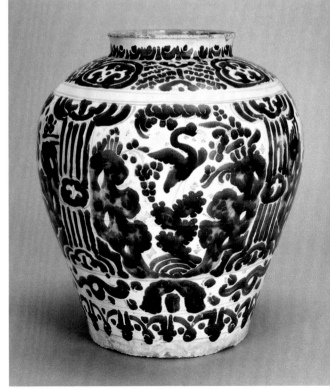

34. Jar with floral pattern, Puebla de los Ángeles, Mexico, early 18th century. Tin-glazed earthenware, 49 x 35 cm (19¼ x 13¾ in.)

35. Jar (tibor), Puebla de los Ángeles, Mexico, about 1700. Tin-glazed earthenware, 30 x 27 x 27 cm (11¾ x 10⅝ x 10⅝ in.)

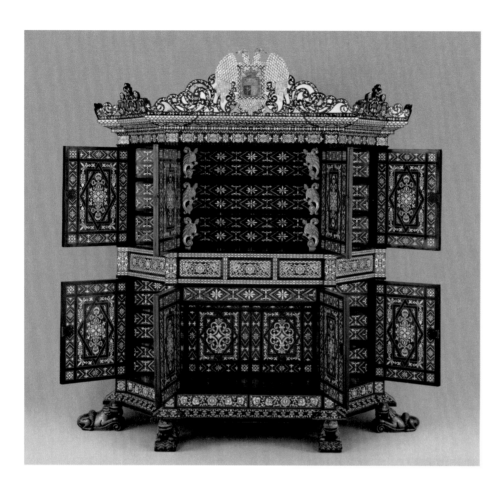

recorded through the eighteenth century as "from China" could also have been made in Korea, Japan, or Gujarat in India.[38] Some of the most highly valued items of furniture from Asia were those polychromed and finished with a lacquered surface, using a technique purported to have been invented in China but expanded and perfected in Japan (see, for example, figs. 10 and 57).[39] Forms of lacquerware had been produced in Latin America before the conquest; during the colonial era, silver and gold leaf were added to the process as makers absorbed influences from Asian wares and other decorative arts.[40]

Another type of furniture imported from Asia was decorated with inlay, including Japanese examples inlaid with mother-of-pearl on a black lacquer ground as well as tortoiseshell and mother-of-pearl pieces from Goa and Gujarat. Spanish-Moorish traditions of inlaid and marquetry furniture merged with Asian examples in the hands of Latin American craftsmen, who created exquisite and distinctive inlay work in a variety of woods, ivory, bone, silver, tortoiseshell, and mother-of-pearl (fig. 36).[41] These pieces were produced in regions throughout the colonies, including Puebla, Campeche, and Durango in Mexico; Lima in Peru; Quito in Ecuador; Bogotá in Colombia; Caracas and Cumaná in Venezuela; and Guatemala and Paraguay.

One exceptional artistic technique invented in the Americas merges inlay and lacquer decoration from furniture and combines both with European oil painting traditions to produce the truly multicultural and distinctively Mexican genre of *enconchado* (shell

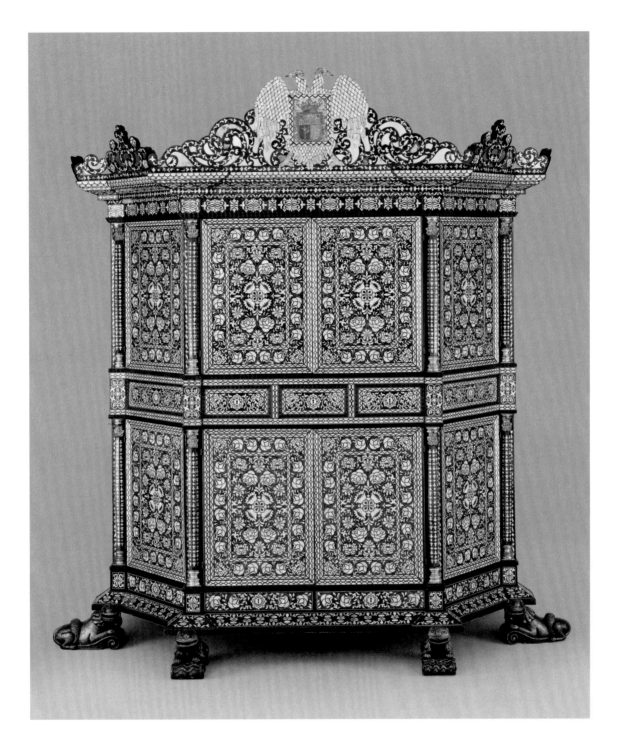

36. Cabinet, Lima,
Peru, 1680–1700.
Mahogany, mother-of-
pearl, ivory, tortoise-
shell, Spanish cedar,
259.1 x 227.3 x 66 cm
(102 x 89½ x 26 in.)

37. Juan González (active late 17th century–early 18th century). *Saint Francis Xavier Embarking for Asia*, Mexico City, 1703. Oil on wood inlaid with mother-of-pearl, 113 x 91.8 cm (44½ x 36⅛ in.)

64

inlay) painting.⁴² Inspired by Japanese export lacquer, it first developed in the late seventeenth century. Wooden panel paintings and frames are inset with pieces of mother-of-pearl and then painted with thin layers of glaze oil paints, creating an art form unique to colonial Mexico. Enconchado paintings often feature elaborately inlaid and painted frames that depict flowers and birds drawn specifically from Japanese lacquerware.⁴³ Frequently used to relate the stories of the life of Christ or the Virgin in multiple panels, or assembled into screens that depict the conquest of Mexico in elaborate detail, enconchados represent a spectacular New World response to the global world of the early modern era.

One outstanding example of enconchado portrays the celebrated early sixteenth-century missionary Saint Francis Xavier examining a map of Asia before his departure for that continent (fig. 37). Although he never set foot in America, Francis Xavier was celebrated in numerous statues and paintings in Mexico during the viceregal period for his missionary work in Japan. The painting was completed in Mexico City by the artist Juan González in 1703 for Ana Rodríguez de Madrid, sister of the first marquis of Villamediana and daughter of Pascual Rodríguez de Mediavilla y Rodríguez del Corral,

who had arrived in New Spain some thirty years earlier.[44] The main figures in this composition are treated in shell, as are the flowers and the wings of the cherubs who frame the central inscription. The frame itself has a decoration of birds and foliage reminiscent of Japanese *raden* lacquerwork.[45] The painting was also clearly inspired by a European print from about 1630 of the same subject by the Dutch artist Cornelis Bloemaert II, making it a truly global artifact in its conception and fabrication.

Probably the type of object brought from Asia that most represents cultural exchange was the folding screen, or biombo. Used in homes to divide spaces, block drafts, provide privacy, and create a theatrical backdrop for entertaining, they were introduced to the Western world through the early modern global trade. Although folding screens probably had arrived in Latin America before 1614, through Portuguese and Spanish traders or Jesuit missionaries, the first officially documented examples arrived in Mexico in that year as gifts to the viceroy from the Japanese embassy of Hasekura Rokuemon Tsunenaga (fig. 38). Most Asian screens were made either of polychromed and lacquered wood or of watercolors on paper mounted on wooden stretchers. Their elaborate decorations often included gold. A 1726 Spanish dictionary describes the biombo as a "treasure that came to us from China or Japan, and from there comes the word."[46]

38. *Hasekura Rokuemon Tsunenaga (1571–1622),* Italy, 1615. Oil on canvas, 196 x 146 cm (77⅛ x 57½ in.)

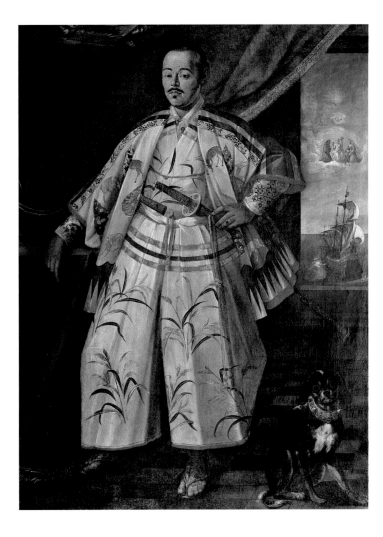

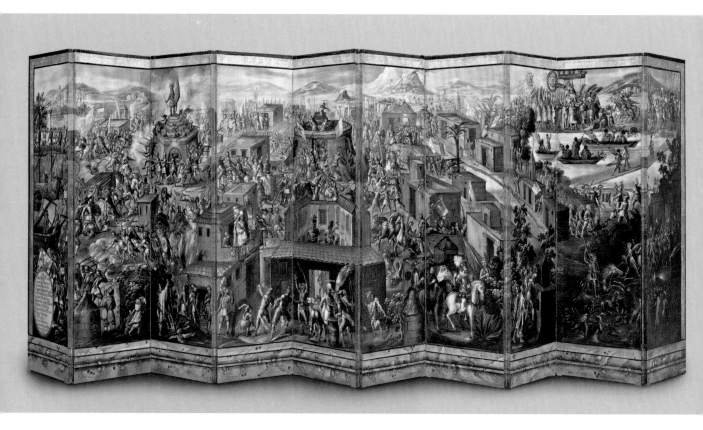

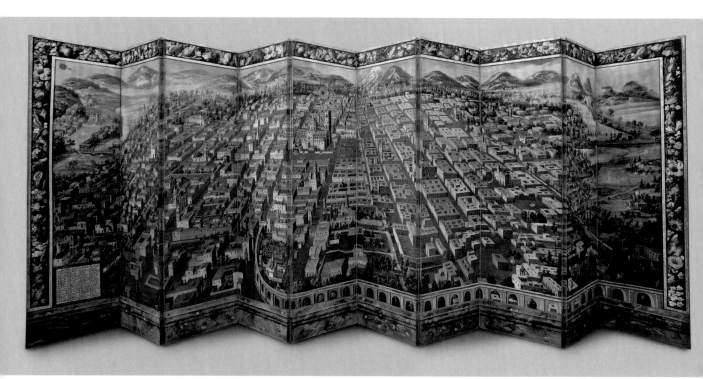

39. Biombo with
scenes of the conquest
of Mexico (front) and
view of Mexico City
(back), Mexico City,
late 17th century. Oil
on canvas, 2.1 x 5.5 m
(about 7 x 18 ft.)

Sometime in the early seventeenth century, local artists in Latin America began making their own imitations of Asian screens, using local lacquer or enconchado techniques on wood, or oil-on-canvas paintings or fabrics over stretchers. Two types of screens evolved, a short form for the estrado known as a *rodaestrado*, and a slightly taller one for the bedroom, usually comprising eight to ten panels. Both are referred to as "biombos" in household inventories; for instance, the Counts of Xala had "four lacquer biombos from China" in addition to three rodaestrados, two of damask and one of red Chinese fabric.[47] The same owners also had eight painted screens, two of them described as having "achinado" (Chinese-like or chinoiserie) figures on a vermilion ground, indicating they were not Asian, but rather imitation screens made in Europe or Mexico, possibly Mexican lacquerwork.

Painters in Mexico—including some of the best known, such as Juan Correa and Miguel Cabrera—merged the style of the Asian prototypes with traditional European painting styles and techniques to produce oil-on-canvas folding screens depicting subjects popular in New Spain, such as the conquest of Mexico, the encounter of Cortés and Moctezuma, the Four Continents, and the entrance of the viceroy, as well as city views, along with emblematic and allegorical scenes.[48] One example features a bird's-eye view of Mexico City on one side, related to the Kyoto screens imported on the galleons, and a scene of the Conquest on the reverse (fig. 39). Folding screens seem to have been made locally in other areas of Latin America as well.[49]

Like porcelain, biombos were not found only in upper-class or urban households.[50] The Mexican painter Miguel Cabrera owned five screens when he died in 1768, including a rodaestrado of only three panels with gilded trim valued at an exceptionally high 100 pesos, suggesting that it was an imported example, possibly an Asian table screen, always short and often containing only three panels.[51] Another of the recorded screens is actually the makings for a biombo, which Cabrera likely was preparing to paint.

The luxury material of ivory was another Asian import that found a home in the Americas. In addition to its use as inlay and decorative trim on furniture, ivory was also traded in the form of carved sculptures.[52] Via the Portuguese route, carvings came from China, Ceylon, India, and Goa; via the Spanish route, they arrived from China and the Philippines, where a large group of Chinese craftsmen (known as *sangleys*) had settled outside the city walls of Manila. At the end of the sixteenth century, the Bishop of Manila, Fray Domingo de Salazar, wrote: "Churches are beginning to be furnished with the images the sangleys made, and which we lacked before."[53] One of the most prominent ecclesiastical uses of Asian-made ivories was the very large choir stall lectern in the Cathedral of Mexico made of ebony and other exotic woods and originally adorned with twelve large ivory carvings of saints, installed in 1770.[54] An earlier example was in the church of Santa Clara in Mexico City, where in 1692 a confraternity of *chinos* commissioned a side altar screen with images of Christ made from ivory.[55]

Carved ivory figures of Christ, as a child or on the cross, seem to have been the most common ivory item imported to the Americas from Asia. They made their way to many remote areas of the empire, appearing in domestic as well as religious settings.[56] In the elegant home of the Count of Xala in Mexico City, an ivory Christ on an ebony cross with silver tips hung over the estrado and was framed by a baldachin of damask. The family also had a series of six landscapes carved in relief in ivory and two spectacular "towers" more than a *vara* in height of ivory carved in "filigree." But most impressive of all must have been the large ivory figure of Saint Michael, complete with helmet and sword of worked silver, that occupied a niche on the landing of the main

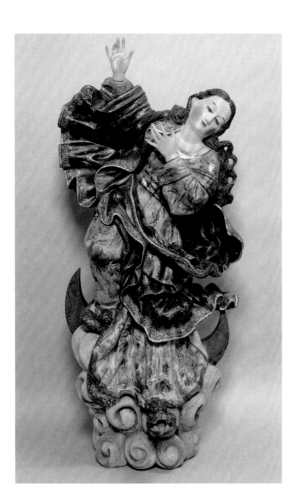

68

staircase. Not all ivory objects were as monumental, nor were they necessarily religious. Smaller items found in New Mexico include ivory beads, turned finials, a cane handle, and combs.[57] These secular objects may have been imported from Asia readymade or carved in Mexico from the imported raw material.

In some areas of Latin America, such as Guatemala, imported ivory was carved locally into small-scale sculptures of saints to which were added wooden faces and hands.[58] In the reverse combination, hands and faces for saints were carved from ivory in Asia and shipped to the Americas; or hands, and faces with non-Asian features, were sometimes made from raw ivory in the Americas. These ivory components were applied to wooden bodies or dressed armatures. In Ecuador, Asian ivories seem to have influenced both the scale and the palette of exquisite, small-scale wooden polychrome sculptures. Bernardo de Legarda (1700–1773), the best-known sculptor from Quito, owned four Asian ivories, including an image of the Immaculate Conception.[59] Carved of wood or molded from lead, the delicate faces of these figures were varnished with an unusually white pallor, in imitation of ivories. The clothing of the figures was polychromed "a la chinesco" with Asian textile motifs (fig. 40). Also in Ecuador, a new craft was invented, in which artisans (in some cases, nuns in convents) split balls of ivory in half and sculpted them in relief with elaborate nativities or other scenes of the lives of Mary and Christ.[60] In Peru and Mexico, carving in alabaster, a tradition from the precolonial era, was influenced by Asian ivories

with some carvings of the Christ Child as a shepherd remarkably similar to images of the young Buddha and some alabaster Virgins imitating the sway or curve of Asian ivories.

In Latin America, status was often defined as much by behavior and appearance as by actual nobility or race. Markers of status went beyond household furnishings to include dress and accessories. In spite of repeatedly enacted sumptuary laws, people from every class aspired to appear wealthy by wearing clothing made of imported Asian materials. As early as 1594, the Viceroy of Peru, the Marqués de Cañete, observed that "Chinese silk and other textiles were so cheap that Indian caciques and even commoners were using them for clothing instead of cloth of local manufacture."[61] A later source in Mexico reported that "all classes, from Indians of the torrid Lowlands . . . to the pampered Creoles of the capitol, went dressed in fabrics of the Far East, the cottons of Luzon or India or the silks of China."[62] Portraits confirm this phenomenon, often depicting both men and women clothed apparently in Chinese silks, such as the elegant red dress worn by a Mexican woman posed in front of a harpsichord (fig. 41). Even nuns outfitted for their ceremony of profession sometimes are depicted wearing capes made of what appear to be Chinese silks (fig. 42).

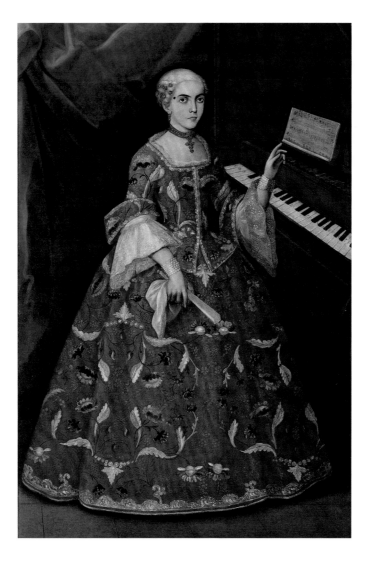

41. Unknown artist, *Young Woman with a Harpsichord*, Mexico, early 18th century. Oil on canvas, 156.5 x 102.5 cm (61⅝ x 40⅜ in.)

42. José de Alcíbar
(active 1751–1803).
*Sor María Ignacio de la
Sangre de Cristo*, Mexico,
about 1777. Oil on canvas,
180 x 109.2 cm (70⅞ x
43 in.)

The 1736 manifest of a galleon heading from the Philippines to Spain via Mexico gives an idea of the types of textiles available through the trade: brocades and silks interwoven with gold and silver threads, cottons and muslins from India, Japanese kimonos, silks and other fabrics for interiors and upholstery, mohair, taffetas, glossy silks, embroidered velvets, damasks, and satins.[63] Fabrics such as these made it to many areas of Latin America, including the northern frontier of New Spain, present-day New Mexico. Even a relatively humble *mestizo* blacksmith from Taos left to his only daughter in 1748 "10 *varas* of red Chinese silk bolt cloth" and "6 *varas* of ribbon from China woven with gold and silver."[64] A 1762 will from Santa Fe mentions "one fine kimono" (*quimono fino*).[65] This term appears in other records in New Mexico, as well as in Mexico City, but it is unclear whether it refers to actual kimonos imported from Japan or imitations made locally.[66]

Painted or printed cotton and muslin fabrics with large floral motifs imported from India, and imitations of it made in the workshops of Europe and Latin America, were known collectively by the term *indianilla*. The material was a common fabric for women's skirts and men's housecoats throughout the colonial era, as seen in a few surviving examples and in *casta* paintings (fig. 43; see fig. 19). For instance, the inventory of a mercantile store in downtown Santa Fe in 1815 lists bolts of wide and narrow indianilla cloth.[67] This reference is followed by "19 *varas* of the same from Barcelona," indicating that the printed calico from Barcelona, which began to be exported legally to Mexico after 1789, had reached New Mexico, although it commanded a lower price than the East Indian version.[68]

Asian textiles also appeared in religious vestments and in altar frontals and canopies. Some articles were embroidered in Asia for export to Latin America, sometimes as specific commissions. Others were made in the colonies: embroiderers had emigrated from Spain early on, establishing a guild in Mexico by 1546, and later nuns became famous for their needlework. White silk bolt cloth imported from Canton often served as the base for elaborate working with multicolored silk threads, also imported from Asia.[69]

Besides creating clothing from imported Asian fabrics, Latin Americans used them in upholstery, curtains, bedding, cushions, pillows, valances, bed canopies, and numerous other domestic objects. Even carriages and sedan chairs in Latin America were sometimes upholstered with Chinese silks.[70] Asian fabrics also appear as wall coverings, as in an entire room at Chapultepec Castle in Mexico City that was decorated in 1640 with "Mandarin damask."[71] Chinese hand-painted wallpaper was brought to the Americas and used to decorate upper-class dwellings.[72]

Asian fabrics also influenced local textile production in family or cottage industries as well as in the larger factories in Latin America—such as those in Puebla, Campeche, and Querétaro in Mexico; in Quito, Ecuador; in Calera de Tango near Santiago in Chile; and in Lima and Cuzco, Peru.[73] Tapestries produced in colonial Peru combine a sophisticated indig-

43. Miguel Cabrera (1695–1768). *De negro y de india, china cambuja* (From Black and Indian, *China cambuja*), Mexico City, 1763. Oil on canvas, 134 x 103 cm (52¾ x 40½ in.)

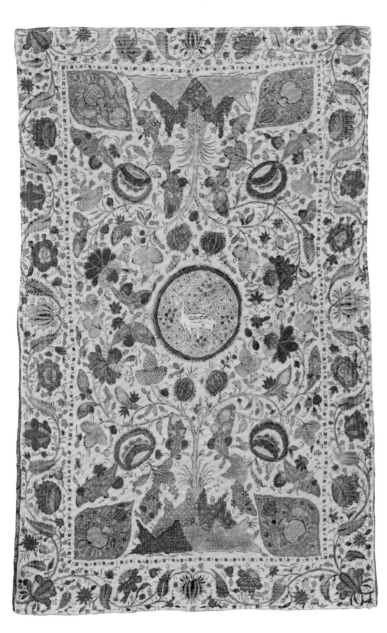

44. Bedcover
(palampore), India,
17th or 18th century.
Plain-weave cotton,
painted or printed with
mordants and dyed
with natural pigments,
221.9 x 143 cm (87⅜ x
56¼ in.)

enous tradition of tapestry weaving with strong inspiration from Asian fabrics (see fig.
11).[74] Many individual works of textile art display Asian influence in their design, such as
an embroidered Mexican bedcover that makes obvious reference to its Indian *palampore*
counterpart (figs. 44 and 45). These fabrics influenced other forms of decorative arts,
perhaps best illustrated in Mexico by the sculptural arts in the Bajío region, where the
flat, elegant patterning of carved and gilded altar screens and church decorations echoes
the distinctive Asian-inspired textiles produced in the factories of Querétaro in the eigh-
teenth century.

 One further ubiquitous accessory to a colonial woman's dress also provided an
opportunity to advertise her social standing and taste: her fan. Examples imported from
Asia were the most prized; one of the ladies-in-waiting to the vicereine in Mexico in 1691
owned sixty fans from Spain and China.[75] The most unusual of the fans produced locally

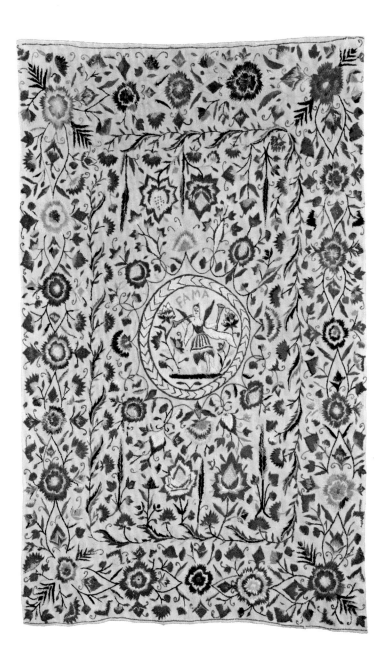

45. Bedcover, Mexico, about 1775. Wool crewel-work embroidery on cotton, 234.9 x 148.6 cm (92½ x 58½ in.)

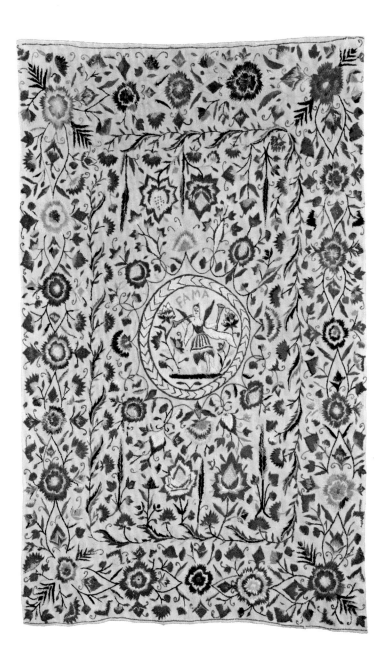

in Latin America were made of bird feathers, applying a long pre-Columbian tradition of feather arts to the Asian folding fan form.[76]

IN AN ERA OF GLOBAL TRADE, residents of even remote areas of the Americas, across most economic and social classes, encountered imported Asian goods and aspired to acquire them to display social status as well as sophisticated tastes. The written records they left behind, with their careful recording of these materials' sources, indicate the value they placed on owning foreign objects. Pictorial sources confirm that Asian arts were present in domestic and religious life across the region. Artists in the Americas responded to these influences by combining borrowed Asian elements with indigenous techniques and European traditions to create original and multicultural art forms unique to the New World that reflect the global spirit of the era.

74

Within the coat of arms:
DESPVES
DE DIOS
LA CASA DE VIROS

THE LACQUER ARTS
of Latin America

MITCHELL CODDING

AMONG THE Latin American decorative arts influenced by the arts of Asia during the colonial era, the indigenous lacquer traditions of Mexico and the Andes were the most profoundly affected. As demand exceeded supply for the exotic and expensive Asian lacquerware brought to Acapulco on the Manila galleons, artisans in Mexico and Colombia began to apply their skills to the production of lacquerware for the Spanish market. It is most likely Catholic missionaries who were originally responsible for encouraging the lacquer makers to adapt their ancient techniques to new forms, as well as providing them with the European prints, drawings, and illuminated manuscripts that served as models for the pictorial decoration found on the earliest known examples. Beginning in the second half of the seventeenth century, and through the eighteenth century, Asian and indigenous motifs were incorporated into the decoration of the colonial lacquerware. This practice resulted in lacquerware of enormous diversity that combined indigenous, European, and Asian decorations and forms. Inspired by the challenge of creating lacquerware whose appearance and quality were comparable to those of Asian lacquerware, indigenous artisans produced works of amazing complexity in both technique and iconography. In the seventeenth and

eighteenth centuries virtually all Asian lacquer decoration techniques were copied or simulated by makers in Mexico, Colombia, and Ecuador, including inlay, carving, and the use of gold and silver flakes and foils, in addition to the imitative technique of japanning. Consequently, the finest colonial lacquerware became as highly prized in Europe and America as the best imported Asian wares. Colonial lacquers were sent by viceregal officials as gifts for the secular and ecclesiastical aristocracy of Europe and were treasured decorative objects in the churches and noble palaces of the viceroyalties.

In a treatise on current and historical events in the Philippines published in Mexico City in 1609, some forty years after the beginning of the galleon trade, Antonio de Morga detailed the vast array of goods produced throughout Asia that were sent to Manila by merchants from Guangzhou, Zhangzhou, Fuzhou, Nagasaki, the Maluku Islands, Malacca, India, Borneo, Thailand, and Cambodia for shipment to Acapulco. Among them were lacquer objects from Japan, which included "small writing desks, chests, and small boxes of woods, with varnishes and curious decorations."[1] In the first half of the seventeenth century, the limited supply of such highly prized Asian lacquerware prompted the creation of a new Spanish colonial lacquer tradition.

The lacquerware of Latin America, among the most original and exceptional decorative arts produced during the viceregal era, developed in the sixteenth and seventeenth centuries in two broad traditions. One arose in the viceroyalty of New Spain, centered in west-central Mexico in the present-day states of Michoacán and Guerrero; the other in the viceroyalty of Peru, encompassing the Andean region from the city of Pasto in southwest Colombia to Quito, Ecuador, and beyond into the highlands of Peru. Both traditions developed from pre-Columbian lacquer techniques that used organic materials endemic to the regions of production, distinct from East Asian lacquers that employed a resin obtained from the lacquer tree (*Toxicodendron vernicifluum*, formerly *Rhus verniciflua*). These unique American lacquer traditions, which combine indigenous materials and techniques, European forms, and designs borrowed from Europe, Asia, and pre-Hispanic America, serve as the ultimate expression of the merging of cultures that defines the arts of viceregal Latin America.

Mopa mopa, a translucent pale green natural resin, is the principal medium for the lacquerware generally referred to as *barniz de Pasto* (Pasto varnish), which has been produced in Colombia, Ecuador, and Peru from the viceregal period to the present day. Even though mopa mopa had been known to naturalists for several centuries, the botanical source of the resin was not identified until relatively recently.[2] The sticky elastic resin is obtained from the garbanzo-bean-sized leaf buds of the mopa mopa tree (*Elaeagia pastoensis* Mora), native to the tropical rain forests of the mountains of southwest Colombia near Mocoa, the capital of the Department of Putumayo. Its use by the pre-Hispanic peoples of Colombia has been confirmed by the discovery of beads made of mopa mopa in tombs belonging to the ancestors of the Pasto Indians that date back more than a thousand years.[3] The earliest references to the use of mopa mopa for decorating objects are associated with the village of Timaná, situated over one hundred miles northeast of Pasto. In 1582 the Augustinian friar Jerónimo de Escobar noted in his description of the province of Popayán that the indigenous people of Timaná made long staffs painted with a varnish in bright colors.[4] The Franciscan chronicler Pedro Simón, writing around 1626, confirmed that the inhabitants of Timaná, as well as of Mocoa, Quito, and other parts of Peru, produced staffs and tobacco boxes that were decorated with a resin of various colors obtained from the leaf buds of a tree in the region.[5]

46. Qero, Peru, 16th–
17th century. Wood with
mopa mopa inlays, 20.5
x 17.4 cm (8⅛ x 6⅞ in.)

During the colonial period the indigenous peoples of the Sibundoy Valley supplied the resin-covered leaf buds, pressed into blocks, to the lacquer artisans, who processed and colored the resin for application on a variety of decorative wooden objects. The transformation from raw mopa mopa into a decorative lacquer was a largely manual process, beginning with the removal of impurities such as leaves, bark, and other organic matter. Small amounts of the gummy resin were then chewed or boiled in water (or both) to make it sufficiently elastic to stretch into thin sheets, which also facilitated the removal of additional impurities. This process was repeated numerous times to achieve the most transparent lacquer. Once the material was purified, organic and mineral colorants were added through kneading or chewing. After the resin was heated again in boiling water, two artisans would stretch the highly elastic mopa mopa into extremely thin sheets by pulling it in opposing directions with their hands and teeth. The shapes for a decorative design then were cut from the center of the sheet, where the resin was thinnest, and applied with heat to a wooden object. Once the resin had cooled, the bond was permanent. The resulting lacquer provided an exceptionally durable, waterproof surface impervious to most organic solvents.

Two independent mopa mopa lacquer traditions developed: one in the Andean region of Peru, Ecuador, and Bolivia was associated primarily with Inka *qero* cups, wooden beakers made in pairs used for the ritual consumption of maize beer (*chicha*); the other, centered in Pasto and, to a lesser extent, in Quito, was characterized by European forms and motifs exhibiting a pronounced Asian influence. Early in the colonial era, qeros with colored mopa mopa inlays of traditional Inka animal and floral motifs began to supplant those with the linear incised designs typical of the Inka period. The pictorial style of

seventeenth- and eighteenth-century examples are distinguished by their elaborate figural designs based on Inka mythological and historical themes (fig. 46).[6]

Mopa mopa achieved its fullest artistic expression as a lacquer medium in the seventeenth and eighteenth centuries in the hands of the *barnizadores*, the indigenous or mestizo lacquer artisans of Pasto and Quito. Both cities were closely aligned throughout most of the colonial period since Pasto fell under the jurisdiction of the Royal Audiencia of Quito, rather than the Royal Audiencia of New Granada, centered in Bogotá. An administrative subdivision of the Viceroyalty of Peru, the Royal Audiencia of Quito had political, military, and religious jurisdiction over an area that today comprises Ecuador and parts of southern Colombia, northern Peru, and northern Brazil. The earliest reference to the production of lacquer objects in Pasto appears in a history of the conquest of the New Kingdom of Granada that dates from around 1676 by the Colombian bishop Lucas Fernández de Piedrahita, who notes that by this time barniz de Pasto already enjoyed considerable fame in Europe. Throughout the eighteenth century various travelers made their way to Pasto, where they studied, described, and extolled the virtues of the prized lacquer. The naturalist-explorers Jorge Juan and Antonio de Ulloa, who visited in 1740, remarked that barniz de Pasto rivaled the best Asian lacquers in its colors' beauty, shine, and durability. Miguel de Santiesteban, who arrived at Pasto in December 1740 on his journey from Lima to Caracas, observed the barnizadores firsthand and provided the earliest detailed account of their techniques. Friar Juan de Santa Gertrudis, who visited Pasto in 1761–62, also described the process, adding that the lacquered plates, chargers, bowls, basins, and cups were as lustrous as Chinese porcelain, for which they were easily mistaken.[7]

Alexander von Humboldt, the famous German naturalist, visited Pasto in 1801 and recorded in his diary a wealth of detail on the history, manufacture, and commerce of barniz de Pasto.[8] Of particular interest is his report that the barnizadores credited Catalina Petronila de Mora, who they claimed had held *encomiendas* in Timaná at the turn of the seventeenth century, with having established the industry in Pasto. Encomiendas were grants to individuals in reward for their services to the Crown that allowed the encomenderos to exact tribute and labor from specific indigenous populations, in exchange for protecting and instructing them in the Catholic faith. Other lacquer artisans told Humboldt that Catalina Petronila de Mora had learned the art from her Indian laborers and then perfected it in Pasto. It should be noted that Timaná was one of the earliest centers of lacquer production, but to date no historical documentation has been found to confirm the oral history of the barnizadores regarding Catalina Petronila de Mora and the origins of barniz de Pasto. Humboldt goes on to note that in 1801 there were eighty barnizadores, including several masters with four or five laborers, who used six hundred to eight hundred pounds of mopa mopa annually in the manufacture of lacquerware valued at 10,000 to 15,000 pesos, or reales, which had an equivalent value in United States dollars. He also provides the earliest identification of some of the lacquer's colorants: indigo dissolved in water for blue; pure indigo for black; annatto for red; indigo blue diluted with the powdered root of *Escobedia scabrifolia* (a saffron-like colorant) for green; *Escobedia scabrifolia* over silver leaf for gold; and lead oxide for white.

The lacquerware of Pasto is distinguished from the products of the indigenous tradition by the technique that came to be known as *barniz brillante*. This glowing metallic luster, achieved by combining silver or gold leaf with the transparent lacquer, created an effect similar to those of Asian lacquers that incorporated gold and silver powder or foil. The technique involved laminating pieces cut from sheets of mopa mopa resin over silver or gold leaf. The pieces were then applied to the object as independent design elements; as smaller pieces of a larger design, like marquetry; or stacked in multiple layers to create

designs in relief. Additional details, such as the veins of a leaf or flower, were incised in the lacquer. In some of the most complex early treatments, artisans used minute threads of black or white barniz to outline figures, add fine details, or create shading effects by cross-hatching (fig. 47).

During the colonial period barniz de Pasto was employed in the decoration of a wide variety of secular and religious wooden objects, including larger case pieces such as large fall-front desks, small portable desks, chests, domed coffers, bookstands, picture frames, gourd vases, trays, bowls, plates, nesting beakers, and cups. The early seventeenth-century examples incorporate floral, foliate, and hunting motifs that include dogs, horses, stags, and lions, along with mythological beasts such as unicorns, dragons, and snail-men. These early designs clearly derive from fifteenth- and sixteenth-century European sources, such as illuminated manuscripts, prints, and drawings, most likely supplied by Catholic missionaries, who also probably conceived the idea of adapting indigenous lacquer techniques to produce decorative objects that would compete with Asian lacquerware. Pieces produced from the last half of the seventeenth century through the eighteenth century exhibit an eclectic mix of motifs drawn from European, American, and Asian sources: the squirrel-and-grapevine motif common to sixteenth-century Chinese and Japanese decorative painting, as well as seventeenth-century lacquers from the Ryukyu Islands (Okinawa); peonies and carnations from Chinese porcelains and textiles; parrots, monkeys, jaguars, bears, armadillos, palm trees, passionflowers, and fruits native to Colombia; as well as the double-headed eagle of the Habsburg kings of Spain, horses, lions, griffins, pelicans, and baskets of fruit borrowed from European heraldry, mythology, and still-life paintings.

47. Coffer, Pasto, Colombia, about 1650. Wood with barniz de Pasto, and silver fittings, 19.2 x 27.2 x 13.6 cm (7½ x 10¾ x 5⅜ in.)

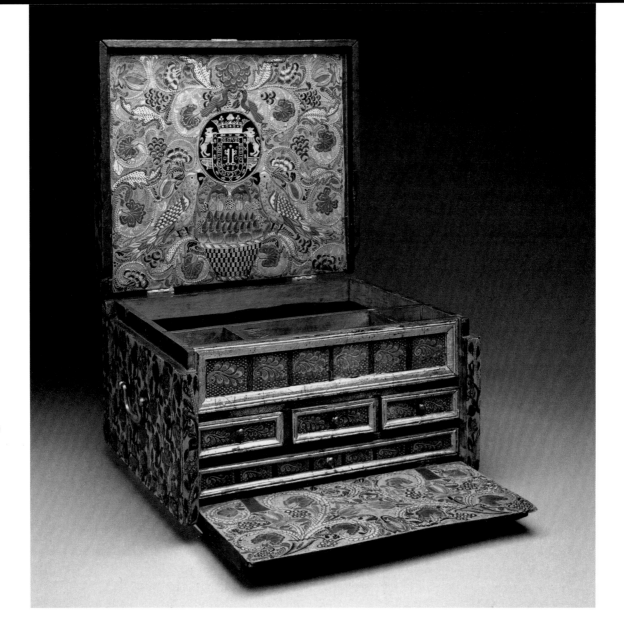

48. Portable writing desk,
Pasto, Colombia, about
1684. Wood with barniz
de Pasto, brass fittings,
and silver drawer pulls,
20 x 31 x 36 cm (7⅞ x 12¼
x 14⅛ in.)

49. Lid of writing desk

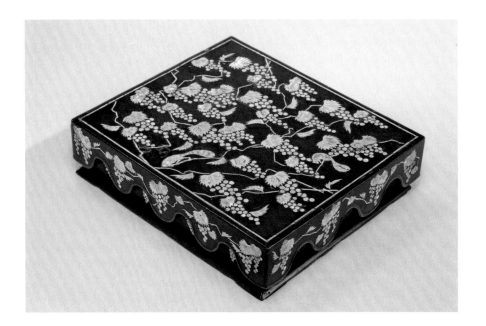

50. Nested boxes,
Ryukyu Islands, Japan,
17th century. Lacquer
with mother-of-pearl
inlay, outer box: 42.5
x 32.7 x 11.7 cm (16¾ x
12⅞ x 4⅝ in.)

All these influences can be found on a portable desk of about 1684, commissioned by the bishop of Popayán, Cristóbal Bernardo de Quirós (1618–1684), as a gift for his brother, Gabriel Bernardo de Quirós, secretary to Charles II, who had been granted the title of Marqués de Monreal on December 27, 1683 (fig. 48).[9] The exterior of this writing desk exemplifies the fusion of Asian and indigenous motifs, where the squirrel-and-grapevine motif has been reinterpreted with a local monkey-and-passion-flower vine motif (figs. 49 and 50). Even the form of the writing desk, with its subtly curved edges and slightly elevated fall-front, more closely resembles sixteenth-century namban lacquer cabinets from Japan than traditional Spanish models. The synthesis of these diverse artistic and cultural traditions is most notable on the interior of the lid, which displays the coat of arms of the Quirós family over a basket filled with tropical fruits, flanked by parrots, all set against a rich background of carnations, vines, leaves, and agraz berries.[10]

Mopa mopa lacquer was produced in Quito as early as 1625, though extant pieces and documents date the activity of barnizadores primarily to the eighteenth century.[11] The presence of workshops of barniz de Pasto in Quito is confirmed by a *vargueño* that bears the inscription "facto in Quito en 1709."[12] The similarities in design and motifs of the barniz created in Pasto with this dated vargueño, as well as other pieces in museums in Quito, suggest that barnizadores from Pasto were responsible for establishing workshops in Quito in the late seventeenth century that continued to produce wares until the nineteenth century.[13]

The second major lacquer tradition developed in Mexico. Early historical accounts refer to the local lacquerware as *pinturas* (paintings) or *barnices* (varnishes). The later terms *laca* (lacquer) and *maque* (from the Japanese word *maki-e*, for lacquers incorporating gold or silver) did not come into use until the eighteenth century, when the chinoiserie style, which emphasized gold in decoration, became popular. The essential ingredients for all the colonial Mexican lacquers were *aje* and chia oils, which were combined with powdered dolomite or other mineral clays to produce a thick liquid or soft paste. Organic and mineral colorants were added to the mixture, and this served as the lacquer medium that was applied to a variety of wooden objects and gourds. Aje oil was obtained from the females of a small sap-feeding insect (*Llaveia axin* or *Coccus axin*), cultivated for this purpose since pre-Hispanic times on acacias, piñon pines, and hog plum trees, among others.[14] Female insects were gathered during the rainy season of May and June and boiled in water until the waxy fat floated to the surface for collection. The boiled insects were then squeezed in a fine cloth to extract any remaining fat, which was purified by additional boiling and straining. Solid when cooled, the malodorous fat was wrapped in corn husks for storage.[15]

Chia oil was extracted from the seeds of a sage plant native to Mexico (*Salvia chian*), which the Aztecs cultivated as a major food crop as well as for its oil and medicinal uses. Oil from the seeds of the *chicalote*, or Mexican poppy (*Argemone mexicana*), which is toxic and mildly narcotic, was used interchangeably with chia oil in the preparation of the lacquer. To extract the oil, the seeds were first toasted and ground, then mixed with hot water to form a paste that was kneaded until drops of oil began to appear. The paste was wrapped in a fine cloth and squeezed to extrude the oil, which was strained for impurities and boiled to preserve it for storage.[16] When combined with aje oil, the chia or chicalote oil acted as a thinner and a drying agent, forming a hard lacquer surface that was impermeable to most liquids.

The discovery of well-preserved polychrome gourd vessels at archaeological sites in Chiapas, Coahuila, Yucatán, Morelos, and Puebla has firmly established the existence of a pre-Hispanic lacquer tradition in Mexico dating back more than two thousand years. Indigenous codices and histories, along with early Spanish chronicles, further detail the large-scale production of these "painted" gourd cups among the Mexica, Purépecha, and Maya.[17] In the famous *Florentine Codex* the Franciscan missionary Bernardino de Sahagún documented the use of aje in the decoration of gourds. Drawing on the accounts of native informants, he described the products sold in the great Aztec market of Tlatelolco as gourds with raised designs created by scraping and rubbing with aje oil (*axin*) and powdered pits of the sapote fruit, and then smoking.[18]

Artisans continued to produce painted and lacquered gourd cups and containers in central and southern Mexico throughout the colonial period, but it was not until the seventeenth century that they adapted the indigenous Mexican lacquer technique to decorative arts intended for the Spanish market. In the seventeenth and eighteenth cen-

turies the cities of Peribán, Uruapan, and Pátzcuaro in the modern state of Michoacán, and Olinalá in the state of Guerrero, became the principal centers of production. Each of these centers developed distinct styles and techniques that were employed in the making of a diverse array of decorative utilitarian objects.

Peribán, in western Michoacán, near the border with Jalisco, was home to the earliest workshops for lacquerware in Mexico. The Franciscan chronicler Alonso de la Rea, writing in 1639, credited the indigenous lacquer artisans with having invented in Michoacán the art that he called "Peribán painting."[19] He praised this lacquer not only for its beauty, but also for its durability and resistance to hot liquids. De la Rea went on to describe the technique, observing that a coating of the lacquer was first applied to the object and allowed to dry completely. "Figures, mysteries, or landscapes" were incised on the surface and the interior of the designs then were removed down to the wood with a steel point, or burin. Colored lacquers were applied one color at a time, filling in the excised areas of the designs. De la Rea reported that Peribán lacquer was used to decorate a variety of fine writing desks, boxes, chests, bowls (*bateas*), gourd bowls (*tecomates*) and cups (*jícaras*), and other curious objects.

The inlay, or *embutido,* technique first described by De la Rea, a technique of pre-Hispanic origins, characterized the lacquers of Peribán from the seventeenth into the early eighteenth century and those of Uruapan in the eighteenth century. The complex designs found on early Peribán lacquers were the result of a labor-intensive and

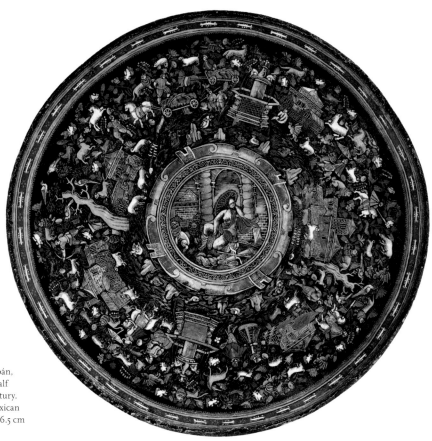

51. Batea, Peribán, Mexico, first half of the 17th century. Wood with Mexican lacquer, 7.9 x 56.5 cm (3⅛ x 22¼ in.)

time-consuming method. Each application of lacquer required burnishing with a soft
cloth while curing, a process that took several days. Artisans then added details to the fig-
ures by incising cross-hatching, which was then filled with lacquer of a contrasting color,
creating a shading effect clearly borrowed from contemporary European engravings (fig.
51). The exuberant, but limited, color palette of Peribán lacquers consisted of red, yellow,
orange, blue, green, black, and white. Mineral clays were sources for reds and yellows,
while organic pigments yielded additional colors: brazilwood or cochineal for red, saf-
fron root for yellow, mangrove bark for blue, and charred corncobs or charred guava tree
branches for black.[20]

The earliest and finest examples of Peribán lacquerwork date roughly to the first
half of the seventeenth century. Barely a dozen pieces from this period survive, limited
to a few bateas, chests, and large fall-front desks. Most were preserved in Spanish collec-
tions, prized in their day for the colorful decoration and exotic medium. The bateas in
fact gained such fame that any large lacquered bowl often was referred to as a *peribana*
into the nineteenth century. Truly objects fit for a king, the two Peribán domed writing
desks in the collection of the Monasterio de las Descalzas Reales in Madrid almost cer-
tainly were a gift from the Spanish monarch to the Carmelite nuns. The same applies
to a batea, of similar style and decoration, in the Conceptionist convent at Ágreda, Soria,
in northern Spain, home to the mystic Sister María de Ágreda (1602–1665), who was
a longtime correspondent and adviser to Philip IV. A contemporary painting by Antonio
de Pereda, *Still Life with Ebony Chest*, gives further proof of the prized status of Peribán
lacquers (fig. 53). Atop the ebony chest, at the right, sits a Peribán jícara cup, accompa-
nied by equally valuable burnished red earthenware from Tonalá, Mexico, the famed
búcaros de Indias. This unique visual record of a Peribán gourd cup, none of which are
known to have survived, helps establish dates for extant lacquer pieces on the basis of a
stylistic comparison of the decorative motifs. For instance, the figure of a siren and the
accompanying designs seen on the gourd cup are very similar to those on the reverse of
the Peribán batea (fig. 52).

Typical motifs on early Peribán lacquers include central strapwork cartouches
influenced by European mannerism containing allegorical or mythological figures. The
cartouches are surrounded by imaginary landscapes populated with courtly figures in
late sixteenth-century European dress engaged in all manner of outdoor activities, hunts,
and combats. A fantastic menagerie of domestic animals, wildlife, and mythical creatures

53. Antonio de Pereda
(1611–1678). *Still Life
with Ebony Chest*,
Spain, 1652. Oil on
canvas, 80 x 94 cm
(31½ x 37 in.)

inhabits the scenes, ranging from dragons and unicorns to deer and wild boar to
eagles and lions, as well as the occasional New World species, such as the armadillo.
The compulsion to leave no space undecorated, or *horror vacui*, so characteristic of the
colonial decorative arts, is epitomized by the Peribán lacquers. Dutch and Flemish
prints served as the primary source for these images, yet the creativity of the indige-
nous artisan remains omnipresent.

Pátzcuaro, located in the center of Michoacán, gained renown in the eighteenth
century for its Asian-inspired lacquerware. The composition of the lacquer differed
little from that of Peribán—aje oil, chia oil, mineral clays, and organic pigments—yet
the technique more closely approximated japanning. Wooden objects were decorated
by applying a single-color lacquer ground, predominantly black or red, on which the
scenes and designs were painted with a brush using natural pigments and gold, either
leaf or powdered. Local artisans produced a wide array of forms, from small coffers to
large pieces of furniture, but they are best known for large bateas, some exceeding one
meter in diameter, and for *almohadillas* (sewing boxes).

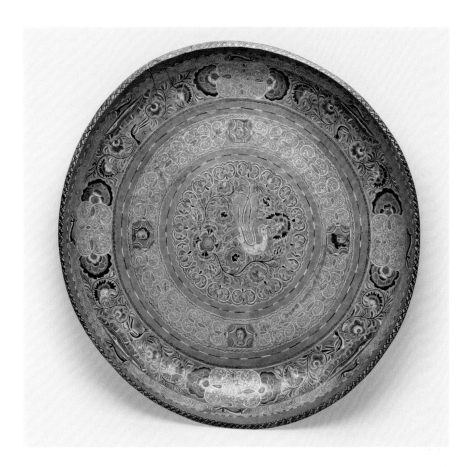

54. Batea, Pátzcuaro,
Mexico, about 1800.
Wood with Mexican
lacquer and painted
decoration, 11.5 x 86 cm
(4½ x 33⅞ in.)

Pátzcuaro lacquerware exhibits a variety of motifs adapted from European and
Asian sources. Many of the bateas maintain the decorative program established at
Peribán with a central cartouche or medallion containing figures, surrounded by four
smaller medallions with separate scenes or figures. Since a number of pieces display sim-
ilar themes or motifs, they are believed to originate from the same workshop.[21] A group
of five bateas exhibit an Asian-inspired border of four peonies that frames scenes of
daily life and recreation among figures in contemporary European dress. Another small
cluster of works displays scenes from classical mythology. Yet another group of large
bateas dating from the late eighteenth century, decorated with concentric bands of Asian-
inspired floral motifs usually done in gold on a reddish ground, always includes figures
of greyhounds in one of the borders (fig. 54).

The lacquer arts were already thriving in Pátzcuaro when the Spanish friar
Francisco de Ajofrín visited the province in 1766. Ajofrín noted in his diary that a cele-
brated painter of noble Indian lineage, José Manuel de la Cerda, created impressive lac-
querwork objects that "in fineness and luster exceed Chinese lacquer and are possessions
suitable for persons of very high status." He also reported seeing a dozen bateas made of
ash that De la Cerda was preparing for the vicereine Marquesa de Cruillas.[22] Considered
the finest of all of the Pátzcuaro lacquer artisans, De la Cerda was the only one to sign his
work, of which a few pieces survive today.[23]

Although the exact dates for José Manuel de la Cerda are not known, he clearly
influenced the style of Pátzcuaro lacquerwork through the close of the colonial era.

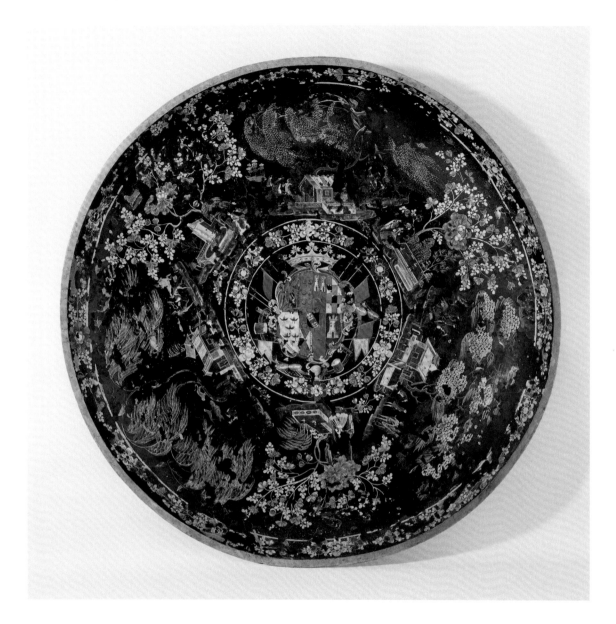

55. José Manuel de
la Cerda (active mid-
18th century). Batea,
Michoacán, Mexico,
mid-18th century. Wood
with Mexican lacquer
and painted decoration,
diam. 107 cm (42⅛ in.)

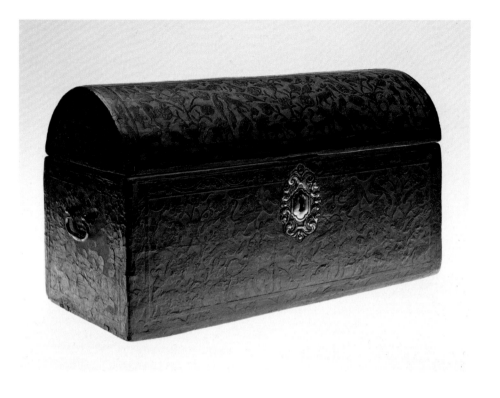

Works from the De la Cerda workshop show the most pronounced Asian influence: landscapes of weeping willows, flowering plums, cranes, and pagodas and other structures of a general Asian style, all set against a ground of black lacquer (fig. 55; see also fig. 74). The eighteenth-century fashion for chinoiserie decoration, and in particular European japanned furniture, served as the inspiration for these designs. Despite the abundant supply of Asian lacquers for direct comparison, De la Cerda may have borrowed his designs from European examples or from pattern books.[24] A militaristic theme runs through many of the bateas and case pieces, as European soldiers and cavalry prepare for combat, battle turbaned soldiers (Indians or Turks), and besiege cities with cannons. Sewing boxes and other small pieces from the workshop are generally rococo in style and of a more pastoral theme, exhibiting narrative scenes of daily life, courtship, and recreation framed within rocaille and floral borders.

 Olinalá, in the eastern part of the modern state of Guerrero, also emerged as a major lacquer center in the eighteenth century. Unlike the artisans of Peribán or Pátzcuaro, those in Olinalá relied solely on chia oil mixed with mineral clays and organic colorants for their lacquer. According to Joaquín Alejo de Meave, the village priest in 1791, the lacquerers of Olinalá excelled in the "painting" of gourd cups and larger gourd vessels (jícaras and tecomates), but they also manufactured lacquered chests, writing boxes, trays, sewing boxes, candle screens, and bookstands (fig. 56).[25] Meave dedicated most of his invaluable essay on lacquer technique to the composition of colorants for the lacquer, giving recipes for red, blue, yellow, green, crimson, pur-

56. Coffer, Olinalá, Guerrero, Mexico, 18th century. Wood with Mexican lacquer, 26 x 46.5 x 21.3 cm (10¼ x 18¼ x 8⅜ in.)

ple, black, and white. He also described the two techniques for decorating lacquer-wares. The first, known as *rayado*, or scoring, required the application of two layers of lacquer of contrasting colors. While the second layer of lacquer was still soft, the designs were scored in outline into the lacquer with a maguey or cactus spine and the surrounding areas were excised. This exposed the contrasting first layer of lacquer, leaving the outlined designs of the second layer in relief. In the second technique, called *plateada* or *dorada a pincel*, silver or gold leaf was adhered to the base coat of lacquer, on which the designs were painted in lacquer with a fine brush. Alejo de Meave observed that only men practiced the gilding technique, whereas women were involved in all facets of lacquer production, including the laborious task of grinding the mineral clays.

LONG BEFORE THE ARRIVAL of Europeans, the peoples of Latin America had developed decorative lacquer traditions using local materials. Their successors in the colonial era of global trade were inspired by imported Asian lacquerwares as well as European decorative styles. The exceptional examples of barniz de Pasto and the lacquers of Peribán and Pátzcuaro from the seventeenth and eighteenth centuries that survive today stand as a testament to the creative genius of these indigenous lacquer artisans, who synthesized the techniques and decorative traditions of Asia, Europe, and the Americas into works of enduring quality and beauty that rival the Asian lacquers that inspired them.

RELIGIOUS ORDERS
and the Arts of Asia

GAUVIN ALEXANDER BAILEY

SPANISH, PORTUGUESE, AND FRENCH America owe some of their earliest and most long-lasting interactions with Asia to the global missionary network of Catholic religious orders, notably the Jesuits, Franciscans and other so-called Mendicant (begging) orders, and their more settled counterparts, from Ursulines to Benedictines. The profound cultural effect of Asia on viceregal Latin America has most often been traced through mercantile and geopolitical players, focusing on New Spain and the Manila galleon trade. But the reach of missionaries from religious orders extended throughout Asia as well as the New World, and built on contacts made well before the founding of European colonies.

Because they were in the vanguard of European expansion into both Asia and America and frequently established themselves well beyond European colonial territory, missionary orders were in a privileged position to connect visual cultures of profoundly different peoples across vast distances. They also founded arts and crafts workshops on their outermost missions that further aided intercultural exchange, as Japanese, Chinese, or indigenous American artists incorporated their own styles, techniques, and even iconographies into the work they produced for mission communities and for export. The

57. Lectern, Japan,
1580–1620. Wood with
lacquer and mother-of-
pearl, 35 x 31 cm (13¾ x
12¼ in.)

Society of Jesus (Jesuits) began its work in India in 1542, only two years after the order's
foundation, and rapidly built one of the most widespread missionary enterprises—
particularly in Asia, where the order moved beyond the Portuguese coastal strongholds
of Goa and Macau to foundations in the major cities of India, Ceylon (Sri Lanka), Japan,
and China.[1] The Franciscan and Dominican orders also dominated the Asian mission
network, particularly in India, China, and Japan, with the Dominicans reaching Goa
in 1510 and the Franciscans arriving in 1517. These Mendicant orders boasted a much
longer history of contact with Asia: the Franciscan Giovanni di Piano Carpini and the
Dominican André de Longjumeau had led missions to the court of the Mongols in 1245
and 1248, respectively, twenty years before Marco Polo visited Kublai Khan.[2] Although
all three orders maintained a presence in the Asian Portuguese cities and in the Spanish
Philippines, the activities that put them most intimately in contact with Asian peoples—
and which gave them the greatest renown in Europe and Latin America—were these
missions beyond the European sphere.

 The Jesuit missions to Japan (founded in 1549) and China (1580) made the most
prominent contributions to the history of missionary art. The Jesuit art school in Japan—
referred to as a "Seminary of Painters"—was founded in 1583 by the Neapolitan lay broth-
er Giovanni Niccolò. It was the only mission art academy in Asia comparable in scale to
the ateliers in Paraguay and Chile that the Jesuits would establish in the seventeenth and
eighteenth centuries.[3] Although the Seminary of Painters was not conceived as a means
for intercultural artistic exchange, Japanese styles increasingly made their mark on the
Catholic imagery produced by the workshop. After being assimilated into the Jesuit

college in Nagasaki (founded 1593–94), Niccolò's academy grew exponentially as art was added to the college curriculum: in 1594 it boasted more than twenty artists, and by 1603 most of the seventy students in the college were trained there. These apprentices worked both in European media—oil on copper, wood, and canvas—and in traditional formats such as Japanese hanging scrolls in indigenous watercolors on paper. Non-Christian workshops also adopted European styles, notably the furniture makers of the Momoyama period (1573–1615), who crafted Christian objects in the so-called *namban,* or "Southern Barbarian," style, such as triptych frames and missal stands that the Jesuits exported to Europe and Latin America (fig. 57).[4]

The Jesuits' China mission was also a center for art production, commissioning Chinese-style woodblock prints to illustrate Gospel stories and catechisms in the early seventeenth century. The most prolific activity was at the court of the Qing emperors in Beijing in the eighteenth century, when Jesuit artists worked in conditions of near servitude under the watchful eye of the emperor, Chinese artists, and a small army of eunuchs. The most famous were Giuseppe Castiglione (known in Chinese as Lang Shining), Jean-Denis Attiret (Wang Zhicheng), and Michel Benoist (Jiang Youren), who adapted their European training to execute Chinese-style landscape and portrait paintings, enameled metalwork, painted porcelains, and clocks. They also designed the fountains, cascades, parterre gardens, bridges, and pavilions of the Qianlong Emperor's pleasure gardens at Yuanmingyuan (the Garden of Perfect Brightness, completed in 1783) in a combination of Chinese and rococo architecture that recalled Queen Marie-Antoinette's famous *hameau,* or fantasy village, which opened at Versailles in the same year.[5] Although these activities were not directly related to the Jesuits' mission, they did gain them influence at court. And although the Jesuit artists disdained working in Chinese ink and color instead of oil and had contempt for the Chinese love of asymmetry and two-point perspective, they created some of the most subtle blends of Chinese and European styles yet attempted. An example of such work is Attiret's *Ten Fine Horses* (before 1768), an album of ten leaves, which combines traditional Chinese ink landscape painting with European-style modeled figural painting and one-point perspective to give parts of it—notably the foreground figures—a three-dimensional effect.[6]

Although fascinating as episodes of intercultural exchange, these mission workshops were far outstripped in productivity by converted and unconverted Chinese in mainland China, Manila, Goa, and Macau. Especially prolific was the Chinese settlement in Manila known as the Parián, which gave its name to the Asian markets in Mexico City and Puebla. Already in the late sixteenth century it was home to non-Christian Chinese bachelor traders and craftsmen known as *sangleys,* after the Chinese *chang lai* ("frequent arrivals"), who helped make it the largest Chinese settlement outside China during the trading season. Crafts production soon extended north of the Pasig River to the Chinese convert communities of Binondo (in 1596) and Tondo (in 1611), under the supervision of the Dominicans and Augustinians (a third mendicant order), respectively. From at least 1590 these workshops specialized in ivory sculpture, particularly crucifixes and statues of the infant Christ, the Madonna, and a range of saints, as well as paintings and altarpieces for use in the Philippines and for export to Macau, Latin America, and Europe. Several of the ivories, such as a seventeenth-century *Saint Rose of Lima,* even represented Latin American saints, demonstrating the Western Hemisphere's critical importance as a market (fig. 58). Exquisitely rendered, the figure is shown wearing the habit of a Dominican (Saint Rose was a Third Order, or lay, Dominican), and the gently flowing folds of the drapery, particularly around the headpiece and veil, are a tour de force with

their subtly beveled edges and suggestion of a gentle swaying motion.[7] Jesuits, Dominicans, Franciscans, and Augustinians ordered prodigious quantities of these works to populate ready-made wooden altarpieces for their missions on the archipelago and in Latin America, and they also purchased large numbers of ivories made by mainland (unconverted) Chinese in Fujian Province, whose main center of production was at the coastal center of Zhangzhou. As early as 1561 Portuguese travelers were marveling at their quality.[8]

Chinese and Japanese artists also made Christian sculptures and paintings in Macau. As early as 1594 a painting and sculpture school was established in the Jesuit College of São Paulo—Niccolò's Japanese academy joined it following the expulsion of Christians from Japan in 1614. A crafts workshop also existed in the Franciscan monastery of Santo Antônio.[9] An example of the sculpture produced by these artists is a striking polychrome wooden statue, *Christ at the Column*, in the Church of São Domingos in Macau (seventeenth or eighteenth century), which exhibits a profound understanding of Iberian sculptural style, particularly its focus on naturalism and pathos. In fact, only its lack of the traditional glass eyes and its high, arched eyebrows and moue-like lips indicate that it was made by Chinese or Japanese craftsmen. As it happens, the largest Asian artwork ever commissioned in viceregal America was made in Macau: the iron and bronze choir screen at Mexico City Cathedral, designed in 1721 by the painter Nicolás Rodriguez Juárez, was shipped via Acapulco and Manila in 1722–23 and cast in the courtyard of the Franciscan monastery by Macanese metalworkers, who were able to understand the instructions (a diagram of sorts called a *mapa*) only with the help of an Italian Franciscan translator.[10] Before it was transported back to New Spain and finally erected in the cathedral in 1730, it was the subject of much interest in Macau, where Chinese officials came to view this strange foreign object with its miniature Greco-Roman columns and balustrades.

East Asian sources of Christian ivories were rivaled by those of India and Ceylon, particularly Goa, where Hindu and convert sculptors executed thousands of high-quality pieces for religious orders and lay patrons in Portuguese India and Africa, Portugal, and Brazil.[11] A kind of global outsourcing

58. *Saint Rose of Lima,* Philippines, 17th century. Ivory, h. 43 cm (16⅞ in.)

59. Nativity, Ecuadoran, with Hispano-Philippine ivory inserts, 18th century. Polychromed and gilded wood and ivory, Mary: h. 19.7 cm (7¾ in.); Joseph: h. 21.6 cm (8½ in.)

also developed, in which Goan or Filipino ivory manufacturers made heads, hands, and sometimes feet to be attached either to a wooden armature for dressing (in which case the piece would be called an *imágen de vestir*) or to be incorporated into wooden bodies carved either in the Philippines and Goa or in Latin America. A Holy Family assembled in late eighteenth-century Quito combines ivory heads and hands made in workshops in Manila with locally made bodies of polychromed wood and decorated with gilding, in imitation of Chinese silk garments of the sort popular not only with secular patrons but for Church vestments (fig. 59).[12] The diminutive set would have adorned a private oratory in someone's home, an unconsecrated miniature chapel or niche where priests could nevertheless say Masses for the household—or simply a small retablo placed in the bedroom for personal devotion.

The brilliance of Chinese and Indian ivory carvers is evident in the way they imparted indigenous styles to Western prototypes, which were derived mostly from Antwerp prints. Chinese sculptors preserved the linearity and beveled edges of Chinese drapery, aspects of Chinese physiognomy, Chinese-style landscape features and decorative motifs, and even elements of Chinese Buddhist iconography such as the *apsara*, a flying deity resembling an angel.[13] Correspondingly, Goan works, whether in ivory or polychrome wood, bear the distinctive stylistic signature of Hindu art: figures are stocky and rigid, their bold, rounded forms forcefully evoking the third dimension despite being applied primarily to flat surfaces. They are generally depicted frontally, and they exhibit the dimpled necks and inexpressive facial features of Hindu sculpture.[14] Their drapery is treated decoratively, occasionally imitating the cut or pattern of Indian garments or adorned with beaded jewelry. As it does in China, non-Christian iconog-

60. Pulpit, Church of Saint Jerome, Mapusa, Goa, second half of 18th century. Wood with polychrome and gilt

96

raphy appears in some Christian sculpture from Goa, notably the wooden half-human, half-snake caryatids supporting pulpits in Goa and in the smaller colonies of Daman and Diu, which Ines Županov has recently suggested are Hindu *naga/nagini* (a cobra-/serpent king or queen related to water) and related tree spirits known as *yaksha/yakshi*. A spectacular specimen is the pulpit at the Church of Saint Jerome, Mapusa (fig. 60). The pulpit also includes on its panels four *Kirtimukha* ("glorious face") masks, which represent another Hindu spirit.[15]

Missionary orders reached the Americas less than a decade after they had established themselves in Asia, and many—notably the Mendicants and Jesuits—founded mission arts and crafts workshops there like those in India and Japan. In 1523 the first missionaries arrived in New Spain—a trio of Franciscans from Ghent who founded the first mission art workshop in Tlatelolco in 1533.[16] The Dominicans followed them into central New Spain in 1526 and the Augustinians in 1533, but the Jesuits did not arrive until 1572 and had to found their missions farther north. In 1532 the Franciscans and Dominicans also led the way in South America, the Franciscans setting up their first headquarters in Quito two years later, where another friar from Ghent, Jodoco Ricke de Marselaer, helped found the first South American mission arts workshop in 1551. Both orders rapidly spread southward into present-day Argentina (1549) and Chile (1553).[17] The Jesuits, bolder than they had been in New Spain, established themselves early in South America: in Brazil in 1549, Peru in 1568, and Paraguay in 1608. Other orders followed later on, including the Mercedarians and Augustinians in Spanish America and the

Benedictines and Carmelites in Brazil. Although most missionaries in the Americas operated in a context of conquest—which was not the case in Asia, where they were often embedded deeply in non-European states—certain regions such as Paraguay and Chiloé (Chilean Patagonia) were distant enough from European settlements that Amerindians were able to make more decisive cultural contributions to mission life.

Even more than they were in Asia, religious orders in the Americas were driven by a utopian faith that they could create ideal communities like those of the early Christians in Europe. Amerindians were believed to offer a "clean slate" for conversion—some even thought that they were the Lost Tribe of Israel—in contrast to people from Asian cultures, whom missionaries perceived as being more advanced and therefore corrupted. Artistic and cultural accommodation with indigenous people were key for creating the kind of community the missionaries had in mind. The earliest experiments in accommodation occurred immediately after the conquest of Mexico (1521), particularly at the hands of the Ghent Franciscans, who combined a humanist interest in empirical inquiry and education with an urge to create utopian societies inspired by the works of the Renaissance thinkers Desiderius Erasmus and Thomas More. The first bishop of Mexico, the Franciscan Juan de Zumárraga, filled his copies of Erasmus's *Epigrammata* (1518) and Thomas More's *Utopia* (1516) with marginal notes, and Don Vasco de Quiroga, bishop of Michoacán, was directly motivated by *Utopia* in the urban planning of the mission centers he founded in his diocese.[18] Yet these schemes had less to do with adapting to indigenous ways than with imposing systems on aboriginal peoples that the friars believed would be good for them. Much has been made of the enlightened attitudes of the humanist friars and their Jesuit successors, and they are extraordinary for their time, but it is crucial that we acknowledge the ambiguity of these missionary strategies and not whitewash their ultimate goal of Christian conquest.

Like their secular counterparts, missionary orders relied on commercial trade via the Manila galleons and Goa-Brazil routes for the Asian objects they introduced into Latin America; in fact, they invested in this trade as a way to support their mission activities. But they also shipped Asian items independently as part of their extensive and regular correspondence network, the early modern equivalent of sending items by diplomatic bag. Jesuit mission stations were required to send annual and triennial letters and personnel reports to the Society's headquarters in Rome; overseas missionaries amounted to 8 to 12 percent of all Jesuits after about 1640. Individual Jesuits in Asia also kept up regular communication with family members, patrons, and scientists in Europe and Latin America through private letters and packages.[19]

Missionaries took Asian artworks with them on their own travels: the Jesuit Diego Luis de San Vitores carried a Filipino sculpture of the *Virgin Immaculate* from Manila to New Spain via Guam; a Franciscan friar transported an eighteenth-century ivory, another *Virgin Immaculate*, to the monastery of San Francisco in Santiago; and around the same time a Jesuit missionary took a Filipino ivory crucifix to Santa Ana, the most distant of the Chiquitos missions of lowland Bolivia.[20] Among the most spectacular imports are seven large wooden polychrome sculptures of Christ at the Passion in the Carmelite monastery in Cachoeira (Bahia, Brazil), which have the ivory skin, subtle musculature, high, arched eyebrows, and moue of Filipino and Macanese sculpture. Their glass eyes indicate that they may have come from Manila, and not Macau.[21] These sculptures were valued precisely because they had been made in Asia: the cabinets built to house them in the church sacristy are painted to complement Asian-inspired décor, in black and red imitation lacquer on the outside and bright red, blue, and green floral motifs derived

from silk textiles on the inside. The movement of objects between the continents sometimes went the other way; for example, the Franciscans and Jesuits imported into China feather paintings made by Nahua artists (the indigenous people of the former Aztec Empire), such as a *Mary Magdalene* the Franciscans imported via Manila in 1578 and a *Four Seasons* series that the Jesuits gave to the Wanli Emperor of China (r. 1572–1620). Feather painting had been one of the most elite crafts techniques under the Aztecs, and missionaries kept the workshops active, producing tapestries of European subjects. The sixteenth-century missionary to China Matteo Ricci included depictions of Latin American feathers and their sources in the world map he executed for Chinese scholars.[22]

Missionaries also brought Asian artworks directly to the attention of Native American artists, which resulted in spectacular hybrid art forms. Such is a series of late seventeenth- or early eighteenth-century tapestries, probably from a single workshop (*obraje*) or even a single weaver in the highlands of Peru. They could have been made in Cuzco or the Lake Titicaca regions, both major crafts centers, or in the southern Andes (present-day Bolivia), where early colonial tapestries were also produced (see fig. 11). These rare, elite Peruvian tapestries are modeled directly on Ming Dynasty silk textiles, especially high-quality embroideries, known in English as mandarin squares, indicators of rank worn by members of the Imperial court. Made of cotton, camelid fiber, and silk, the tapestries employed a sophisticated weaving technique of pre-Inka origin and integrated Chinese style and motifs with native flora and fauna. Because the weaving technique follows Andean tradition, it is unlikely that the weavers were trained by a professional from Asia.[23] There are very few such tapestries, and not a single mandarin square survives in Latin America, so it is most probable that a few missionaries, or even a single Jesuit, took these Chinese textiles to Peru rather than their being imported in greater numbers by the Manila galleons. The Jesuits were the only missionaries working at the Beijing court at the time these tapestries were made, and they could have carried rank badges with them to their college in Cuzco or to their mission headquarters in Juli, on the shores of Lake Titicaca.

Missionaries also imported Asian stories to the Americas. Works celebrating the Christian spiritual conquest in Asia, as well as more scientific volumes by missionaries about Asian geography, flora and fauna, culture, and the arts, reached Catholic America in such quantities that Asia became associated in people's minds with Christian triumph, and such works were found in colonial Latin American libraries from New Spain to Paraguay.[24] Religious travelers also created illustrated records of the local customs in Asia, such as the Jesuit Adriano de las Cortes, who chronicled his shipwreck and capture in China in a manuscript he produced in Manila in 1621–26.[25]

Missionaries also helped fuel enthusiasm for Asian antiquity among Latin American intellectuals, who increasingly sought links between ancient Asian and pre-Hispanic civilizations.[26] The sixteenth-century Peruvian Jesuit José de Acosta was the first to propose that Amerindian peoples migrated over what became known as the Bering Straits land bridge from Asia.[27] Subsequent generations noted similarities between pre-Hispanic art and that of China or Southeast Asia and the apparent affinity between Aztec picture writing and Chinese script. Athanasius Kircher, the author not only of *China illustrata* but also of works on Egyptian hieroglyphics, linked Asian with Mexican antiquity by deriving Indian, Chinese, and Aztec cultures from Ancient Egypt—a theory very popular with viceregal *criollos* (people of European extraction born in America) eager for an American antiquity comparable with that of the Old World. Kircher's works were read avidly by prominent colonial intellectuals such as the poets

61. Unknown artist,
Saint Paul Miki, Mexico,
17th century. Carved,
polychromed, and gilded
wood, 149.5 x 30.3 cm
(58⅞ x 11⅞ in.)

62. Unknown artist,
Saint Felipe de Jesús,
Mexico, about 1650.
Oil on canvas, 152.4 x
121.9 cm (60 x 48 in.)

Sor Juana Inés de la Cruz and Carlos de Sigüenza y Góngora, and he corresponded
with other viceregal literati.[28]

Triumphalist missionary stories about Asia inspired paintings, sculptures, and
sculptural panels of Asian Christian martyrs, most famously the twenty-six Japanese
martyrs of 1597—who included Franciscans and three Jesuits—and the "Great
Martyrdom" of 1622. Many of these artworks were specifically intended to motivate
missionaries in the Americas, such as the eighteenth-century sculptural groups titled
Three Martyrs of Japan, made for the principal Jesuit church in Santiago, and a seven-
teenth-century statue of Saint Paul Miki from one of the Jesuit missions in northern
New Spain (fig. 61). The statue of Saint Paul Miki is particularly interesting since it
was made in Asia, probably in Macau or the Philippines. The statue was carved from
non-American pine and has a Chinese inscription on its back.[29] Paul would have been
chosen for a missionary audience because, of the three Jesuit martyrs, he was the only
one about to be ordained a priest when he was killed. Other visual representations of
martyrs aimed at a lay audience, such as the Franciscan martyrs depicted in Lázaro
Pardo Lagos's giant canvas in the Recoleta church in Cuzco (about 1630) and the
mid-seventeenth-century New Spanish painting showing Saint Felipe Jesús, a Mexican-
born Franciscan, being martyred in Nagasaki (fig. 62).[30] An especially early represen-
tation of the 1597 martyrs is a monumental mural cycle in the Franciscan monastery

63. Chinese temple
lion, Church and
Monastery of Santo
Antônio, João Pessoa,
Brazil, about 1734

64. Chinese temple lion,
Church of San Agustín,
Manila, Philippines,
1587–1607

65. Sacristy ceiling
(detail), Church
of Nossa Senhora
do Rosário, Embu,
Brazil, 18th century.
Polychromed wood

in Cuernavaca (Mexico) that dates to the 1620s.[31] Representing the various stages of the Christians' imprisonment and death march, it culminates in a panoramic mass crucifixion on a hill originally containing more than one hundred figures.

Religious orders also employed the decorative arts to celebrate their Asian adventures. The stone Chinese temple lions (about 1734) carved by Brazilian sculptors that guard the courtyard of the Franciscan monastery of Santo Antônio in João Pessoa are strikingly similar to Chinese ones guarding the entry to the Augustinian church in Manila (figs. 63 and 64). Wooden versions of these beasts from the late seventeenth or early eighteenth century support a bier for the *Dead Christ* in the Jesuit church in Embu (São Paulo).[32] It is not known how this last set of lions reached this small Jesuit retreat chapel, begun in 1698, but they are not the only Asian aspect of the church, which also boasts an impressive sacristy ceiling painted predominantly in a red color reminiscent of Chinese cinnabar paste seals and in the cobalt blue on porcelain decoration, its Catholic emblems surrounded by frames depicting chinoiserie landscapes and a larger band of Chinese-style floral decoration that looks as if it was inspired by textiles (fig. 65).

The Jesuits even brought a prominent Asian person to Latin America as a symbol of Christian triumph. Catarina de San Juan, a former Muslim and alleged descendant of Tamerlane and relative of the sixteenth-century Mughal Emperor Akbar, became Puebla's most beloved anchorite and mystic. Three separate biographies of Catarina were published in the late seventeenth century, one of them the longest work ever printed in New Spain.[33] Although documentary evidence is inconclusive, it seems that the Jesuits converted her mother around 1601 in Agra or Lahore and, intending to present her daughter as a model Christian, they transported her via Cochin to Manila, probably with the intention of sending her to New Spain. Although her biographers fancifully attributed her voyages to pirates, it is more likely that the whole tour was a Jesuit public relations stunt. After she arrived in Mexico, she became a regular visitor at the Jesuit church of La Compañía in Puebla and went to Jesuit confessors. The viceregal elite attended her funeral, which featured an expensive catafalque decorated with paintings and poetic inscriptions by such literary luminaries as Sor Juana. In the Compañía (Jesuit) church it is still possible to see an alabaster plaque celebrating a woman "quam Mogor mundo, Angelopolis caelo dedit" (who in Mughal lands dedicated herself to the world, [and] in Puebla gave herself to heaven).

Throughout the colonial period, church officials often traveled between Asia and Latin America, even holding posts in both hemispheres. Especially common were bishops of Manila who had worked in—or, as time went on, were born in—New Spain, beginning with the Spanish-born first bishop of Manila, the Dominican Domingo de Salazar (in office 1579–94), and the Mexican-born bishop Don Miguel de Poblete (1653–67).[34] A similar relationship obtained in the Portuguese Empire: the first bishop of Brazil, Dom Pedro Fernandes Sardinha, was vicar-general of Goa before moving to Salvador in 1552, and the Bahia native Dom Alexandre da Silva Pedrosa Guimarães was bishop of Macau between 1772 and 1789. The first missionaries to reach the Philippines also came directly from New Spain, including the five Augustinian friars led by Andrés de Urdaneta, who accompanied the conquistador Miguel López de Legazpi to Cebu in 1565, and the architect and Jesuit superior in the Philippines Antonio de Sedeño, who served in Florida and as a rector of the Jesuit college in Mexico City before setting out for Manila in 1580.[35] Others made virtual voyages: although the pioneering Asian missionary Francis Xavier never visited the Western Hemisphere, the so-called Apostle of

the Indies was also a patron of missionaries in the Americas and was regularly depicted
in paintings in the act of baptizing Native Americans; for example, in a 1721 painting
by Antonio de Torres he is shown baptizing a Mexican cacique, who appears to wear a
mantle of Asian silk, and figures in the background wear traditional feathered headgear
meant to recall imperial Aztec regalia (fig. 66).

Antonio de Sedeño was one of several architects and artists who went from or via
New Spain to the Philippines. Indeed, the arts and architecture of the islands have close
affinities with those of New Spain. An early example is the seventeenth-century mural in
the old sacristy of the Augustinian monastery in Manila, painted in strapwork designs in
red and black, which is similar to the earliest generation of monastic mural paintings in

New Spain (both were based on European engravings, from which they got their coloring). Another example is the massive stairwell in the same complex, which recalls Mexican examples like the great staircase at San Nicolás in Actopan (begun in 1546).[36] Notable is the late eighteenth-century Franciscan church of Our Lady of the Gate in Daraga, with its massive Solomonic columns—championed by Gianlorenzo Bernini, they became one of the leitmotifs of the Baroque worldwide—and relief carving of vegetation, scrolls, and figures of saints so pronounced that it casts dramatic shadows over the whitewashed facade (fig. 67).

There is, however, less evidence for artists going the other way. Only two artists are known to have trained in Asia before working in Latin America. The first is a French Jesuit brother who worked for the Chinese emperor before relocating to Brazil. Born in Rouen in 1656, Charles de Belleville trained as a sculptor in France and executed the spectacular unpainted oak triptych for the altar of the Jesuit church in Périgueux, in the Dordogne, now in the Cathédrale Saint-Front; it is recognized as an outstanding example of provincial French Baroque (fig. 68). The quality of Belleville's work demonstrates that the Jesuits did not send merely second-rate talent to their overseas missions. The sculptor went to China in 1698 on the ship *Amphitrite* on the return journey of a diplomatic mission from the Kangxi Emperor to King Louis XIV. Under the Chinese name Wei Jialu, Belleville worked for nine years at the imperial

67. Facade, Church of Nuestra Señora de la Porteria (Our Lady of the Gate), Daraga, Philippines, 1773

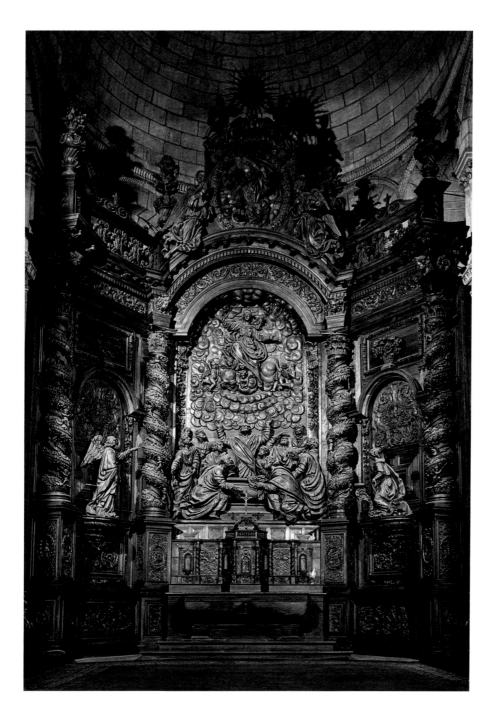

68. Charles de Belleville
(1656–1730). Altar of the
Assumption, Cathédral
Saint-Front, Périgueux,
France, before 1688. Oak

Chinese court as a painting teacher, and he designed and oversaw construction of the
Jesuits' Beitang (North) Church in Beijing (completed in 1703), the headquarters of the
French mission, as well as the French Jesuit residence in Guangzhou (Canton).[37]

Disillusioned by the harsh and inflexible conditions under which the Jesuits oper-
ated at court, Belleville boarded a ship in 1707 to return to France. When the ship called
in at Salvador, Belleville was so ill that the Society granted him two years' leave to recu-

69. Charles de
Belleville (1656–1730).
Sacristy ceiling,
Church of Belém de
Cachoeira, Brazil,
1700–1710

perate in Brazil—a leave he managed to extend for more than twenty years, making himself useful by building and decorating Jesuit structures. His only surviving Brazilian work is the painted ceiling in the Jesuit seminary of Nossa Senhora de Belém outside Cachoeira, the most authentically Asian-style artwork made in South America (fig. 69).[38] Recently restored to its former glory, it is divided into two rows of three sunken panels painted with brightly colored floral decoration as well as more abstract arabesques in gold or silver around the insides of the panels and in gold only on the frames, all against a black field. The ceiling's black background imitates Chinese lacquers, as do the gilding, silver paint, and richly colored flowers. The luxurious floral wreaths around a central medallion include Chinese flowers such as peonies and lilacs but also the passionflower (*mburucuyá*), native to Brazil, with its distinctive pinwheel shape—an unexpected and subtle homage to the church's surroundings. The overwhelmingly Chinese style of this ceiling is surprising when it is compared to Belleville's Périgueux altarpiece. Perhaps it was pure nostalgia for his time in China, but it was more likely meant as a commemoration of the Jesuits' Asian missionary triumphs. Belleville's work inspired a fad for Chinese décor in Brazilian church interiors, particularly in sacristy ceilings but also in organ cases and choir stalls (as in Mariana Cathedral) and wall panels (as in the chancel of the Capela de Nossa Senhora do Ó in Sabará). But Belleville's ceiling reflects contemporary tastes at the imperial Chinese court, whereas the others are examples of chinoiserie—an Asian-inspired decorative style refracted through a rococo lens that reflected European rather than Asian aesthetics.

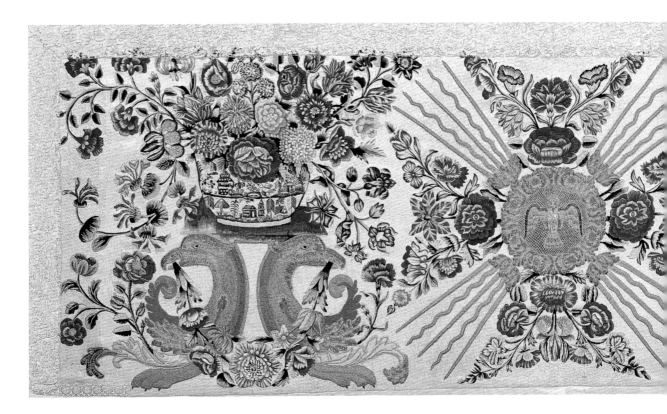

Esteban Sampzon (or Samzon), a Filipino lay sculptor employed by the Dominicans and other religious orders in Buenos Aires and Córdoba (in present-day Argentina), is the only Asian artist known to have worked in colonial Latin America. His self-identification in 1780 as an "Indian from China" (*indio de la China*) is typical of the vague nomenclature used for Asians in the Americas, but he clearly stated that he came from the Philippines. He was born in 1756 in the parish of San Bartolomé de Tambobong (now Malabon City in Metro Manila, northwest of the historic center); it is still a mystery how the sculptor made it by 1780 from the Philippines to Buenos Aires—indeed, it would be hard to find a city in Spanish America farther away from the Manila galleon port of Acapulco, if he took that route.[39] Sampzon instead may have traveled via Macau, Goa, and Brazil. Illicit trade, including in Asian objects, was rife between the Portuguese and Spanish colonies, and Portuguese and Brazilian sculptors and retablo (altarpiece) makers also often took that route to Buenos Aires or Paraguay to find work. Since by his own account he had already been an *"escultor de profesión"* (professional sculptor) for seven years by 1780, Sampzon must have trained in the Chinese crafts neighborhoods of Manila—mostly probably in the Dominican neighborhood known as Binondo, not only because it was close to Tambobong, but also given his later associations with the Dominicans.[40]

The church of San Bartolomé, where Sampzon was baptized, still has a collection of eighteenth-century sculptures probably also made in Binondo, including a fine *Man of Sorrows* and a sculpture of its patron, Saint Bartholomew, in the high altar retablo. The Saint Bartholomew has features strikingly similar to those of Sampzon's work in Buenos Aires and Córdoba, another confirmation that the sculptor mastered

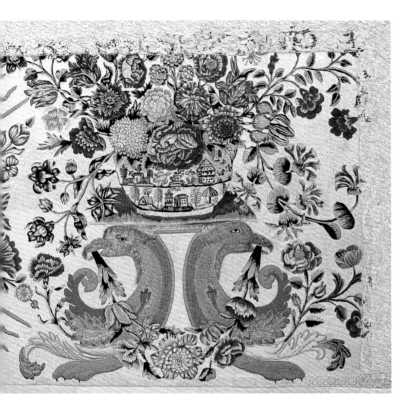

70. *Dove of the Holy
Spirit* altar frontal,
Ursuline workshop,
Quebec City, about
1700. Embroidery
with silk, wool, and
gold and silk metallic
threads, trimmed
with needle lace,
95.5 x 264 cm (37⅝ x
103⅞ in.)

his craft while still in the Philippines.[41] It is possible that the Dominicans arranged
for Sampzon's transfer to Buenos Aires, since his first residence there was in the
Dominican monastery of San Pedro Telmo, adjacent to the church of Nuestra Señora
del Rosario (now popularly known as Santo Domingo).

Sampzon's only firmly documented sculpture is the *Penitent Saint Dominic*
(1800), made for the Dominican sacristy in Buenos Aires.[42] His work is marked by
an extraordinary realism, a dancelike gracefulness in pose and gesture, the tendency
toward elongated faces, and a keen eye for human suffering. Three sculptures of the
Ecce Homo survive in Buenos Aires, the best of which is the moving *Christ of Patience
and Humility* at the church of La Merced. His Córdoba sculptures, however, are the
finest, including his masterpiece, the *Saint Matthew and the Angel* group, part of a se-
ries of the four Evangelists he executed for Córdoba Cathedral before 1805. In an inge-
nious ballet of gestures, Matthew lifts up his hands to acknowledge the raised hands
of the child angel standing next to him, a vivid representation of the transmission of
divine knowledge from angel to saint. Despite his many commissions and status as
the only *santero* (sculptor of religious imagery) in Córdoba, Sampzon died in relative
poverty shortly after 1827.[43]

French missionaries, notably Jesuits, created yet another network between
Asia and the Americas. They had missionary bases in Vietnam, Pondicherry (India),
Ottoman Turkey, and China. In the New World, they were very active in the areas
of North America that comprised Nouvelle-France. Jesuits, Recollects, Sulpicians,
and Ursuline nuns worked among Native American groups including the Hurons
(Wyandots or Wendats), Iroquois (Haudenosaunees), and others in the Great Lakes

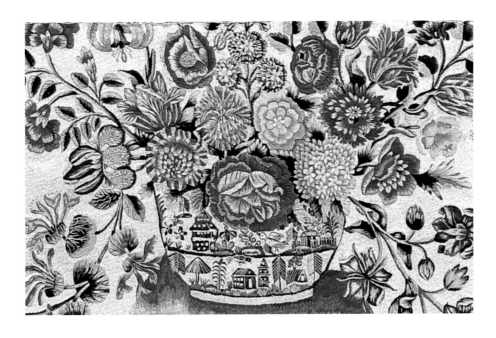

and Mississippi Valley regions in the seventeenth and eighteenth centuries. French missions were celebrated in publications such as the Jesuit *Relations* (*Relation de ce qui s'est passé aux missions des pères de la Compagnie de Jesus en la Nouvelle France*, 1632–72), a veritable encyclopedia of Jesuit activities in North America, and the *Lettres édifiantes et curieuses* (1702–76), which related Jesuit adventures in Asia and America alike.

Asian arts came into the picture not through the Jesuits but in the Ursuline ateliers in Quebec City.[44] A dominant presence in Nouvelle-France from 1639, the Ursulines were unique among female religious orders in the Americas in the degree to which the French colony relied on their arts production. From their convent workshop they furnished its churches with liturgical embroideries—their textiles rank among the most splendid in the colonial Americas—and from 1717 on they gilded and painted the city's sculptures and sculptural panels, adorning them with delicate patterns and landscapes.[45] They also carried out more direct and sustained missionary activities among Native Americans than did their more cloistered counterparts in Spanish and Portuguese America, interacting with aboriginal girls and women through education and crafts work in their schools in Quebec City and elsewhere and on indigenous missions. Several of their altar frontals were probably made for the Jesuit mission of Notre-Dame-de-Lorette, founded in 1674 for displaced Huron Catholics who had fled the Great Lakes region after the collapse of the Jesuit missions earlier in the century.[46] The forty-seven surviving embroidered altar frontals made by the Ursulines are multimedia and labor-intensive productions that involved painting, gilding, high-relief quilting, and embroidery.

It was in these embroideries that the nuns began to incorporate Asian motifs (blue-and-white porcelains, pagodas, birds of paradise) into designs that also combined French and Native American figures. Their very choice of Asian-inspired colors and depictions of porcelains may have been inspired by Jesuit attempts to determine a palette that would appeal to Amerindians: the Jesuit missionary Charles Garnier

noted in 1645 that the Hurons responded well to "a fine red and fine blue." The reds inspired by Chinese lacquers and the bright cobalt blues of porcelains—both Chinese and imitation-Chinese made at the Rouen kilns—would have fit the bill.[47] The most important series of the Ursuline "missionary embroideries" are the frontals known as the *Dove of the Holy Spirit*, the *Immaculate Conception*, and the *Sacred Heart of Jesus*, all made about 1700, which feature vases of flowers, garlands, and griffins against an off-white background. The *Dove of the Holy Spirit* depicts the most elaborate blue-and-white Chinese-style vases and incorporates indigenous imagery (longhouses, wooden palisades, Native American hunters) into the otherwise Asian motifs of pagodas, flowers, and birds (fig. 70). Although these representations of aboriginal people are largely fanciful, the Ursulines did subsequently adapt aspects of Native American imagery, creating works in the so-called *style barbare*, which appealed to a growing curiosity for such things on the part of the French and then the British after the conquest of Quebec in 1759–60.[48]

THE ASIAN AMERICAN artistic encounters initiated by the Catholic missionary orders are interesting not merely from a historical point of view or because of the novelty of the works of art they engendered: they also offer fascinating insight into the ways the visual arts can mediate between cultures. The privileged position missionaries occupied, well beyond the limits of European expansion, and their emphasis on arts training among non-Europeans, created a catalyst for deeply acculturative artworks combining European, Asian, and Amerindian forms to such an extent that they are no longer "purely" the product of any of the three. And far from being a simple by-product of Euro-Christian conquest—paradoxically, since it was often their purpose to celebrate Catholic world hegemony—these paintings, sculptures, and tapestries with their Hindu gods or Brazilian flora testify to a dialectic between cultures. They reveal commonalities, parallels, misunderstandings, and even hostilities that reflect the cultural diversity of the artists and societies that created them and a reality in which non-Europeans—beyond the conquered zones at least—usually had no intention of converting to an imported religion but were willing to engage through the arts.

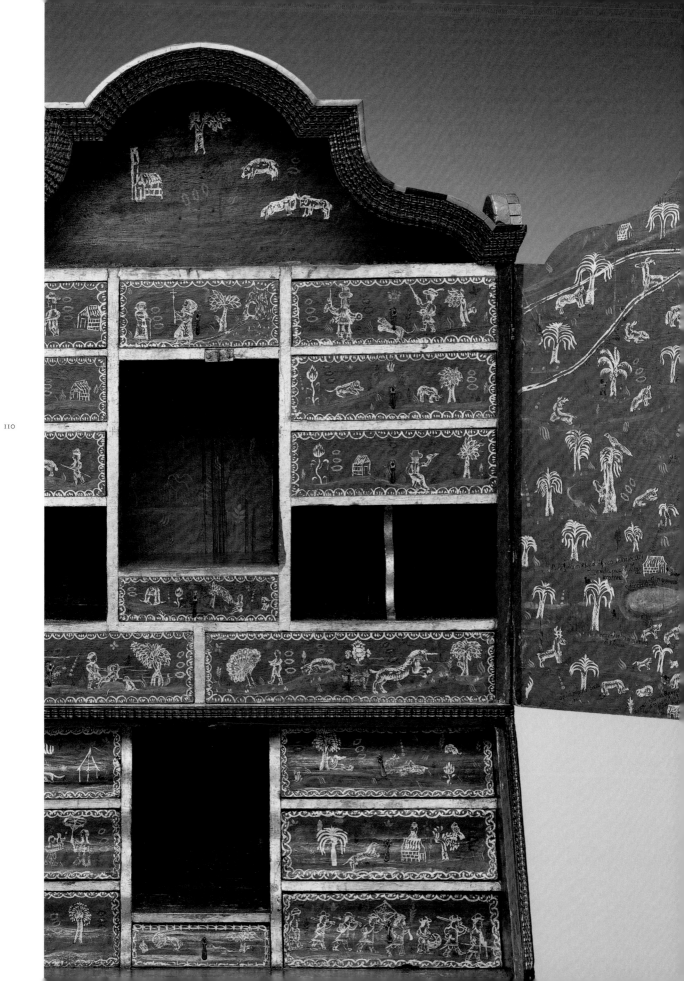

CHINOISERIE
in the Colonial Americas

DENNIS CARR

BY THE LATE seventeenth century, the burgeoning commercial networks between Europe and Asia and rising general interest in the East among intellectuals and tastemakers in Europe had evolved into a fashion for Asian art, today known as chinoiserie (meaning "in the Chinese taste"). Chinoiserie as a decorative style developed first in the French court of Louis XIV and quickly spread across the courts and gentry of Europe, reaching its height by the mid-eighteenth century. A style that spanned both the baroque of the late seventeenth century and the fanciful rococo style of the eighteenth, chinoiserie freely adapted a broad range of Asian prototypes and infused them with whimsical, inventive, and romantic visions of the exotic East. Pagoda temples sprang up in formal English gardens, Chinese birds took flight on elaborately carved chimneypieces, and painted Asian-style figures glided across the fronts of cabinets among flowers twice their size, in a playfully incongruous menagerie. A satirical writer in the 1750s asserted: "So excessive is the love of Chinese architecture become, that at present the foxhunters would be sorry to break a leg in pursuing their sport over a gate that was not made in the Eastern fashion of little bits of wood standing in all directions."[1] Far from the enlightened intellectual culture that came out of Asia,

specifically China, in the seventeenth century, chinoiserie of the eighteenth century promoted a luxurious material culture that was filtered through the prevailing European tastes in architectural, interior, and furniture design. It was only a matter of time before this fashion spread to Europe's colonies in the Americas, which had themselves been receiving direct importation of luxury goods from Asia on a vast scale, in some regions for more than a century.

Yet, once European chinoiserie began to wash up on the shores of the Americas, its artistic influence was just as powerful on the material culture of the Americas as that of the Asian imports. Members of the gentry of the American colonies and vice-royalties still defined themselves largely in relation to the European courts, and they inevitably saw Asia through European eyes. In the Americas, this style manifested itself as it had for the gentry in Europe, in lavishly painted and decorated interiors, ornate furniture, sartorial embellishments, and ceramic objects created in the style of Chinese blue-and-white porcelain. In Catholic Latin America, unlike in Protestant North America, chinoiserie was also to be found in ecclesiastical contexts, such as interior church architecture and furnishings in Brazil, Colombia, Ecuador, and Guatemala; it also appeared in the embroidered textiles of the Ursulines of Quebec, in Catholic Nouvelle-France. The fashion for japanning, a painted imitation of Japanese lacquerwork on furniture and wall paneling, spread throughout New England, New Spain, the Caribbean, and parts of South America. This decorative style went hand in hand in the Anglo world with the popularity of drinking imported Chinese tea, which was all the rage during the eighteenth century. By 1758 the English writer Robert

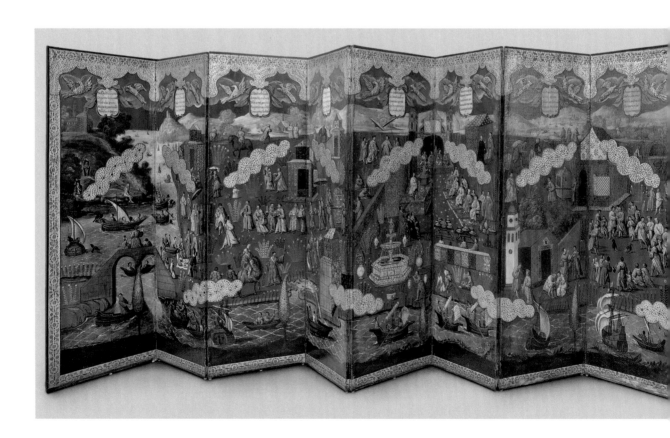

Dossie noted that the desire for luxury "prevails not only in the European countries, but in the respective settlements of their people in Asia and America."[2] By embracing this distinctly European and globally oriented style, residents of the colonial Americas both celebrated the global reach of their respective mother countries and asserted their own position within the worldwide market for Asian goods and ideas.

New Spain, positioned at the heart of the transpacific and transatlantic trade between Asia and Europe, was one of the earliest places to embrace this new style.[3] Mexico, in particular, had been receiving prodigious quantities of Asian export goods from the sixteenth century onward, and New Spanish artists created objects that imitated the luxurious Asian ceramics, textiles, lacquered furniture, and Chinese and Japanese folding screens that had been imported aboard the Manila galleons and brought as gifts by traveling emissaries. Yet artists and patrons still looked to Europe for inspiration, and the view of Asia presented in chinoiserie-style objects of the late-seventeenth and eighteenth centuries made in New Spain is overtly European, inspired by European printed and written sources. Part of what defines chinoiserie is the reliance for its designs on printed materials from Europe that circulated throughout the world. Works such as Johannes Nieuhof's *Embassy of the East India Company* (1665), the Jesuit Athanasius Kircher's encyclopedic *China illustrata* (1667), and William Dampier's *A New Voyage Round the World* (1697) were part of a lively print culture in Europe that promulgated ideas and images of Asia to an audience hungry for news of Europe's spiritual and mercantile conquests in the Far East.[4]

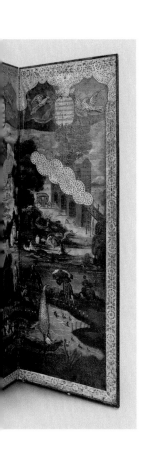

An extraordinary early example of the chinoiserie style in Mexico is a *biombo* screen painted in the late seventeenth century (fig. 71). Stretching nearly twenty feet, the screen is composed of ten oil-on-canvas panels painted in a continuous narrative that spans its length.[5] Its size suggests that it was used in a salon in a grand Mexican house.[6] This screen relates to the tradition of biombo production in New Spain but it draws more inspiration from European conceptions of Asia via printed texts and European stylistic elements. The stylized "golden cloud" motifs that punctuate the scenes recall traditional Japanese Momoyama-period screens, but the raised, multicolored ornament is reminiscent of Spanish cordovan leather tooling that was a remnant of the Moors' centuries-long occupation. The arches at the top of each panel also have a pronounced Moorish character, as do the teardrop-shaped trees that dot the landscape.

This screen stands out among other seventeenth-century Mexican biombos for the strongly Chinese (rather than Japanese) style of its imagery, its rare depiction of Asian subjects, and its reliance on European printed books. The direct source for much of the imagery is the Portuguese Jesuit Álvaro de Semedo's popular account of the Chinese court, republished widely in various editions and languages during the seventeenth century, including the well-known Spanish version, *Imperio de la China* (1642). Semedo's book was adapted by Olfert Dapper in his illustrated encyclopedic history of the Dutch East India Company, printed in Amsterdam in 1670; that volume was republished the following year in English as Arnoldus Montanus's *Atlas Chinensis*, an illustrated compendium of Chinese life and culture that circulated widely in the Americas.[7] These later illustrated sources did much to popularize Semedo's account, and it is possible that they had the most direct influence on the screen, which was made likely within a decade or two of their publication.

For example, the scene of the procession on the third and fourth panels closely recalls a passage from the text describing the elaborate processions of the Chinese rulers (quoted from Montanus):

114

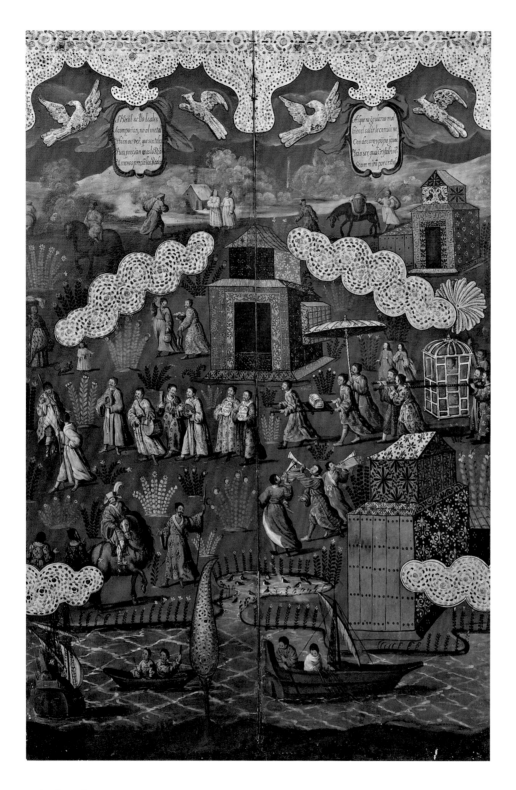

El Real sello leales
Acompañan, no al metal
Quien au Der, que son telas
Pues precian mas lo Real
Amenos preciables Reales

A que su govierno mal
Sibic el salir le cenuic ne
Con de corey pa pa jejum
Esta a ser qual Crystal vne
Sca m mira por erstut

72. Panels 3 and 4
of the biombo shown
in fig. 71

The most eminent *Mandarins* (according to *Semedo*) send two of their Men a good distance before them, each with a Cane of about a Mans length, striking all the way that they go. . . . Behind these follow two more with Silver Plates, fasten'd to the end of a Stick, on which in great Characters is Ingraven the Title and Quality of the *Mandarin*: Then come four more, Trailing Cords of Cotton, others Chains in their Hands, and such like Instruments of Punishment. . . . Just before the Sedan is carry'd the Emperor's Seal, in a Golden Cabinet, on a Bier; . . . several walk before, which on Copper Basons, Bells, Tabers, Trumpets, and other Instruments, make a pleasing sound.[8]

On the panels showing the procession, inscriptions in the cartouches at the top of each panel read: "To the royal seal they are loyal / They follow not the metal / And one can see that they are such / Because they appreciate more the royal / And depreciate the money" and "To the one who governs poorly / It is better that he goes / With decorum and pomp equally / And if he is to be like crystal / He should be seen through crystal."[9] The mandarin is shown being carried in a glass litter, a symbol of his transparency as a ruler (fig. 72). Each panel contains similar rhyming verses describing the action presented in the scene, each conveying a moralistic, often satirical message related to virtuous behavior and good government in a poetic language typical of popular Spanish literature of this period. The screen borrows liberally from sections of Dapper as well, including the scene of cormorant fishing on panels 1 and 2, which correspond to his description; and the depiction of cockfighting on panels 7 and 8, which follow Kircher's elaborate accounts of the sport in *China illustrata*.

One can imagine a group of viceregal elites gathered around this screen, pausing to admire the strange images of China and finding humor in the thinly veiled critiques of European society. For Jesuit intellectuals, such as Kircher, and for many sympathetic elites of New Spain, China offered a model of an ancient, ordered, and virtuous society, one to be emulated by Europeans. Throughout the screen, figures wearing the distinctive black habits and cornered hats of the Jesuits interact freely with the Chinese characters, suggesting the order's spiritual successes in Asia. Yet the setting of this screen is an elaborate fiction. Sections of it may indeed relate to specific areas of Mexico City, especially the canals and waterways on the outskirts of the city; however, most of the composition is a fanciful composite of views of China presented through the lens of European sources.[10] The red ground of the central passages of the screen relates stylistically to Asian as well as European lacquers, but it is also an artistic convention that distinguishes this as an imaginary landscape, reviving the Renaissance trope of the New World as Cathay. The blend of visual and literary influences in this chinoiserie fantasy merge in Mexico, a place of significant social and cultural heterogeneity—as though Mexico were a virtual middle ground between Asia and Europe, a New World that might take heed of the moralizing messages contained in the screen.

As intellectual interest in China during the seventeenth century gave way to more fanciful designs of the eighteenth century, chinoiserie appeared in elite viceregal homes in Mexico. Here Asian imports, such as screens, carpets, porcelains, and costly textiles, sold in places like the Parián market in Mexico City and along the overland route of the Manila galleon trade, mixed with locally made objects created in the Chinese taste. In an extraordinary ex-voto painting from about 1751, a Chinese or Chinese-style folding screen stands at the foot of an elaborate bedstead whose headboard is painted with chinoiserie designs on a vermillion ground. The headboard was undoubtedly of local manufacture, as examples of this type survive in Mexico (fig. 73; see fig. 7).[11] Among the other furnishings shown in the painting, depicting the opulent bedroom of Don Juan Garcia Truxillo, a

prominent Mexico City merchant, are a costly imported carpet and elaborate red silk hangings on the bed and in the doorway, and glass, silver, and porcelain vessels on the table.

The detailed 1784 inventory of the grand residence of the Count of Xala in Mexico City distinguishes between objects imported from China and those made locally with chinoiserie motifs, called *achinado*, or in a Chinese style.[12] The record identifies as Chinese a table, several chests, and four folding screens of "Chinese lacquerware." Another dozen objects are listed as "achinado," including two large red armoires, a chest of drawers with Chinese figures on a blue ground, a round table, and a red clock. Other pieces are described as *maque*, a term for locally produced lacquerwares. Similarly, the inventory of another prominent household, the Cortés del Rey hacienda, lists a "lacquerware bookstand" not specified as being from China, which indicates it may have been of Mexican manufacture.[13] These inventory references detail the mixing of both imported and locally produced objects in elite households, as well as the recognizable local chinoiserie styles that were readily identified by the appraisers.

Among the most well known of the locally produced objects of the period in a chinoiserie style were lacquerwares made in the western state of Michoacán. Here European chinoiserie lacquerwork blended with an indigenous tradition of lacquer production during the late seventeenth and eighteenth centuries, first in Peribán and later in the area of Pátzcuaro. The most celebrated of the colonial lacquer artists in Pátzcuaro was the indigenous painter of noble origin Manuel de la Cerda (or Zerda), who signed two of his surviving pieces: a large *batea* thought to have been made for the Marquesa de Cruillas, wife of the viceroy of New Spain; and a marvelous desk-on-stand of distinctly Anglo-Dutch design (fig. 74). The desk exemplifies De la Cerda's painting in the chinoiserie style, showing

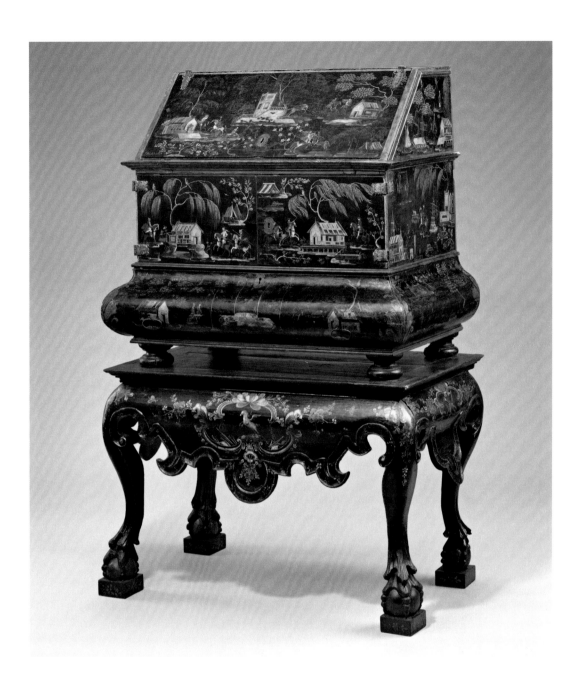

74. José Manuel de la Cerda (Zerda) (active mid-18th century). Desk-on-stand, Mexico, about 1760. Linden wood with Mexican lacquer and polychrome decoration, Spanish cedar, 154.9 x 102.1 x 61 cm (61 x 40³/₁₆ x 24 in.)

exotic-looking buildings and weeping willow trees delicately picked out in gold paint on a black background. Also featured are figures on horseback with sabers drawn, cannons laying siege to a city, and military campaign tents, recalling the famous battles of the Moors and Christians that were reenacted in festivals in New Spain during the eighteenth century.[14] Like both Asian and European examples, De la Cerda's desk turns furniture into a narrative surface, where scenes are played out both horizontally and vertically on the doors, drawers, and sides. Although the source for De la Cerda's imagery is not known, he often shows figures in contemporary Western clothing inhabiting his scenes, providing a contemporary setting for images of historical conquest and encouraging European viewers to project themselves into the scene.

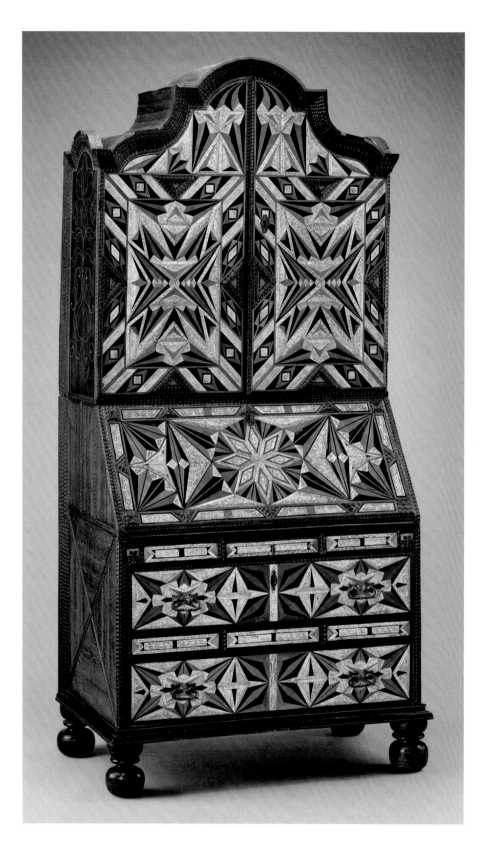

75. Desk and bookcase, Puebla de los Ángeles, Mexico, mid-18th century. Inlaid woods and incised and painted bone, maque, gold and polychrome paint, metal hardware, 221 x 104.1 x 67.3 cm (87 x 41 x 26½ in.)

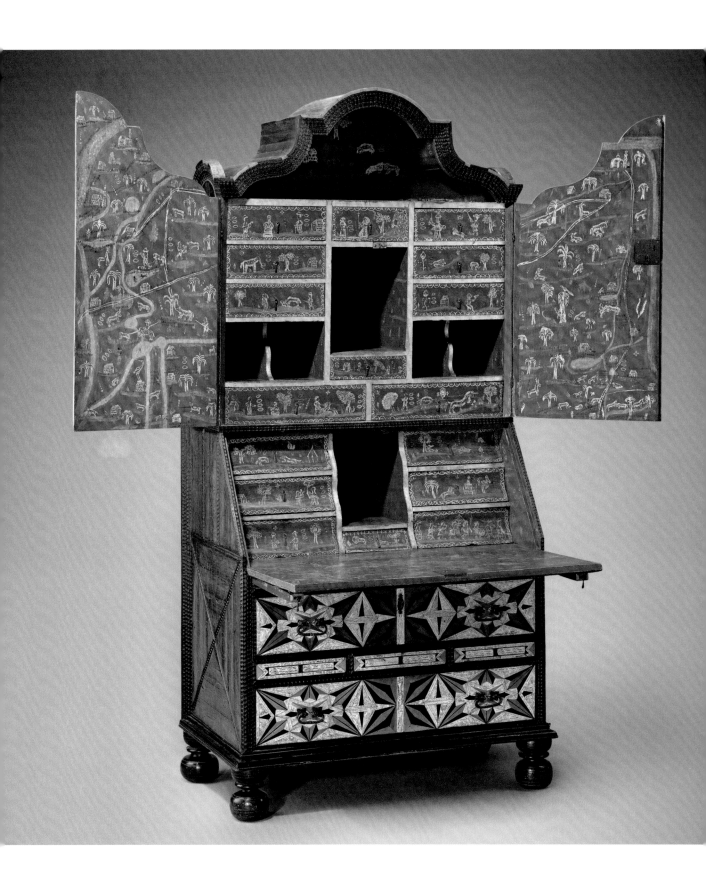

Chinoiserie-style painting also appears on a group of furniture made in the mid-eighteenth century in the city of Puebla, home of the talavera potteries and one of the stops along the trade route bringing Asian objects from the Pacific coast. Among the most extraordinary of these are a pair of desks and bookcases with inlaid and incised bone decoration (fig. 75). The exterior facade displays striking geometric Mudéjar designs of bone and wood, a Hispano-Moresque style popular in Mexico in the eighteenth century, while the interior displays chinoiserie-style painting in gold on a red background. The maps on the inside of the doors show views of an extensive hacienda in Veracruz owned in the sixteenth century by the wealthy Don Gaspar Miguel Rivadeneira Cervantes. They are rendered in a style that recalls chinoiserie painting of the eighteenth century but also relates to indigenous mapping traditions of Mexico, as seen on early colonial maps of the region created by Nahuatl-speaking artists.[15] This mixing of European and indigenous sources extends to the material as well: the red background is likely maque (from the Japanese *maki-e*), an indigenous lacquer made of the oils of the *aje* beetle and chia seeds, mixed with clay and pigments, that was used in pre-Hispanic Mexico.

Among imported lacquerware, Japanese lacquer boxes and trays were some of the most prized objects of the Asia trade with Europe, and once Japan was closed to direct trade with the West in the early seventeenth century, tighter supplies of these precious commodities only increased demand. European artists could not replicate the hard, durable surfaces of true Asian lacquerwork, but during the seventeenth century they developed ingenious methods of simulating it, which they called "japanning," or in Spanish *barniz* (varnish) or, more specifically, *barniz à la Chineza* (varnish in the Chinese taste). European artists' manuals, such as William Salmon's *Polygraphice* (1672) and John Stalker and George Parker's *Treatise of Japaning and Varnishing* (1688), suggested ways to imitate Asian lacquers using traditional European painting and finishing materials. These methods involved covering the surface of a decorative object with multiple layers of pigmented varnish, on which artisans often painted figures and scenes in an Asian style, gilded and embellished with colored glazes and metallic paints and powders. Stalker and Parker even provided plates of images based on Asian designs for copying; or, practitioners could paste cutouts from the book directly on objects and varnish over them, in the technique known as *decoupage* or *lacca povera*. The authors claimed to have studied Japanese originals and to "have exactly imitated their Buildings, Towers and Steeples, Figures, Rocks, and the like, according to the Patterns which the best workmen amongst them have afforded us on the Cabinets, Screens, Boxes, &c." Yet they were not shy about having "helpt them a little in their proportions, where they were lame or defective, and made them more pleasant, yet altogether as Antick."[16] Although the earliest known copy of Stalker and Parker's *Treatise* in colonial America was recorded in Philadelphia in 1783—some fifty years after the rage for japanned furniture in Anglo America was at its height—it is nonetheless plausible that this widely read treatise provided indirect inspiration for the many European-trained japanners who plied their trade throughout the American colonies, from Boston to Brazil.[17]

Among the other early European sources on japanning that circulated in the Americas included Salmon's *Polygraphice*, which was available for sale in Boston by 1719.[18] For more general readers, the *Gentleman's Magazine* in February 1736 featured "Instructions in the Arts of Japanning with the True India Varnish," and copies are known in American libraries.[19] Robert Dossie's two-volume *Handmaid to the Arts* (1758) appeared in the collection of the Library Company of Philadelphia by 1765.[20] Artists and patrons in Latin America were more likely to consult the Italian Jesuit Filippo Bonanni's

76. Jean Berger
(active 1718–1732).
Page from manuscript
book, Boston, 1718,
Watercolor on paper,
14 x 12.7 cm (5½ x
5 in.)

Tratado sopra la vernice (Treatise on Varnish, 1720) or its Spanish translation by Genaro Cantelli, *Tratado de barnizes*, published in Valencia in 1735.[21] Even where these books were not available, imported japanned objects from Europe could have also served as models for local craftsmen.[22] A European source was probably known to the French Huguenot painter Jean Berger, who created in Boston in 1718 a remarkable manuscript book of chinoiserie designs, with conventional imagery of Asian-style buildings, trees, and birds set within a fanciful composition (fig. 76).[23]

European craftsmen trained in the art of japanning probably had the single greatest impact on the development of the style in the American colonies, such as in the British West Indies and also in Boston, which became one of the leading centers of the production of japanned furniture during the early eighteenth century.[24] In Port Royal, Jamaica, a group of English-trained furniture makers was likely producing japanned furniture for local clientele.[25] In Boston, the first craftsman known to have specialized in japanning was Nehemiah Partridge, who advertised in the *Boston News-Letter* in 1712 that he did "all Sorts of Japan Work" at his shop on Tremont Street.[26] Robert Davis, who apprenticed as a japanner in England, immigrated to Boston sometime after 1717 and worked closely with his father-in-law, the Boston japanner William Randle; he later entered the business of making and selling looking glasses.[27] In 1726 the Boston cabinetmaker William Price advertised, "Jappan Work, viz. Chest of Drawers, Corner Cubboards, Large & Small Tea Tables, &c. done after the best manner by one late from London."[28] Thomas Johnston became one of the city's most prominent japanners by the 1740s, creating furniture for the Boston elite, along with coats of arms and other decorative painted objects.

He had four sons in Boston, Thomas Jr., William, Benjamin, and John, who took after him in the trade, and a son-in-law, Daniel Rea, who also became a partner in the family business.[29] The more than fifty surviving pieces of furniture from Boston decorated in this fashion testify to the city's robust trade that linked furniture makers and decorative painters.[30]

The most common forms of japanned furniture in Boston included pieces typically found in bedchambers, such as high chests, dressing tables, and looking glasses; others, such as tall case clocks, tea tables, and tea boards, populated more public parts of the house. Tall clocks, like this example made in Boston, would have been an object suitable for a fashionable parlor or public space. This clock has one of the best-preserved surfaces of eighteenth-century japanning in Boston and shows the various layers of the complex built-up surface with oil paints, gesso, glazes, and metallic powders (fig. 77). Though even the high-style Boston japanning did not reach the level of sophistication achieved by the most technically complex European prototypes, its practitioners created dazzling visual effects and rich surface treatments that surpass the fanciest painted American furniture of the time. The technique remained popular in other Anglo colonies as well throughout the eighteenth century; japanners were active in New York by the 1730s and later in Philadelphia.[31] The vogue in New England continued well into the nineteenth century.[32]

Boston japanning typically was painted directly on the wood substrate, usually locally available maple or pine. The painter started with a base of lampblack to simulate Japanese lacquer, or broad brushstrokes of lampblack (or dark brown paint) over a red ground to simulate tortoiseshell. Boston japanners often added raised figures in gesso, which were painted in oil paints and then highlighted with glazes and metallic powders, as seen in a high chest made in Boston in the 1730s (fig. 78). The powdered bronze, silver, or gold was sprinkled over a size, such as hide glue, to adhere it to the surface. In 1734 William Randle charged the Boston cabinetmaker Nathaniel Holmes for "Jappanning a Piddement [pediment] Chest & Table Tortoiseshell & Gold."[33] The final step was to add "penwork," applied with a fine brush to give figures definition and detail.

77. Works by John
Doane (1733/34–1801).
Tall case clock, Boston,
1738–41. Pine with
japanned decoration,
241 x 43.7 x 23.5 cm
(94⅞ x 17¼ x 9¼ in.)

78. John Pimm
(active by 1735, died
in 1773), japanning
attributed to Robert
Davis (died in 1739).
High chest, Boston,
1730–39. Soft maple,
black walnut, white
pine, mahogany, with
japanned decoration,
216.5 x 106.7 x 64.1 cm
(85¼ x 42 x 25¼ in.)

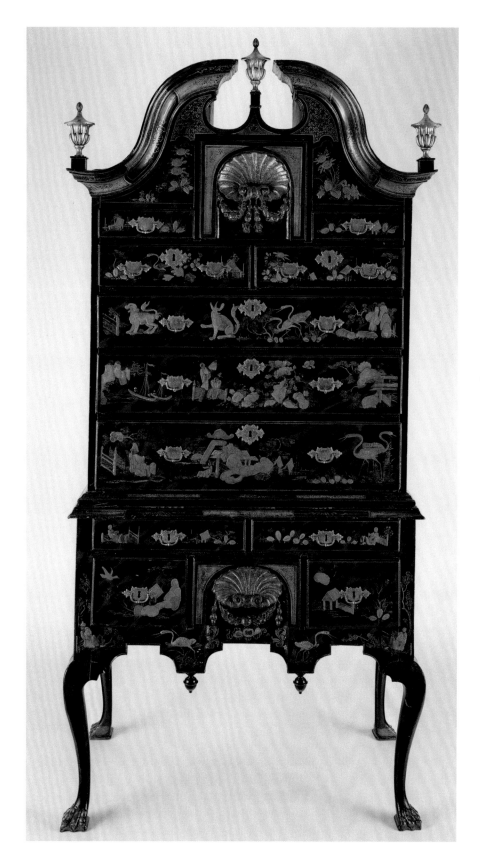

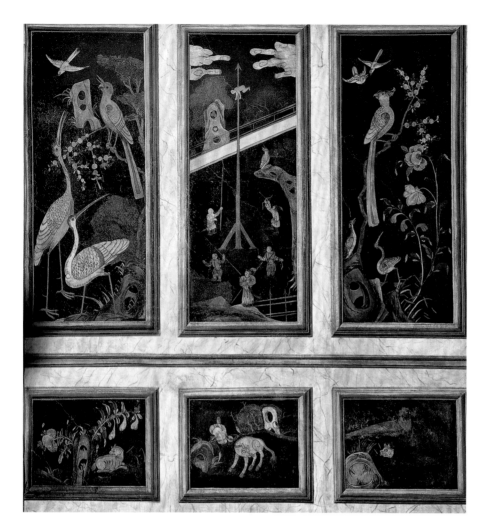

79. William Gibbs
(died in 1729). Painted
wall mural, Vernon
House, Newport, Rhode
Island, 1710–29. Oil on
plaster

Most chinoiserie-style painting in New England in the eighteenth century was confined to fashionable furniture, but a rare example of architectural painting survives in the eighteenth-century Vernon House in Newport (fig. 79). The artist likely responsible for these wall paintings is William Gibbs, a Boston decorative and sign painter who moved to Newport around 1708 and was the owner of the house until his death in 1729. In the 1930s workmen investigating a leak behind later wooden paneling in the parlor discovered sixteen painted scenes that had been hidden from view since the eighteenth century. The painted panels feature scenes of Chinese architecture, birds, craggy rocks, and flowers, alongside three rather vivid scenes of torture. The format and imagery in these wall paintings suggest that Gibbs was not copying from any one particular source but, rather, had access to objects from Asia, such as Coromandel screens produced in China and Asian export porcelain wares, as well as European printed materials.[34] Although the wall paintings were executed in oil paints, without the layering and metallic powders often seen in japanned furniture, Gibbs may have also produced such pieces, as a japanned high chest, table, and looking glass are recorded among the contents of his house just two years after his death.[35] A nineteenth-century account suggests the pres-

ence of an original painted fresco, now lost, on the second floor of the house, depicting scenes of "the West Indies, or South America."[36]

Architectural chinoiserie painting can be found in other areas of the Americas in the eighteenth century—in particular Brazil, where a number of churches boast lavish interior treatments in the style, and in Guatemala in the Church of La Merced. The Brazilian churches are concentrated largely in the former captaincy of Minas Gerais (General Mines), in the southeastern highlands some two hundred miles north of Rio de Janeiro. The discovery of gold in this region in the seventeenth century made it briefly one of the wealthiest areas in the Portuguese Empire. A flurry of church building followed, sponsored mostly by private donors, as the Mendicant orders were prohibited by the Portuguese Crown from operating in this region. One such example is the small chapel of Nossa Senhora do Ó, built about 1718 in Sabará, which features some of the earliest japanned decoration in Brazil (fig. 80). These paintings, executed on seven large panels surrounding the altar, depict scenes of pagoda-roofed buildings, ships, and birds in a decorative ensemble that stands apart from and yet harmonizes with the lavishly painted and carved Baroque interior. The japanned background is done in dark blue, possibly Prussian blue, an expensive synthetic pigment that was available only after 1708, with gold figures painted on top. Once thought to have been painted by an artist trained in Asia, these panels are clearly done in a European chinoiserie style.[37] These

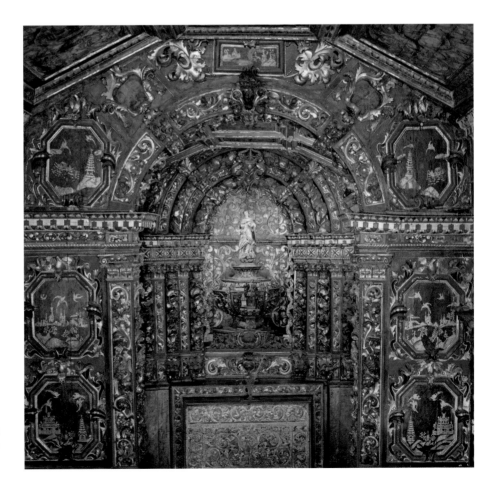

80. Altar panel, Nossa Senhora do Ó, Sabará, Brazil, about 1718. Oil and gilt on board

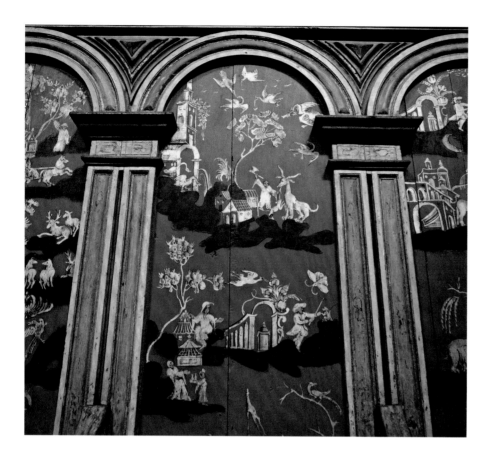

paintings would have projected a distinctly global feel to the worshippers in this small chapel in a tiny mountain town.

Despite its remoteness, Minas Gerais was connected to the markets in Rio de Janeiro, where its gold was traded for Asian commodities brought by Portuguese merchant ships. Chinoiserie painting there would have celebrated the global power of the Portuguese Empire during its expansion under João V, as well as embraced the fad for chinoiserie just as it was becoming popular in Portugal.[38] Other churches in Minas Gerais boast interior decoration in this style, such as Nossa Senhora da Conceição in Catas Altas and Igreja do Santana in Barão de Cocais, and many examples of religious objects, such as oratories, are also decorated with fanciful chinoiserie elements, from Minas Gerais, Bahía, and other regions.[39]

The largest and most impressive example of chinoiserie architectural painting in Minas Gerais adorns the cathedral in Mariana. The chancel of the cathedral features two large choir stalls leading to the main altar, where twenty seat backs are painted in gold over a red ground. In this instance, a European object may have provided the inspiration for the painting in the choir, as the cathedral also features a large Hamburg-built Arp Schnitger organ with a red chinoiserie-decorated case, a gift from the Portuguese Crown that was installed in the cathedral sometime after 1753.[40] The decoration on the seats is reminiscent of passages of chinoiserie decoration on the organ; however, the stalls are far more elaborate: figures in gold and silver cavort on irregular outcroppings of rock that were rendered in silver paint, now darkened and tarnished (fig. 81.)

82 and 83. Cornelius
Kierstede (1674–about
1757). Candlesticks
and snuffer stand, New
York, about 1705. Silver,
each candlestick: 29.8
x 16.5 x 16.5 cm (11¾ x
6½ x 6½ in.); snuffer
stand: 20.8 x 13 x 13 cm
(4¼ x 5⅛ x 5⅛ in.)

For much of colonial America, England provided a major source of inspiration for the chinoiserie-style objects that filled fashionable homes across the continent. The cabinetmaker Peter Hall advertised that at his shop in Charleston, South Carolina, "gentlemen and ladies of taste may have made, and be supplied with, Chinese tables of all sorts, shelves, trays, chimney pieces, etc., being at present the most elegant and admired fashion in London."[41] Boston newspapers eagerly reported the arrivals of shipments of Chinese tea in London in the 1740s, noting their quantity and variety.[42] Imported English chinoiserie pattern books, such as William and John Halfpenny's *New Designs for Chinese Temples* (1750–52), Matthias Darly's and George Edwards's *A New Book of Chinese Designs* (1754), Thomas Chippendale's *Gentleman and Cabinet-Maker's Director* (1754; 3rd edition, 1762), and William Chambers's *Designs of Chinese Buildings* (1757), circulated widely and were found in colonial libraries. Imported from London or made by local craftsmen, Asian-style objects reflected the worldly, fashionable taste of generations of colonial Americans.

Among the earliest expressions of chinoiserie in American silver is a set of candlesticks and snuffer stand made by the New York silversmith Cornelius Kierstede around 1705 with images of exotic figures in the English mode (figs. 82 and 83). While such decoration was popular in England beginning in the 1670s, chinoiserie chased decoration is rare in colonial American silver.[43] The bases of the candlesticks and snuffer stand are embellished with gesturing figures, accompanied by oversized birds and plants, in an individualistic style. These images may derive from English patterns for embroidery or costume designs; however, it has been suggested that the figures with feathered headdresses and feather skirts may in fact have a South American origin.[44] This rare silver group was made for Johannes Schuyler and his wife, Elizabeth Staats Wendell, around the time that Schuyler served as mayor of Albany, New York.

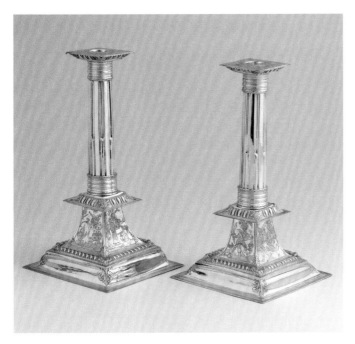

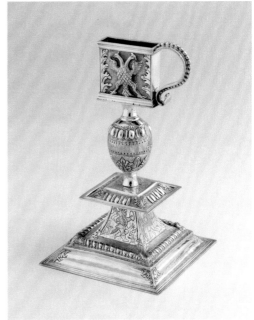

By the end of the seventeenth century, the burgeoning Atlantic trade and the growing fortunes of the Boston mercantile aristocracy contributed to the rise of an elite culture tied to the global circulation of goods. Successful New England merchant families, such as the Pickmans, Hancocks, and Lees, who made their money in Atlantic commerce, owned large quantities of imported China wares, expensive cotton and silk textiles imported from India, China, and Europe, luxurious bed hangings in the chinoiserie style, and japanned furniture made by both local and English craftsmen.[45] Benjamin Pickman was said to have owned a suite of elaborate Boston japanned furniture in a bedchamber in his fashionable Salem, Massachusetts, residence.[46] Thomas Hancock ordered chinoiserie wallpaper from England in 1738 for his grand house in Boston.[47] Sir William Pepperrell of Kittery, Maine, owned a Boston-made silver teapot in the shape of English chinoiserie prototypes and imported Chinese ceramic examples (fig. 84).[48]

The popularity of tea drinking in the Anglo colonies produced an elaborate material culture of locally made objects for preparing and consuming the addictive commodity that were on a par with those from England. Teapots, hot water urns, sugar bowls, creamers, strainers, teaspoons, and salvers were all part of the elaborate British ritual of taking tea. As the price of tea dropped in the eighteenth century, the beverage became available to a broader segment of colonial society.

To complement the japanned high chests and dressing tables and the imported English chintzes and Indian cottons that furnished the homes of the Boston elite, local embroiderers also made elaborate objects in the chinoiserie style. These included bed hangings, upholstery, and showpieces to be framed and displayed on the wall.[49] Some of the designs for these embroideries were provided by professional japanners, such as David Mason, who advertised in 1759 that he offered "Drawing on Sattin or Canvis for Embroidering" at his shop in Boston, "where all Sorts of Painting, Japanning, Gilding and Varnishing are done."[50] Abigail Hiller, who ran a boarding school for girls in Boston in the 1740s and 1750s, advertised that she taught

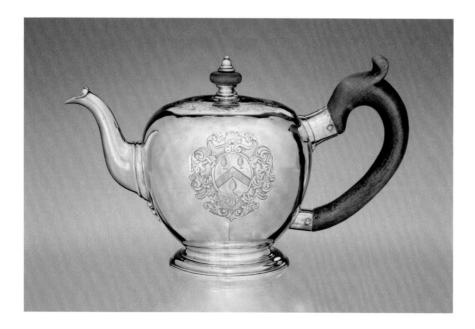

84. Jacob Hurd (1702–1758). Teapot, Boston, about 1740. Silver, 13 x 22.5 cm (5⅛ x 8⅞ in.)

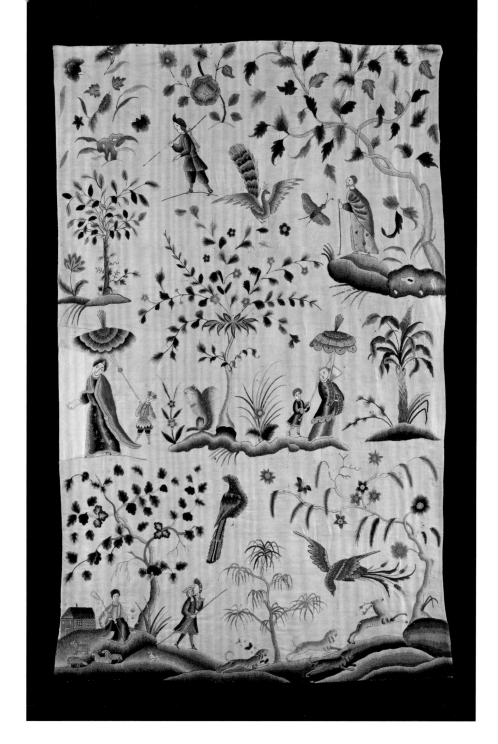

85. Bed curtain, possibly Boston, early 18th century. Cotton twill, embroidered with wool, 188 x 135 cm (74 x 53 in.)

"Japanning, Quill-Work, Feather-Work and embroidering with Gold and Silver, . . . with Patterns and all sorts of Drawing, and Materials for this Work."[51] A bed hanging that may be an example from Boston in this period is worked with exotic birds, flora, and Eastern figures, arrayed in a fanciful design reminiscent of English embroideries and printed cottons (fig. 85). The scenes of the shepherdess next to a red house and huntsmen wearing European attire, which appear in other locally made textiles of this period, anchor this scene in New England, while the flowering trees recall the exotic Indian embroidered covers and petticoats that were being imported into Boston by the

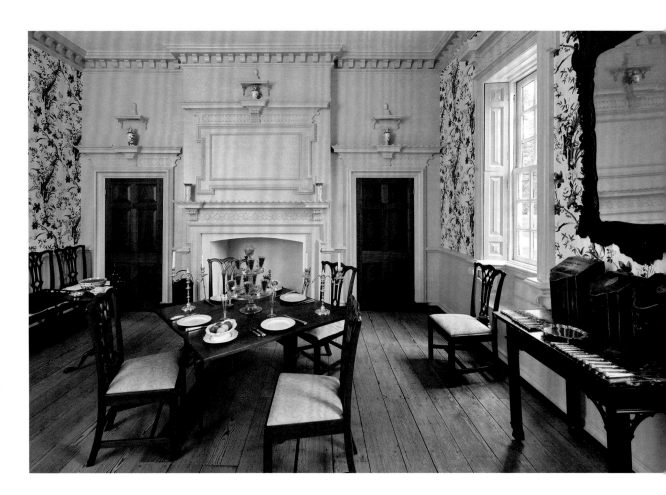

early eighteenth century (see figs. 28 and 44).[52] The elaborately clothed women in the center of the composition—shielded by umbrella-wielding attendants, a symbol of high status in China—may have appealed to the Orientalist fantasies of the Boston elite, making this hanging suitable for a fashionable bedchamber.

Especially in the furniture making and house joinery trades, a proliferation of books in the second half of the eighteenth century provided Chinese-style designs for furniture and architectural ornament. Many of these books appeared in libraries in America not long after they were first printed.[53] These sources accorded with imported objects from Europe, particularly those owned by the fashionable and trend-setting royal governors of each colony, such as Governor John Wentworth of New Hampshire, who likely owned a set of imported London-made chairs in the Chinese mode in the 1760s.[54] After midcentury, buildings in the British colonies of North America started to take on this fashion. In New England houses were ornamented with Chinese-style fretwork on the exterior balustrades, while fashionable wallpaper in the Chinese taste graced their interiors.[55] In the wealthy southern colonies of South Carolina and Virginia, lavish residences incorporated carved Chinese fretwork in staircases and mantelpieces.[56] The grandest example of a complete room done up in the Chinese taste is the parlor of Gunston Hall in Virginia, built for George Mason between 1755 and 1759 by the English craftsmen William Buckland and William

86. William Buckland (1734–1774) and William Bernard Sears (died in 1818). Northeast Parlor of Gunston Hall, Mason Neck, Virginia, 1755–59

Bernard Sears (fig. 86).[57] The Miles-Brewton House in Charleston, completed in 1769, has Chinese-style birds on the carved overmantel and Chinese fretwork in the cornice moldings.[58] In Philadelphia, where the pattern books of Chippendale and Ince and Mayhew were especially influential in the rococo designs of locally made objects, seating furniture in the "Chinese taste" was popular among the elite, such as groups of chairs with pagoda tops that closely followed English designs.

Though such chinoiserie rococo forms tended to appear mostly in Britain and its colonies, examples can also be found in Mexico and in Brazil, where oratories with pagoda tops were made for homes and private chapels of the Brazilian elite.[59] Colonial craftsmen in Brazil and their patrons embraced this style in ecclesiastical settings, as can be seen in the chinoiserie painting in Minas Gerais, in religious sculpture, and in church furniture. In England the trend for applications of chinoiserie to church decoration did not take hold in the same way, although one writer predicted that "the Chinese taste, which has already taken possession of our gardens, our buildings and our furniture, will also find a way into our churches; and how elegant must a monument appear, which is erected in the Chinese taste, and embellished with dragons, bells, pagodas and mandarins?"[60]

The chinoiserie style is ultimately more about European tastes than Asian ones. But it was yet another visual manifestation of the global world at the time, one that provided a vocabulary of design motifs and shared artistic ideas that linked the colonial Americas with Europe, and then eventually to the exotic Far East. The chinoiserie style was a distinctly European fashion that came across the Atlantic primarily through printed sources, design manuals, European-made objects, émigré craftsmen trained in Europe, and patrons who aspired to the most up-to-date aristocratic fashions in Europe. Colonial artists in the Americas added their own artistic traditions to the mix, especially in Mexico, where local methods of producing painted lacquer objects resulted in beautiful hybrid works, like those of the indigenous painter José Manuel de la Cerda; or in Boston, where artisans adapted the European taste for japanning for the local market. The chinoiserie style can be seen in a number of surviving painted interiors of homes and churches in the Americas, and it appears in domestic objects from silver and ceramics to elaborate textiles, both imported and locally made. In America this style never reached the heights that it did in the royal palaces and gardens of Europe, nor perhaps enjoyed such unbridled enthusiasm; however, it sat comfortably alongside the imported Asian objects that were prized possessions in many colonial households. Along with those imports, colonial Americans embraced chinoiserie as a symbol of their aspirations and ambitions in a newly globalized world.

Trade Routes

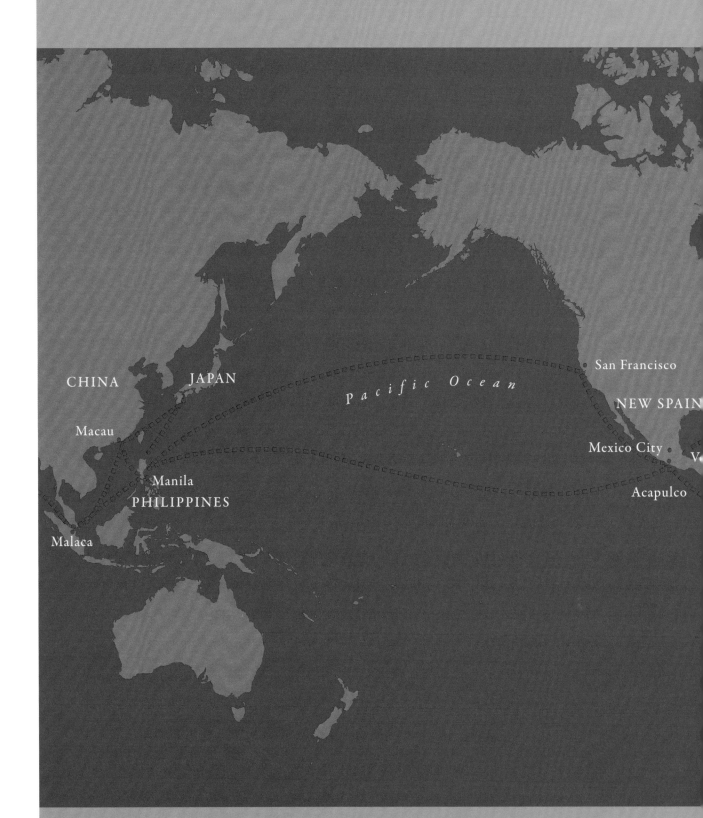

CHINA JAPAN

Macau

Manila
PHILIPPINES

Malaca

Pacific Ocean

San Francisco

NEW SPAIN

Mexico City V

Acapulco

Early trade routes linking Asia, the Americas, Europe, and Africa

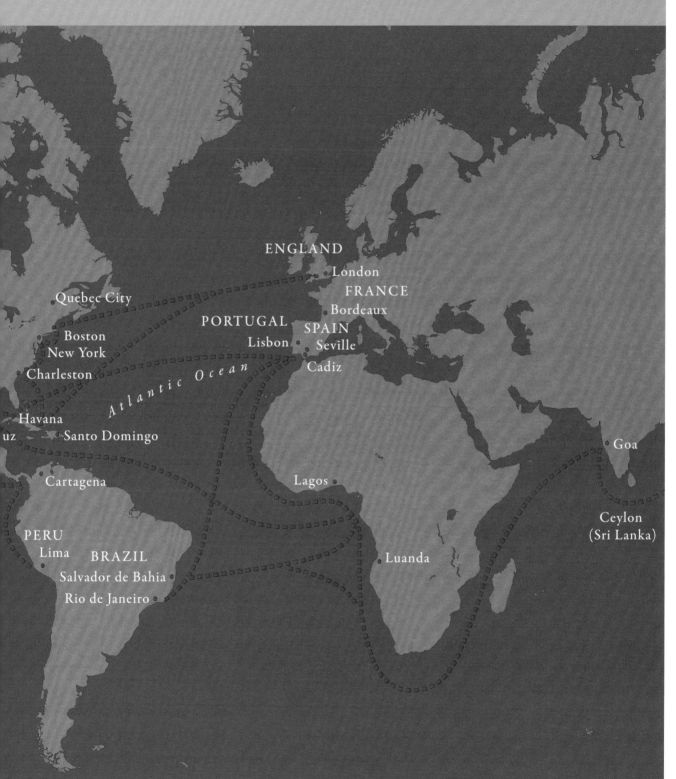

ENGLAND

London

FRANCE

Bordeaux

Quebec City

PORTUGAL SPAIN

Boston
New York

Lisbon Seville

Charleston

Cadiz

Atlantic Ocean

Havana

uz Santo Domingo

Goa

Cartagena

Lagos

Ceylon
(Sri Lanka)

PERU

Lima

Luanda

BRAZIL

Salvador de Bahia

Rio de Janeiro

Notes

Prologue: Coming onto the Map

1. The influence of global exploration on mapping is sketched in David Woodward, "Mapping the World," in *Encounters: The Meeting of Asia and Europe, 1500–1800*, ed. Anna Jackson and Amin Jaffer (London: Victoria and Albert Publications, 2004), 14–31. For an extended account, see Peter Whitfield, *New Found Lands: Maps in the History of Exploration* (New York: Routledge, 1998).

2. Several scholars have recently examined this map. For example, see Alfredo J. Morales Martínez, "Desde Manila: El *Aspecto Symbolico del Mundo Hispanico* de Vicente de Memije y Laureano Atlas," in *Arte en los confines del imperio: Visiones hispánicas de otros mundos*, ed. Víctor Manuel Mínguez Cornelles and María Inmaculada Rodríguez Moya (Castellón: Universitat Jaume I, 2011), 353–73; Ricardo Padrón, "Allegory and Empire," in *Mapping Latin America: A Cartographic Reader*, ed. Jordana Dym and Karl Offen (Chicago: University of Chicago Press, 2011), 84–87; Padrón, "From Abstraction to Allegory: The Imperial Cartography of Vicente de Memije," in *Early American Cartographies*, ed. Martin Brückner (Chapel Hill: University of North Carolina Press, 2011), 35–66; and David Irving, "Musical Politics of Empire: The Loa in 18th-Century Manila," *Early Music* 32, no. 3 (August 2004): 384–402.

Introduction: Asia and the New World

1. Bernardo de Balbuena, *Grandeza Mexicana, y fragmentos del siglo del oro y El Bernardo* (Mexico: Universidad Nacional Autónoma de México, 1941), 73.

2. J. Eric S. Thompson, ed., *Thomas Gage's Travels in the New World* (Norman: University of Oklahoma Press, 1958), 67–68.

3. See Deborah L. Krohn and Peter N. Miller, eds., *Dutch New York between East and West: The World of Margrieta van Varick*, exh. cat. (New York: Bard Graduate Center and New-York Historical Society; New Haven: Yale University Press, 2009); Caroline Frank, *Objectifying China, Imaging America: Chinese Commodities in Early America* (Chicago: University of Chicago Press, 2011), 56, table 1.2, and 138, table 3.1.

4. For an extensive list of trade goods entering the Spanish Philippines from China, Japan, and other ports in Asia by the early seventeenth century, see Antonio de Morga, *Sucésos de las Islas Philipinas* (Mexico, 1609), trans. Hon. E. J. Stanley, published as Antonio de Morga, *The Philippine Islands, Moluccas, Siam, Cambodia, Japan, and China, at the Close of the Sixteenth Century* (London: Hakluyt Society, 1868), 336–43. Still the best and most detailed general history of the Manila galleon trade is the classic survey by William Lytle Schurz, *The Manila Galleon* (1939; repr., Manila: Historical Conservation Society, 1959). See also Shirley Fish, *The Manila-Acapulco Galleons: The Treasure Ships of the Pacific* (Central Milton Keynes, U.K.: Author House, 2011), and Carmen Yuste López, *El comercio de la Nueva España con Filipinas, 1590–1785* (Mexico: Instituto Nacional de Antropología e Historia, 1984).

5. C. R. Boxer, *The Portuguese Seaborne Empire, 1415–1825* (New York: Alfred A. Knopf, 1969), 39–64, 205–27. See also C. R. Boxer, *Portuguese Merchants and Missionaries in Feudal Japan, 1543–1640* (London: Variorum Reprints, 1986).

6. Some tiled roofs survive today. See Gauvin Alexander Bailey, *Art of Colonial Latin America* (London: Phaidon, 2005), 343–45.

7. See Frank, *Objectifying China, Imagining America*, 27–57. The 1651 English Navigation Act barred the importation of Asian merchandise into the colonies unless it was carried aboard English ships.

8. Primary evidence comes from household inventories and archaeological excavations. See Robert A. Leath, "'After the Chinese Taste': Chinese Export Porcelain and Chinoiserie Design in Eighteenth-Century Charleston," *Historical Archaeology* 33, no. 3 (1999): 50–52, 56–58; Jonathan L. Fairbanks and Robert F. Trent, *New England Begins: The Seventeenth Century*, vol. 3 (Boston: Museum of Fine Arts, Boston), 396–97; Jean McClure Mudge, *Chinese Export Porcelain in North America* (New York: C. N. Potter, 1986).

9. The 1749 inventory of the merchant George Jaffrey II (1682–1749) of Portsmouth, N.H., lists, for example, "1 Quilted China bowl Crack'd," "5 Mended China Plates," and "10 burnt China plates whole & mended" in the dining room and cupboard of his grand house on Daniel Street.

10. Edward Taylor, *Edward Taylor's* Gods Determinations *and* Preparatory Meditations: *A Critical Edition*, ed. Daniel Patterson (Kent, OH: Kent State University Press, 2003), 470.

11. The last museum exhibition to take on such a hemispheric approach to the Americas in their relationship with Asia was more than seventy years ago: *The China Trade and Its Influences*, exh. cat. (New York: Metropolitan Museum of Art, 1941). The issue of the effect of global trade on artistic production in this period has been taken up more recently by important exhibitions and their accompanying catalogues: Jay A. Levenson, ed., *Circa 1492: Art in the Age of Exploration* (Washington, D.C.: National Gallery of Art, 1991); Ann Jackson and Amin Jaffer, eds., *Encounters: The Meeting of Asia and Europe, 1500–1800* (London: Victoria and Albert Museum, 2004); Jay A. Levenson, ed., *Encompassing the Globe: Portugal and the World in the 16th and 17th Centuries* (Washington, D.C.: Arthur M. Sackler Gallery, Smithsonian Institution, 2007); and Amelia Peck, ed., *Interwoven Globe: The Worldwide Textile Trade, 1500–1800* (New York: Metropolitan Museum of Art, 2013).

12. See Thomas DaCosta Kaufmann, *Toward a Geography of Art* (Chicago: University of Chicago Press, 2004), 232. See also the introduction by Wendy Bellion and Mónica Domínguez Torres and essays in "Objects in Motion: Visual and Material Culture across Colonial North America: A Special Issue," *Winterthur Portfolio* 45, nos. 2–3 (Summer–Autumn 2011).

13. See Sofia Sanabrais, "The *Biombo* or Folding Screen in Colonial Mexico," in *Asia and Spanish America: Trans-Pacific Artistic and Cultural Exchange, 1500–1850*, ed. Donna Pierce and Ronald Otsuka (Denver: Denver Art Museum, 2009), 69–106.

14. María Teresa Espinosa Pérez, "Constelación de imágenes: En los confines del viento," in *Viento detenido: Mitologías e historias en el arte del biombo—Colección de biombos de los siglos XVII al XIX de Museo Soumaya* (Mexico: Museo Soumaya, 1999), 235–46.

15. I am grateful to Daniel Liebsohn for kindly sharing this object and information. My translation.

16. Elena Phipps, Johanna Hecht, and Cristina Esteras Martín, *The Colonial Andes: Tapestries and Silverwork, 1530–1830* (New York: Metropolitan Museum of Art, 2004), 80–82, 250–55; Rebecca Stone Miller, *To Weave for the Sun: Andean Textiles in the Museum of Fine Arts, Boston* (Boston: Museum of Fine Arts, Boston, 1992), 201–3.

17. See Masako Yoshida, "Embroideries of Flower, Bird, and Animal Design in Honkokuji and Saikyoji," in *Genesis (Bulletin of Kyoto University of Art and Design)* 11 (2007): 101–19, and "Trade Stories: Chinese Export Embroideries in the Metropolitan Museum," *Metropolitan Museum Journal* 49 (2014): 165–85. I thank Masako Yoshida for her kind assistance with this textile.

18. See Robert Hunter, "A Newly Discovered Eighteenth-Century American Porcelain Teabowl," *The Magazine Antiques* 178, no. 1 (January–February 2011): 254–57.

19. Experiments in porcelain production continued in Philadelphia in the early 1770s with the American China Manufactory

of the émigré English potters Gousse Bonnin and George Anthony Morris, from which a number of pieces survive. See Robert Hunter, ed., *Ceramics in America, 2007* (Milwaukee: Chipstone Foundation, 2007).

20. See Elizabeth Abbott, *Sugar: A Bittersweet History* (London: Duckworth Overlook, 2009).

21. See Barbara McLean Ward and Gerald W. R. Ward, *Silver in American Life: Selections from the Mabel Brady Garvan and Other Collections at Yale University* (New York: American Federation for the Arts and the Yale University Art Gallery, 1979), 147; Helen A. Cooper et al., *Life, Liberty, and the Pursuit of Happiness: American Art from the Yale University Art Gallery* (New Haven: Yale University Press, 2008), 34.

22. See María Campos Carlés de Peña, *A Surviving Legacy in Spanish America: Seventeenth- and Eighteenth-Century Furniture from the Viceroyalty of Peru* (Madrid: Ediciones El Viso, 2013), 241–87. See also the entry on enconchado furniture by Jorge F. Rivas in *Journeys to New Worlds: Spanish and Portuguese Colonial Art in the Roberta and Richard Huber Collection*, ed. Suzanne L. Stratton-Pruitt and Mark A. Castro (Philadelphia: Philadelphia Museum of Art, 2013), 190–91.

23. See, for example, George Kubler, *The Shape of Time: Remarks on the History of Things* (New Haven: Yale University Press, 1962).

24. See Kaufmann, *Toward a Geography of Art*, 233.

25. Gustavo Curiel, "El efíme-ro caudal de una joven noble: Inventario y aprecio de los bienes de la marquesa Doña Teresa Francisca María de Guadalupe Retes Paz Vera," *Anales, Museo de América* 8 (2000): 65–101.

26. Brandon Brame Fortune, "'Studious Men Are Always Painted in Gowns': Charles Willson Peale's *Benjamin Rush* and the Question of Banyans in Eighteenth-Century Anglo-American Portraiture," *Dress* 29

(2002): 27–40; Krohn and Miller, *Dutch New York between East and West*, 162–64.

27. See Carrie Rebora and Paul Staiti et al., *John Singleton Copley in America*, exh. cat. (New York: Metropolitan Museum of Art, 1995), 224–29.

Asian Luxury Exports to Colonial America

1. Mendoza's wife, Teresa de Castro, was the first Spanish vicereine to travel to Peru. She died in Cartagena de Indias in 1596. Her lineage is recorded on the right side of the arms on the plate. Rocío Díaz, *Chinese Armorial Porcelain for Spain* (London: Jorge Welsh Books, 2010), 87–91. Personal communication from Antonio Díez de Rivera to Thomas Lurie, February 2, 2005.

2. Biblioteca del Congreso Argentino, *Gobernantes del Perú, cartas y papeles, siglo XVI*, vol. 12 (Madrid: Sucesores de Rivadeneyra, 1926), 242; personal communication from Dr. W. Michael Mathes, Curator of Mexicana, Lutro Library, San Francisco, to Thomas Lurie, June 12, 2005.

3. For cochineal, see Amy Butler Greenfield, *A Perfect Red: Empire, Espionage, and the Quest for the Color of Desire* (New York: HarperCollins, 2005), 85.

4. See Dennis O. Flynn and Arturo Giráldez, "Born with a 'Silver Spoon': The Origin of World Trade in 1571," *Journal of World History* 6, no. 2 (Fall 1995): 209.

5. See ibid., 202. The Chinese came to prefer Spanish dollars (eight reales) that were minted in Peru, which were ultimately melt-ed down and cast into traditional Chinese ingots.

6. Gauvin A. Bailey, "Asia in the Arts of Colonial Latin America," in *The Arts in Latin America, 1492–1820*, ed. Joseph J. Rishel and Suzanne Stratton-Pruitt (Philadelphia: Philadelphia Museum of Art, 2006), 57.

7. See Christiaan J. A. Jörg, *Chinese Ceramics in the Col-*

lection of the Rijksmuseum, Amsterdam: The Ming and Qing Dynasties (Amsterdam: Philip Wilson in association with the Rijksmuseum, 1997); Anne Gerritsen, "Fragments of a Global Past: Ceramics Manufacture in Song-Yuan-Ming Jingdezhen," *Journal of the Economic and Social History of the Orient* 52, no. 1 (2009): 117–52; and Margaret Medley, "Organization and Production at Jingdezhen in the Sixteenth Century," in *The Porcelains of Jingdezhen*, ed. Rosemary Scott (London: Percival David Foundation of Chinese Art, 1993), 69–82.

8. Although introduced to Chinese porcelain in the fourteenth cen-tu-ry, Europeans were unable to duplicate it for over four hundred years.

9. The border design is typically found on small Chinese export porcelain dishes dating from 1575 to 1615. Maura Rinaldi, *Kraak Porcelain: A Moment in the History of Trade* (London: Bamboo, 1989), 88–91.

10. Díaz, *Chinese Armorial Porcelain for Spain*, 87. See also Jean-Paul Desroches, Gabriel Casal, and Franck Goddio, eds., *Treasures of the San Diego* (Paris: Association Française d'Action Artistique, 1997), 325, 346.

11. For other dishes with a similar border and a European coat of arms, see Alberto Varela Santos, *Portugal in Porcelain from China: 500 Years of Trade*, vol. 1 (Lisbon: Artemágica, 2007), 171–74, and William R. Sargent, *Treasures of Chinese Export Ceramics at the Peabody Essex Museum* (New Haven: Yale University Press, 2011), 147–48. For early examples found in North America of Chinese export porcelain with European arms, see David Sanctuary Howard, *Chinese Armorial Porcelain* (London: Faber and Faber, 1974), 176, 359.

12. Michael Dillon, "Transport and Marketing in the Development of the Jingdezhen Porcelain Industry during the Ming and Qing Dynas-ties," *Journal of the Economic and Social History of the Orient* 35, no. 3 (1992): 279, 280–81.

13. W. L. Schurz, *The Manila Galleon* (1939; repr., Manila: Historical Conservation Society, 1985), 15, 27, 57.

14. Bailey, "Asia in the Arts of Colonial Latin America," 58.

15. Mendoza's plate may actually have arrived directly from Manila, rather than via New Spain. In 1582, King Philip II had banned not only direct trade between Manila and Peru but also the sale of Asian goods in Peru. During his tenure as viceroy, Mendoza actively petitioned the Crown to lift these bans, and Peru was granted limited permission to import Asian goods from New Spain from 1591 to 1593. Woodrow Wilson Borah, *Early Colonial Trade and Navigation between Mexico and Peru* (Berkeley: University of California Press, 1954), 117–20, 122–23.

16. Linda Shulsky, "Chinese Porcelain in Spanish Colonial Sites in the Southern Part of North America and the Caribbean," *Transactions of the Oriental Ceramic Society* 63 (2000): 83–97. See also George Kuwayama, *Chinese Ceramics in Colonial Mexico* (Los Angeles: Los Angeles County Museum of Art, 1997); Florence Hawley Ellis, *San Gabriel del Yunque: Window on the Pre-Spanish Indian World* (Santa Fe: Sunstone Press, 1988); and Florence Hawley Ellis, *When Cultures Meet: Remembering San Gabriel de Yunque Oweenge* (Santa Fe: Sunstone Press, 1970).

17. See Linda Rosenfeld Pomper, "Early Chinese Porcelain Found in Panama," in *Ceramics in America, 2012*, ed. Robert Hunter (Milwaukee: Chipstone Foundation, 2012), 31–38; Felipe Gaitan-Ammann, "Daring Trade: An Archaeology of the Slave Trade in Late Seventeenth-Century Panama (1663–1674)" (PhD diss., Columbia University, 2012).

18. Desroches, Casal, and Goddio, *Treasures of the San Diego*, 1997; Teresa Canepa, "The Portuguese and Spanish Trade in *Kraak* Porcelain in the Late 16th and Early 17th Centuries," *Transactions of the Oriental Ceramic Society* 73 (2010): 64.

19. Sargent, *Treasures of Chinese Export Ceramics*, 56–68.

20. See José Roberto Teixeira Leite, *A China no Brasil: Influências, marcas, ecos e sobre-vivências chinesas na sociedade e na arte brasileiras* (Campinas, Brazil: Editora da Unicamp, 1999); Bailey, "Asia in the Arts of Colonial Latin America," 59.

21. Julia B. Curtis, "17th and 18th Century Chinese Export Ware in Southeastern Virginia," *Transactions of the Oriental Ceramic Society* 53 (1990): 50.

22. Aaron Miller, "The Far East in the Northeast: An Analysis of the Chinese Export Porcelain Excavated at Ferryland, Newfoundland" (MA thesis, Memorial University of Newfoundland, 2005), 109–11.

23. At Jamestown, the earliest permanent English settlement in the New World, archaeologists have uncovered English, Chinese, French, German, Belgian, Italian, Dutch, Portuguese, and Spanish ceramics. Beverly Straube, "European Ceramics in the New World: The Jamestown Example," in *Ceramics in America, 2001*, ed. Robert Hunter (Milwaukee: Chipstone Foundation, 2001), 47, 51.

24. Charlotte Wilcoxen, *Dutch Trade and Ceramics in America in the Seventeenth Century* (Albany: Albany Institute of History and Art, 1987), 87. See also Russell Shorto, *The Island at the Center of the World: The Epic Story of Dutch Manhattan and the Forgotten Colony That Shaped America* (New York: Doubleday, 2004).

25. Quoted in Howard, *New York and the China Trade*, 61.

26. Jean McClure Mudge, *Chinese Export Porcelain in North America* (New York: Clarkson N. Potter, 1986), 98; and R. T. Haines Halsey, "Ceramic Color Notes in Our Colonial Homes," *Bulletin of the Metropolitan Museum of Art* 19, no. 7 (July 1924): 174.

27. Caroline Frank, *Objectifying China, Imagining America: Chinese Commodities in Early America* (Chicago: University of Chicago Press, 2011), 44.

28. Thomas S. Michie, *The China Trade on Narragansett Bay, 1750–1850* (Providence: Museum of Art, Rhode Island School of Design, 1992), 2.

29. Marley R. Brown, "Ceramics from Plymouth, 1621–1800: The Documentary Record," in *Ceramics in America*, ed. Ian M. G. Quimby (Winterthur, Del.: Henry Francis du Pont Winterthur Museum, 1972), 48.

30. Amanda Lange, *Chinese Export Art at Historic Deerfield* (Deerfield, Mass.: Historic Deerfield, 2005), 134, 138.

31. Alexandra Alevizatos Kirtley, "Survival of the Fittest: The Lloyd Family's Furniture Legacy," in *American Furniture, 2002*, ed. Luke Beckerdite (Milwaukee: Chipstone Foundation, 2002), 9. See also Robert A. Leath, "'After the Chinese Taste': Chinese Export Porcelain and Chinoiserie Design in Eighteenth-Century Charleston," *Historical Archae-ology* 33, no. 3 (Fall 1999): 52.

32. H. A. Crosby Forbes, *Yang-ts'ai, the Foreign Colors: Rose Porcelains of the Ch'ing Dynasty* (Milton, Mass.: China Trade Museum, 1982), 25–27.

33. Mary C. Beaudry, "Ceramics in York County, Virginia Inventories, 1730–1750: The Tea Service," *Conference on Historic Site Archaeology Papers* 12 (1978): 207, 204, 206.

34. Leath, "'After the Chinese Taste,'" 51.

35. Gregory A. Waselkov, *Old Mobile Archaeology* (Tuscaloosa: University of Alabama Press, 2005), 48, 53.

36. The intendant was a senior official with direct responsibil-ity to the French king. Dupuy also owned Asian lacquer. See Philippe Langellier Bellevue Halbert, "Power Houses: Furnishing Authority in New France, 1660–1760" (MA thesis, University of Delaware, 2014), 162, 163, 186, 240.

37. This was also the case at Jingdezhen, where a variety of different craftsmen, each with a specific responsibility, worked together to produce every piece of porcelain. Lothar Ledderose, *Ten Thousand Things: Module and Mass Production in Chinese Art* (Princeton: Princeton University Press, 2000), 3.

38. Lauren Arnold, "Folk Goddess or Madonna?" in *Encounters and Dialogues*, ed. Xiaoxin Wu (Sankt Augustin: Monumenta Serica, 2005), 227–38; Deborah L. Krohn, Peter N. Miller, and Marybeth de Filippis, eds., *Dutch New York, between East and West: The World of Margrieta Van Varick* (New Haven: Yale University Press, 2009), 357; Mudge, *Chinese Export Porcelain in North America*, 98; Leath, "'After the Chinese Taste,'" 51.

39. D. F. Lunsingh Scheurleer, *Chinese Export Porcelain, Chine de Commande* (London: Faber and Faber, 1974), 108; Geoffrey Godden, *Chinese Export Market Porcelain and Its Influence on European Wares* (London: Granada Publishing, 1979), 66.

40. For an overview, see Teresa Canepa, *Zhangzhou Export Ceramics: The So-Called Swatow Wares* (London: Jorge Welsh Books, 2006). For Hanover Square, see David Sanctuary Howard, *New York and the China Trade* (New York: New-York Historical Society, 1984), 65. For Virginia, see Curtis, "17th and 18th Century Chinese Export Ware in Southeastern Virginia," 50.

41. Fragments of an early eigh-teenth-century Yixing teapot were excavated at Ferryland, Newfoundland; see Miller, "The Far East in the Northeast," 118–19.

42. Sargent, *Treasures of Chinese Export Ceramics*, 396.

43. Chinese artists were also adept at copying Western silver, furniture, textiles, and paintings; see H. A. Crosby Forbes, John Devereux Kernan, and Ruth S. Wilkins, *Chinese Export Silver, 1785 to 1885* (Milton, Mass.: Museum of the American China Trade, 1975), and Carl Crossman, *The Decorative Arts of the China Trade* (Woodbridge, U.K.: Antique Collectors' Club, 1991). On Guangzhou, see Patrick Conner, *The Hongs of Canton: Western Merchants in South China 1700–1900, as Seen in Chinese Export Paintings* (London: Martyn Gregory, 2009).

44. William Atwell, "Ming China and the Emerging World Economy, ca. 1470–1650," in *The Cambridge History of China*, vol. 8, ed. Denis C. Twitchett and Frederick W. Mote (Cambridge: Cambridge University Press, 1998), 405; Shelagh Vainker, *Chinese Silk: A Cultural History* (New Brunswick: Rutgers University Press, 2004), 172–73, 176, 192.

45. Elena Phipps, "Cumbi to Tapestry: Collection, Innovation and Transformation of the Colonial Andean Tapestry Tradition," in *The Colonial Andes: Tapestries and Silverwork, 1530–1830*, ed. Elena Phipps, Johanna Hecht, and Cristina Esteras Martín (New York: Metropolitan Museum of Art, 2004), 82.

46. Borah, *Early Colonial Trade and Navigation between Mexico and Peru*, 121; Natalie V. Robinson, "Mantónes de Manila: Their Role in China's Silk Trade," *Arts of Asia* 17, no. 1 (January–February 1987): 65–75.

47. Linda Baumgarten, *What Clothes Reveal: The Language of Clothing in Colonial and Federal America* (Williamsburg: Colonial Williamsburg Foundation, 2002), 82–83, 50–51. Baumgarten lists Maria Lents Egberts's Anglicized name as Mary Lynch Egberts.

48. John Guy, *Woven Cargoes: Indian Textiles in the East* (New York: Thames and Hudson, 1998), 15.

49. Giorgio Riello, *Cotton: The Fabric That Made the Modern World* (Cambridge: Cambridge University Press, 2013), 63; Rosemary Crill, *Chintz: Indian Textiles for the West* (London: V & A Publishing, 2008), 10.

50. Riello, *Cotton*, 148.

51. Ibid., 142.

52. Frank, *Objectifying China, Imagining America*, 46; Krohn, Miller, and de Filippis, *Dutch New York*, 342–62.

53. Amelia Peck, "'India Chints' and 'China Taffaty': East India Company Textiles for the North American Market," in *Interwoven Globe: The Worldwide Textile Trade, 1500–1800*, ed. Amelia Peck (New York: Metropolitan Museum of Art, 2013), 106–7.

54. Leath, "'After the Chinese Taste,'" 53; Peck, *Interwoven Globe*, 232–34.

55. These shortages were felt even in the Americas. In 1662, Jeremias van Rensselaer, Director of the New York colony of Rensselaerswyck, received a shipment of ceramics from his sister in Amsterdam. About them she wrote, "I had much trouble in procuring the small table plates as not many are being made." Charlotte Wilcoxen, *Dutch Trade and Ceramics in America in the Seventeenth Century* (Albany: Albany Institute of History and Art, 1987), 87.

56. Christiaan J. A. Jörg, *Fine and Curious: Japanese Export Porcelain in Dutch Collections* (Amsterdam: Hotei, 2003), 10.

57. See George Kuwayama, "Chinese Porcelain in the Viceroyalty of Peru," in *Asia & Spanish America: Trans-Pacific Artistic and Cultural Exchange, 1500–1850* (Denver: Denver Art Museum, 2006), 170. See also Takenori Nogami, "On Hizen Porcelain and the Manila-Acapulco Galleon Trade," *Indo-Pacific Prehistory Association Bulletin* 26 (2006): 124–30.

58. For example, a Japanese export shaving bowl made in Arita between 1680 and 1700 descended in the Van Cortland family of New York with a history that it originally had been imported by Captain Long of Newport, Rhode Island. Howard, *New York and the China Trade*, 63.

59. Bailey, "Asia in the Arts of Colonial Latin America," 61, 64.

60. Jacques L'Hermite the Younger, quoted in Oliver Impey and Christiaan J. A. Jörg, *Japanese Export Lacquer 1580–1850* (Amsterdam: Hotei, 2005), 27–28.

61. Frank, *Objectifying China, Imagining America*, 1.

62. Krohn, Miller, and de Filippis, *Dutch New York*, 345, 355.

By the Boatload

1. *Thomas Gage's Travels in the New World*, ed. J. Eric S. Thompson (Norman: University of Oklahoma Press, 1958), 7, 35–36, 65.

2. See Woodrow Borah, *Early Colonial Trade and Navigation between Mexico and Peru* (Berkeley: University of California Press, 1954); and George Kuwayama, "Chinese Porcelain in the Viceroyalty of Peru," in *Asia and Spanish America: Trans-Pacific Artistic and Cultural Exchange, 1500–1850*, ed. Donna Pierce and Ronald Otsuka (Denver: Denver Art Museum, 2009), 165–74.

3. Louisa Schell Hoberman, *Mexico's Merchant Elite, 1590–1660: Silver, State, and Society* (Durham: Duke University Press, 1991); and Carmen Yuste, *Comerciantes mexicanos en el siglo XVIII* (Mexico: Universidad Nacional Autónoma de México, 1991).

4. Quoted in Kuwayama, "Chinese Porcelain," 166; and Borah, *Early Colonial Trade*, 121–22.

5. See Florence C. Lister and Robert H. Lister, *Sixteenth-Century Maiolica Pottery in the Valley of Mexico* (Tucson: University of Arizona Press, 1982), 78–79; Jean McClure Mudge, *Chinese Export Porcelain in North America* (New York: Clarkson N. Potter, 1986), 47–50.

6. Mudge, *Chinese Export Porcelain in North America*, 63–84. Also see Peter J. Bakewell, *Silver Mining and Society in Colonial Mexico: Zacatecas, 1546–1700* (Cambridge: Cambridge University Press, 1971).

7. Gustavo Curiel, "Customs, Conventions, and Daily Rituals among the Elites of New Spain: The Evidence from Material Culture," in *The Grandeur of Viceregal Mexico: Treasures from the Franz Mayer Museum*, by Héctor Rivero Borrell Miranda et al. (Houston: Museum of Fine Arts, Houston, 2002), 23–43; and Gustavo Curiel and Antonio Rubial García, "Los espejos de lo propio: Ritos públicos y usos privados en la pintura virreinal," in *Pintura y vida cotidiana en México: 1650–1950* (Mexico City: Fomento Cultural Banamex, Conaculta, 1999), 49–153.

8. Manuel Toussaint, *Colonial Art in Mexico*, trans. and ed. Elizabeth Wilder Weismann (Austin: University of Texas Press, 1967), 168.

9. *Thomas Gage's Travels*, 34.

10. Toussaint, *Colonial Art*, 168.

11. On the *estrado* in Spain, see José Gabriel Moya Valgañon et al., *Mueble español: Estrado y dormitorio* (Madrid: Consejería de Cultural, Dirección General de Patrimonio Cultural, 1990), and Grace Hardendorff Burr, *Hispanic Furniture from the Fifteenth through the Eighteenth Century* (New York: Archive Press, 1964); for Mexico, see Carmen Aguilera et al., *El mueble mexicano: Historia, evolución e influencias* (Mexico: Fomento Cultural Banamex, 1985); for Colombia see María del Pilar López Pérez and Carlos Bejerano Calvo, *En torno al estrado: Cajas de uso cotidiano en Santafé del Bogotá, siglos XVI al XVIII* (Bogotá: Museo Nacional de Colombia, 1996); for Peru see María Campos Carlés de Peña, *A Surviving Legacy in Spanish America: Seventeenth- and Eighteenth-Century Furniture from the Viceroyalty of Peru* (Madrid: Ediciones El Viso, 2013).

12. Carlos F. Duarte, *Museo de Arte Colonial de Caracas "Quinta de Anauco"* (Caracas: Ediciones de la Asociación Venezolana Amigos del Arte Colonial, 1979), 85.

13. A nun's cell in the Conceptionist convent in Quito, Ecuador, contained "an *estrado* of wood with its carpet"; Alexandra Kennedy, "Mujeres en los claustros: Artístas, mecenas, y coleccionistas," in *Arte de la Real Audiencia de Quito, siglos XVII–XIX: Patronos, corporaciones y comunidades*, ed. Alexandra Kennedy (Hondarribia, Spain: Editorial Nerea, 2002), 109–27.

14. María Stoopen, "Edificar una confluencia: Las simientes del mestizaje en el siglo XVI," *Artes de México* 36 (1997): 20–29; and Curiel and Rubial, "Los espejos de lo propio," 105–110.

15. Cristóbal Gutiérrez de Medina, *Viaje de tierra y mar, feliz por mar y tierra, que hizo el excelentísimo señor marqués de Villena* [1640], with introduction and notes by Manuel Romero de Terreros (Mexico City: Instituto de Historia, Universidad Nacional Autónoma de México, 1947), 73–75. Also see Curiel, "Customs, Conventions, and Daily Rituals," 33.

16. Toussaint, *Colonial Art*, 168.

17. Unpublished document, Archivo General de la Nación, Mexico City, Concurso de Peñalosa, v. 1, ff. 396v–397r. See Donna Pierce, "'At the Ends of the Earth': Asian Trade Goods in Colonial New Mexico, 1598–1821," in *At the Crossroads: The Arts of Spanish America and Early Global Trade, 1492–1850*, ed. Donna Pierce and Ronald Otsuka (Denver: Denver Art Museum, 2012), 155–82.

18. For examples from Venezuela, see Duarte, *Museo de Arte Colonial*, 92, 95; for Mexico, see Aguilera et al., *El mueble mexicano*, 60, 68, 106, 128.

19. Tatiana Seijas, *Asian Slaves in Colonial Mexico: From Chinos to Indians* (New York: Cambridge University Press, Cambridge Latin American Studies Series, 2014).

20. Sofia Sanabraís, "The *Biombo* or Folding Screen in Colonial Mexico," in *Asia and Spanish America: Trans-Pacific Artistic and Cultural Exchange, 1500–1850*, Papers of the 2006 Mayer Center Symposium at the Denver Art Museum, ed.

Donna Pierce and Ronald Otsuka (Denver: Denver Art Museum, 2009), 79; Thomas Calvo, "Los japoneses en Guadalajara durante el Seiscientos mexicano," in *Sociedades y Costumbres, Lecturas históricas de Guadalajara II*, ed. José María Muriá and Jamie Olveda (Guadalajara: Instituto Nacional de Antropología e Historia, 81–92; and Melba Falck Reyes and Héctor Palacios, *El japonés que conquistó Guadalajara: La historia de Juan de Páez en la Guadalajara del siglo XVII* (Guadalajara: Universidad de Guadalajara, 2009).

21. Deborah Oropeza Keresey, "Los 'indios chinos' en la Nueva Espana: La inmigracion de la Nao de China, 1565–1700" (PhD diss., El Colegio de México, Centro de Estudios Históricos, 2007). See also Tatiana Seijas, "Transpacific Servitude: The Asian Slaves of Mexico, 1580-1700" (PhD diss., Yale University, 2008), 99.

22. Seijas, *Asian Slaves in Colonial Mexico*, 130–140.

23. Ibid., 127–129.

24. Archivo General de Notarías de Puebla, 1662, foja 670, cited in Enrique A. Cervantes, *Loza blanca y azulejo de Puebla*, 2 vols. (Mexico City: privately printed, 1939), 2:228.

25. Archivo General de Notarías de Puebla, 1621, cited in Cervantes, *Loza blanca*, 2:208.

26. Gauvin Bailey, "Asia in the Arts of Colonial Latin America," in *The Arts in Latin America, 1492–1820*, ed. Joseph J. Rishel and Suzanne Stratton-Pruitt (Philadelphia: Philadelphia Museum of Art, 2006), 60–61.

27. José Antonio del Busto, "El primer japonés en el Perú," *Dominical*, Lima, April 9, 1989, 6; and Mary Fukumoto, "Migración japonesa al Perú," *Boletín de Lima* 20, no. 114 (1998): 80–90.

28. Archivo General de la Nación de México (AGN), Intestados, Inventario de los bienes de don Antonio de Bucareli y Úrsúa (April 19, 1779), partially transcribed in Curiel, "Customs, Conventions, and Daily Rituals," 30–32.

29. Manuel Romero de Terreros, *Una casa del siglo XVIII en México: La del Conde de San Bartolomé de Xala* (Mexico: Imprenta Universitaria, 1957), 16, 69–71.

30. Curiel, "Customs, Conventions, and Daily Rituals," 30.

31. Teresa Castelló de Yturbide and Marita Josefa Martínez del Río de Redo, *Delicias del antaño: Historia y recetas de los conventos mexicanos* (Mexico: Bancomer, 2000), 53.

32. See, for example, Lister and Lister, *Sixteenth-Century Maiolica*; George Kuwayama, *Chinese Ceramics in Colonial Mexico* (Los Angeles: Los Angeles County Museum of Art, 1997); Etsuko Miyata Rodríquez, "Early Manila Galleon Trade: Merchants' Network and Market in Sixteenth- and Seventeenth-Century Mexico"; and Clara Bargellini, "Asia at the Missions of Northern New Spain," in Pierce and Otsuka, *Asia and Spanish America*, 37–57, 191–99; Kathleen Deagan, *Artifacts of the Spanish Colonies of Florida and the Caribbean, 1500–1800*, vol. 1 (Washington, D.C.: Smithsonian Press, 1987); Linda Shulsky, "Chinese Porcelain in Spanish Colonial Sites in the Southern Part of North American and the Caribbean," *Transactions of the Oriental Ceramic Society* 63 (1998–99): 83–98, and "Chinese Porcelain at Old Mobile," *Historical Archeology* 36 (2002): 97–104; *El Camino Real de Tierra Adentro*, ed. Gabrielle G. Palmer and Stephen L. Fosberg, vol. 2 (Santa Fe: Bureau of Land Management, 1999).

33. See Alexandra Kennedy, "Apuntes sobre arquitectura en tierra y cerámica en la colonia," in *Ceramica colonial y vida cotidiana* (Cuenca, Ecuador: Fundación Paul Rivet, 1990), 39–59. An example of a jar from a Venezuelan collection is reproduced in Duarte, *Museo de Arte Colonial*, 88.

34. Florence Hawley Ellis, *San Gabriel del Yunque: Window on the PreSpanish Indian World* (Santa Fe: Sunstone Press, 1988); and *When Cultures Meet: Remembering San Gabriel de Yunque Oweenge* (Santa Fe: Sunstone Press, 1970). The porcelain shards and other artifacts recovered by archaeological excavations in the 1960s are on long-term loan from San Juan Pueblo to the Maxwell Museum of Anthropology, University of New Mexico, Albuquerque. See Pierce, "At the Ends of the Earth"; Linda R. Shulsky, "Chinese Porcelain in New Mexico," in *Vormen uit Vuur* 153, no. 3 (September 1994): 13–18,

and Cordelia Thomas Snow, "A Brief History of the Palace of the Governors and a Preliminary Report on the 1974 Excavation," *El Palacio* 80, no. 3 (October 1974): 1–22. The recovered artifacts from the Palace of the Governors are in the collection of the Laboratory of Anthropology, Museum of New Mexico, Santa Fe.

35. These are noted in unpublished estate wills and inventories now located in the New Mexico State Records Center and Archives in Santa Fe, Spanish Archives of New Mexico (SANM) I and II. Some examples mentioning porcelain include: 1762, Juan Montes Vigil, Santa Fe, SANM I:1055; 1776, María Gertrudes Armijo, Taos, SANM I: 48; 1762, Juana Luján, Santa Cruz, SANM II: 556. The dowry of her daughter, Luisa, is included in the will of Juana. Also see Richard Ahlborn, "The Will of a New Mexico Woman in 1762," *New Mexico Historical Review* 65 (July 1990): 315–55; and Pierce, "At the Ends of the Earth."

36. See Margaret Connors McQuade, *Talavera Poblana: Four Centuries of a Mexican Ceramic Tradition* (New York: Americas Society, 1999); and Robin Farwell Gavin, Donna Pierce, and Alfonso Pleguezuelo, *Cerámica y Cultura: The Story of Spanish and Mexican Mayólica* (Albuquerque: University of New Mexico Press, 2003). For Peru see Kuwayama, "Chinese Porcelain."

37. The most in-depth study of the majolica of Puebla is Cervantes, *Loza blanca.*

38. Toussaint, *Colonial Art*, 168.

39. The height of Japanese production was from 1580 to 1638, when direct exports ceased and subsequently production declined. The most comprehensive source on Japanese lacquer is Oliver Impey and Christiaan Jörg, *Japanese Export Lacquer, 1580–1850* (Amsterdam: Hotei Publishing, 2005).

40. See Mitchell A. Codding, "The Decorative Arts in Latin America, 1492–1820," and Paula Kornegay, "Catalog Entry I-19," in Rishel and Stratton-Pruitt, *The Arts in Latin America*, 98–113, 124–128.

41. Jorge Rivas Pérez, "Of Luxury and Fantasy: The Influence of Asia on the Furniture of Viceregal Spanish America," in Pierce and Otsuka, *Asia and Spanish America*, 119–27; and Rivas Pérez, "Observations on the Origin,

Development, and Manufacture of Latin American Furniture," in *The Arts in Latin America*, 476–506.

42. See Marta Dujovne, *Las pinturas con incrustaciones de concha* nácar (Mexico: UNAM, Instituto de Investigaciones Estéticas, 1984), and *La concha nácar en México* (Mexico: Grupo Gutsa, 1990).

43. Sonia Ocaña Ruiz, "Enconchado Frames: The Use of Japanese Ornamental Models in New Spanish Painting," in Donna Pierce and Ronald Otsuka, eds., *Asia and Spanish America: Trans-Pacific Artistic and Cultural Exchange, 1500-1850*, Papers of the 2006 Mayer Center Symposium at the Denver Art Museum (Denver: Denver Art Museum, 2009), 129–149.

44. See Donna Pierce, Rogelio Ruiz Gomar, and Clara Bargellini, *Painting a New World: Mexican Art and Life, 1521–1821* (Denver: Denver Art Museum, 2004), 187–89.

45. See Ocaña Ruiz, "Enconchado Frames," in Pierce and Otsuka, *Asia and Spanish America*, 129–49.

46. *Diccionario de Autoridades*, Real Academia Española (Madrid, 1726), 609. The author is grateful to Sofía Sanabrais for providing this source.

47. Romero de Terreros, *Una casa del siglo XVIII en México*, 59–61.

48. See surviving examples in *Viento detenido: Mitologías e historias en el arte del biombo* (Mexico: Museo Soumaya, 1999); Teresa Castelló Yturbide and Marita Martínez del Río de Redo, *Biombos mexicanos* (Mexico City: Instituto Nacional de Antropología e Historia, 1970); and Sofía Sanabrais, "The Biombo or Folding Screen in Colonial Mexico," in Pierce and Otsuka, *Asia and Spanish America*, 69–106.

49. María Teresa Espinosa Pérez, "Constelación de imágenes: En los confines del viento," in *Viento detenido*, 235–46.

50. Even in remote areas a handful of biombos were found. See Gustavo Curiel, *Los bienes del mayorazgo de los Cortés del Rey en 1729: La casa de San José del Parral y las haciendas del Río de Conchos, Chihuahua* (Mexico City: Instituto de Investigaciones Estéticas, Universidad Nacional

Autónoma de Mexico, 1993), 22, 25, 54; and Pierce, "At the Ends of the Earth," 180.

51. See Guillermo Tovar de Teresa, *Miguel Cabrera: Drawing Room Painter of the Heavenly Queen* (Mexico: Grupo Financiero InverMexico, 1995), 274–85.

52. Margarita Estella Marcos, *Ivories from the Far Eastern Provinces of Spain and Portugal* (Monterrey, Mexico, 1997); Marjorie Trusted, "Propaganda and Luxury: Small-Scale Baroque Sculptures in Viceregal America and the Philippines," in Pierce and Otsuka, *Asia and Spanish America*, 151–63.

53. D. Salazar, *Carta de relación de las cosas de la China . . .* [1590], quoted in Trusted, "Propaganda and Luxury," 153.

54. It was commissioned in the Philippines by an Archbishop of Manila, Manuel Rojo (1758–d. 1764); Toussaint, *Colonial Art*, 363–64. The lectern was damaged by fire in the 1960s. Although it was restored and returned to the choir, the ivories were not reinstalled and remain in storage.

55. See Virginia Armella de Aspe, "La influencia asiática," in *La concha nácar en México* (Mexico: Grupo Gutsa, 1990), 72.

56. Curiel, *Los bienes*, 28, 53; see also Donna Pierce, "Heaven on Earth: Church Furnishings in Seventeenth-Century New Mexico," in *El Camino Real de Tierra Adentro*, vol. 2, 197–208.

57. Ivory beads were excavated at San Gabriel (1598–1617); turned finials, a cane handle, and a comb were found in the Palace of the Governors (1610–80); and ninety-five ivory combs are listed in the inventory of a mercantile store in downtown Santa Fe in 1815. Pierce, "At the Ends of the Earth," 159, 163, 180.

58. Trusted, "Propaganda and Luxury," 158–62.

59. Will of Bernardo de Legarda cited in Alexandra Kennedy and Marta Fajardo de Rueda, *Barroco de la Nueva Granada: Colonial Art from Colombia and Ecuador* (New York: Americas Society, 1992), 75. Also see Gabrielle G. Palmer, *Sculpture in the Kingdom of Quito* (Albuquerque: University of New Mexico Press, 1987), 75–82, 132–34.

60. Kennedy, "Mujeres," 113–14.

61. Borah, *Early Colonial Trade*, 121.

62. Schurz, "Mexico, Peru and the Manila Galleon," *Hispanic American Historical Review* 1, no. 4 (Nov. 1918): 389, quoting Vicente Riva Palacio, *México á traves de los siglos*, vol. 2, *Historia del Virreinato (1521–1807)* (Mexico, 1880).

63. Pablo Guzmán-Rivas, "Reciprocal Geographic Influences of the Trans-Pacific Galleon Trade" (PhD diss., University of Texas, 1960), 60.

64. Unpublished document, 1748, Antonio Durán de Armijo, San Gerónimo de Taos, SANM I:240.

65. Unpublished document, 1762, Juan Montes Vigil, Santa Fe, SANM I:1055.

66. The following unpublished documents mention garments described as kimonos in Taos, Abiquiu, and Santa Fe, New Mexico: SANM I:48, I:1060, and I:144; for examples in Mexico City see Tovar de Teresa, *Miguel Cabrera*, 265, 281.

67. Unpublished document, 1815, Manuel Delgado, Santa Fe, SANM I:252.

68. Marta V. Vicente, *Clothing the Spanish Empire: Families and the Calico Trade in the Early Modern Atlantic World* (New York: Palgrave Macmillan, 2006), 82–83.

69. Elena Phipps, "The Iberian Globe: Textile Traditions and Trade in Latin America," in Amelia Peck, ed., *The Interwoven Globe: The Worldwide Textile Trade, 1500-1800* (New York: Metropolitan Museum of Art, 2013), 28–45; Virginia Armella de Aspe and Guillermo Tovar de Teresa, *Bordados y bordadores* (Mexico City: Grupo Gutsa, Fernandez Cueto Editores, 1992); and Armella de Aspe, *Hilos del cielo: Las vestiduras litúrgicas de la Catedral Metropolitana de México* (Mexico City: Instituto Nacional de Antropología e Historia, 2007).

70. *Thomas Gage's Travels*, 67 (for Mexico); Duarte, *Museo de Arte Colonial*, 96–97 (for Venezuela); Maria Graham, *Journal of a Residence in Chile During the Year 1823, and a Voyage from Chile to Brazil in 1823*, ed. Jennifer Hayward (University of Virginia Press, 2003), 125 (for Chile).

71. Curiel, "Customs, Conventions, and Daily Rituals," 33.

72. Romero de Terreros, *Una casa del siglo XVIII en México*, 16, 68.

73. See Phipps, "Iberian Globe," in Amelia Peck, *Interwoven Globe*, 28–45; Virginia Armella de Aspe, Teresa Castelló Yturbide, and Ignacio Borja Martínez, *La historia de México a través de la indumentaria* (Mexico: Inversora Bursatil, 1988); Dilys E. Blum, "Textiles in Colonial Latin America," and Gridley McKim Smith, "Dressing Colonial, Dressing Diaspora," in Rishel and Stratton-Pruitt, *The Arts in Latin America*, 146–154, 155–163.

74. Elena Phipps, Johanna Hecht, and Cristina Esteras Martín, et al., *The Colonial Andes: Tapestries and Silverwork, 1530–1830* (New York: Metropolitan Museum of Art, 2004).

75. Curiel, "Customs, Conventions, and Daily Rituals," 29.

76. One is in the collection of the Peabody Essex Museum in Salem, Massachusetts; another is in Braemore House, Hampshire, England.

The Lacquer Arts of Latin America

1. Antonio de Morga, *Sucesos de las Islas Philipinas* (Mexico: [Geronymo Balli, por Cornelio Adriano Cesar], 1609), ff. 161r–164r. My translation.

2. See Luis Eduardo Mora-Osejo, "El Barniz de Pasto," *Caldasia* 11, no. 55 (1977): 5–31.

3. Nina S. de Friedemann, "El barniz de Pasto: Arte y rito milenario," *Lámpara* 23, no. 96 (1985): 17–18.

4. Jerónimo de Escobar, "Memorial que da Fray Geronimo Descobar predicador de la orden de Sant Agustin al Real Consejo de Indias de lo que toca a la provincia de Popayan" (1582), in *Relaciones y visitas a los Andes, S XVI*, ed. Hermes Tovar Pinzón (Santafé de Bogotá: Colcultura/ Instituto de Cultura Hispánica, 1993), 405.

5. Pedro Simón, *Noticias historiales de la conquista de Tierra Firme en las Indias Occidentales*, ed. Manuel José Forero, vol. 6 (Bogotá: Ministerio de Educación Nacional, Ediciones de la Revista Bolívar, 1953), 47.

6. Although mopa mopa had been suspected to be the medium employed in the painted decoration of the colonial qeros, its use was confirmed only recently through analytical sampling. See Richard Newman and Michele Derrick, "Painted Qero Cups from the Inka and Colonial Periods in Peru: An Analytical Study of Pigments and Media," in *Materials Issues in Art and Archaeology VI*, ed. Pamela B. Vandiver, Martha Goodway, and Jennifer L. Mass (Boston: Materials Research Society, 2002), 291–302.

7. Lucas Fernández de Piedrahita, *Historia general de las conquistas del Nuevo Reyno de Granada* (Amberes: J. B. Verdussen, 1688), 360; the dedication, on page ii, is dated August 12, 1676, at Santa Marta, Colombia. Jorge Juan and Antonio de Ulloa, *Noticias secretas de América*, vol. 2 (Madrid: Editorial América, 1918), 252. Miguel de Santiesteban, *Mil leguas por América: De Lima a Caracas, 1740–1741*, ed. David J. Robinson (Bogotá: Banco de la República, 1992), 123–24. Fray Juan de Santa Gertrudis, *Maravillas de la naturaleza*, vol. 2 (Bogotá: Empresa Nacional de Publicaciones, 1956), 76–77.

8. Alexander von Humboldt, *La ruta de Humboldt: Colombia y Venezuela*, ed. Benjamín Villegas, vol. 2 (Bogotá: Villegas Editores, 1994), 152–55.

9. Ampelio Alonso de Cadenas y López, *Elenco de grandezas y títulos nobiliarios españoles, 2013*, 46th ed. (Madrid: Ediciones Hidalguía, 2013), 599.

10. Agraz (*Vaccinium meridionale* Swartz) is a shrub native to Colombia, growing up to seven meters tall, found at altitudes from 2,400 to 4,000 meters, which produces a dark blue or purple fruit that grows in grapelike clusters. Agraz is from the family *Ericaciae*, which includes blueberries and cranberries.

11. Simón, *Noticias historiales*, 47.

12. Museo Franciscano Fray Pedro Gocial, Convent of San Francisco, Quito, Ecuador.

13. For example, Museo Jacinto Jijón y Caamaño, Pontificia Católica Universidad de Ecuador, Quito.

14. Teresa Castelló Yturbide, "Maque o laca," *Artes de México* 153 (1972): 34–35.

15. María Teresa Sepúlveda y Herrera, *Maque: Vocabulario de materias primas, instrumentos de trabajo, procesos técnicos y motivos decorativos en el maque* (Mexico: Instituto Nacional de Antropología e Historia, 1978), 43.

16. Ibid., 62.

17. Isabel Medina González, "¿Maque prehispánico? Una antigua discusión," in *Lacas mexicanas* (Mexico: Museo Franz Mayer and Artes de México, 1997), 22–27.

18. Bernardino de Sahagún, *Florentine Codex: General History of the Things of New Spain*, part 11, *Book 10—The People*, trans. Arthur J. Anderson and Charles E. Dibble (Santa Fe: School of American Research, 1961), 78.

19. Alonso de la Rea, *Crónica de la orden de N. Seráfico P. S. Francisco, Provincia de San Pedro y San Pablo de Mechoacán en la Nueva España* (Mexico: Imprenta de J. R. Barbedillo, 1882), 40.

20. Sonia Pérez Carrillo, *La laca mexicana: Desarrollo de un oficio artesanal en el Virreinato de la Nueva España durante el siglo XVIII* (Madrid: Alianza Editorial, Ministerio de Cultura, 1990), 66–68.

21. Ibid., 123–90.

22. Francisco de Ajofrín, *Diario del viaje que por orden de la sagrada Congregación de Propagana Fide hizo a la América Septentrional en el siglo XVIII*, ed. Vicente Castañeda y Alcover, 2 vols. (Madrid: Real Academia de la Historia, 1958), 1:220.

23. The largest signed piece is the slant-front desk in the collection of the Hispanic Society, (LS1642); see fig. 74.

24. The best-known example is John Stalker and George Parker, *A Treatise of Japaning and Varnishing* (Oxford, 1688).

25. Joaquín Alejo de Meave, "Memoria sobre la pintura del pueblo de Olinalan, de la Jurisdicción de Tlapan," *Gaceta de Literatura de México* 2, no. 22 (June 28, 1791): 173–78.

Religious Orders and the Arts of Asia

1. See Gauvin Alexander Bailey, *Art on the Jesuit Missions in Asia and Latin America, 1542–1773* (Toronto: University of Toronto Press, 1999).

2. Lauren Arnold, *Princely Gifts and Papal Treasures: The Franciscan Mission to China and Its Influence on the Art of the West, 1250–1350* (San Francisco: Desiderata Press, 1999); Christopher Dawson, *Mission to Asia* (Toronto: University of Toronto Press, 1980).

3. See Gauvin Alexander Bailey, "The Calera de Tango of Chile (1741–67): The Last Great Mission Art Studio of the Society of Jesus," *Archivum Historicum Societatis Iesu* 74, no. 147 (January–June 2005): 175–206; Bailey, *Art on the Jesuit Missions*, 65–67, 144–82.

4. Bailey, *Art on the Jesuit Missions*, 69–70, 73–74; Money Hickman, *Japan's Golden Age: Momoyama* (New Haven: Yale University Press, 1996), cat. 124.

5. Léo Keller, "Un pinceau utile pour le bien de la religion: Jean Denis Attiret (1702–1768), dit Wang Zhicheng, peintre jésuite à la cour de Chine," in *La chair et le verbe: Les jésuites de France au XVIIIe siècle et l'image*, ed. Édith Flamarion (Paris: Presses Sorbonne Nouvelle, 2008), 47–74; *The Golden Exile: Pictorial Expressions of the School of Western Missionaries' Artworks of the Qing Dynasty Court* (Macau: Macau Museum of Art, 2002), 230–73.

6. For an illustration of this series, see *The Golden Exile*, 66–75.

7. See Margareta Mercedes Estella Marcos, *Ivories from the Far Eastern Provinces of Spain and Portugal* (Monterrey: Espejo de Obsidiana Ediciones, 1997), cat. 47. See also Gauvin Alexander Bailey, "Translation and Metamorphosis in the Catholic Ivories of China, Japan, and the Philippines, 1561–1800," in *Ivories of the Portuguese Empire*, ed. Gauvin Alexander Bailey, Michel Massing, and Nuno Vassallo e Silva (Lisbon: Scribe, 2013), 240ff; Regalado Trota Jose and Ramón N. Villegas, *Power + Faith + Image: Philippine Art in Ivory from the 16th to the 19th Century* (Makati City: Ayala Foundation, 2004), 22–24, 72, 98–99, 105; Kiyoko Yamaguchi, "The Architecture of the Spanish Philippines and the Limits of Empire," in *Investing in the Early Modern Built Environment: Europeans, Asians, Settlers and Indigenous Societies*, ed. Carole Shammas (Leiden: Brill, 2012), 124–27; Andrew R. Wilson, *Ambition and Identity: Chinese Merchant Elites in Colonial Manila, 1880–1916* (Honolulu: University of Hawai'i Press, 2004), 41–42; Margareta Mercedes Estella Marcos, *Ivories from the Far Eastern Provinces of Spain and Portugal* (Monterrey: Espejo de Obsidiana Ediciones, 1997), p. 21 and cat. 47.

8. The Fujian ports were exempted from the Ming government's 1567 edict forbidding foreign trade. See Gauvin Alexander Bailey, "Incarnate Images: The Jesuits' Artistic Program in Portuguese Asia and Beyond," in *Encompassing the Globe: Portugal and the World in the 16th and 17th Centuries: Essays*, ed. Jay A. Levenson (Washington, D.C.: Arthur M. Sackler Gallery, Smithsonian Institution, 2007), 180.

9. César Guillén Nuñez, *Macao's Church of Saint Paul: A Glimmer of the Baroque in China* (Hong Kong: Hong Kong University Press, 2009), 118–19.

10. Gauvin Alexander Bailey, "Asia in the Arts of Colonial Latin America," in *The Arts in Latin America, 1492–1820*, ed. Joseph J. Rishel and Suzanne Stratton-Pruitt (Philadelphia: Philadelphia Museum of Art, 2006), 59–60; Manuel Toussaint, *La catedral de México* (Mexico City: Ediciones de Arte, 1992), 107–8.

11. Some 572 Goan ivories are preserved in the Museu Histórica Nacional in Rio de Janeiro alone: Museo Histórico Nacional, *A sagração do marfim* (São Paulo: Pinacoteca, 2002), 2; Museo Histórico Nacional, *Arte do marfim* (Rio de Janeiro: Centro Cultural Banco do Brasil, 1993), 14.

12. Jose and Villegas, *Power + Faith + Image*, 92; Richard Aste, ed., *Behind Closed Doors: Art in the Spanish American Home, 1492–1898* (Brooklyn, NY: Brooklyn Museum, 2013), 114–17.

13. Regina Krahl, catalogue entry C-1 in Levenson, *Encompassing the Globe*, 138; Francisco Hipólito Raposo, *Portuguese Expansion Overseas and the Art of Ivory*, trans. Patricia Thorburn (Lisbon: Comissão Nacional para as Comemorações dos Descobrimentos Portugueses, 1991), 55.

14. Ines Županov, *Missionary Tropics: The Catholic Frontier in India, 16th–17th Centuries* (Ann Arbor: University of Michigan Press, 2005): 19.

15. Ines Županov has recently suggested these are Hindu *naga/nagini* (a cobra-serpent king or queen related to water) and related tree spirits known as *yaksha/yakshi*: Ines Županov, "Possessing Images: What Do Naga Do on the Baroque Goan Pulpits?" (paper delivered at the confer-

ence "Christianity Translated: Knowledge Circulation and Epistemic Transformation through Missionary Enterprise," University of Bochum, June 11–12, 2013).

16. Serge Gruzinsky, *Images at War: Mexico from Columbus to Blade Runner (1492–2019)*, trans. Heather MacLean (Durham: Duke University Press, 2001), 70–71.

17. Charles H. Lippy et al., *Christianity Comes to the Americas, 1492–1776* (New York: Paragon House, 1992), 55–58, 64–65.

18. Silvio Zavala, *Sir Thomas More in New Spain: A Utopian Adventure of the Renaissance* (London: Hispanic and Luso-Brazilian Councils, 1955); John Leddy Phelan, *The Millennial Kingdom of the Franciscans in the New World* (Berkeley: University of California Press, 1970), 46; Karen Melvin, *Building Colonial Cities of God: Mendicant Orders and Urban Culture in New Spain* (Stanford: Stanford University Press, 2012), 13–17.

19. Steven J. Harris, "Mapping Jesuit Science: The Role of Travel in the Geography of Knowledge," in *The Jesuits: Cultures, Sciences, and the Arts, 1540–1773*, ed. John W. O'Malley et al. (Toronto: University of Toronto Press, 1999), 217; John Correia-Afonso, *Jesuit Letters and Indian History, 1542–1773* (Oxford: Oxford University Press, 1969).

20. Margarita Mercedes Estella Marcos, *La escultura barroca de marfil en España* (Madrid: Consejo Superior de Investigaciones Científicas, 1984), 266; Jaime Cisneros, *Misiones jesuíticas* (La Paz: La Papelera, 1996), 74. The Santiago Virgin is now in the Museo de San Francisco in Santiago.

21. Maria Helena Ochi Flexor et al., *O conjunto do Carmo de Cachoeira* (Brasilia: IPHAN/Monumenta, 2007), 106–7.

22. Jonathan D. Spence, *The Memory Palace of Matteo Ricci* (New York: Viking Penguin, 1985), 189; see also Teresa Castelló Yturbide, *The Art of Featherwork in Mexico* (Mexico City: Fomento Cultural Banamex, 1993).

23. Schuyler Camman, "Chinese Influence in Colonial Peruvian Tapestries," *Textile Museum Journal* 1, no. 3 (1964): 21–34;

Elena Phipps, Johanna Hecht, and Cristina Esteras Martín, *The Colonial Andes: Tapestries and Silverwork, 1530–1830* (New York: Metropolitan Museum of Art, 2004), 250–56; Rebecca Stone-Miller, *To Weave for the Sun: Ancient Andean Textiles in the Museum of Fine Arts, Boston* (Boston: Museum of Fine Arts, 1992), 201–3.

24. Harris, "Mapping Jesuit Science," 212–13; Ignacio Osorio Romero, *La luz imaginaria: Epistolario de Atanasio Kircher con los novohispanos* (Mexico City: Universidad Nacional Autónoma de México, 1993); Judith Gutiérrez Reyes and Lucía Celaya Méndez, *Catálogo de la biblioteca del noviciado de los dieguinos de San José de Tacubaya*, vol. 1 (Mexico City: Universidad Nacional Autónoma de México, 1991), cats. 16, 25–27. Buenos Aires, Archivo General de la Nación (AGN) IX, 22-6-3, *Temporalidades de Misiones* (1768–78), no. 1, ff. 19b, 20b; no. 2, f. 11a; no. 29, f. 14b; no 24, f. 22a; no. 23, f. 8b; IX, 22-6-4, *Temporalidades de Misiones* (1768–78), no. 20, f. 33a; Lima, Archivo General de la Nación (AGNP), *Temporalidades (Juli)*, leg. 130, 4, f. 53b; *Temporalidades (Potosí)*, leg. 172 (1767–93), ff. 50b, 55a, 57b–58b; C956, *Inventario de la biblioteca y aposentos del Colegio de la Ciudad de Arequipa* (1766), ff. 32b–33a, 38a, 41b.

25. Adriano de las Cortes's manuscript is owned by the Hispanic Society of America; see Mitchell A. Codding and John O'Neill, *Illuminated Manuscripts* (New York: Hispanic Society of America, 2006), 36–37.

26. See Gauvin Alexander Bailey, *Art of Colonial Latin America* (London: Phaidon, 2005), 349–51.

27. Anthony Pagden, *The Fall of Natural Man: The American Indian and the Origins of Comparative Ethnology* (Cambridge: Cambridge University Press, 1994), 146, 149–50.

28. Judith Gutiérrez Reyes and Lucía Celaya Méndez, *Catálogo de la biblioteca de noviciado de los dieguinos de San José de Tacubaya* (Mexico City: Instituto Nacional de Antropología e Historia, 1991), cats. 16, 25–27; Ignacio Osorio Romero, *La luz imaginaria: Epistolario de Atanasio Kircher con los novohispanos* (Mexico City:

140

Universidad Nacional Autónoma de México, 1993), xv–xliv; Octavio Paz, *Sor Juana*, trans. Margaret Sayers Peden (Cambridge, Mass.: Harvard University Press, 1988), 166, 176–77.

29. Clara Bargellini and Michael K. Komanecky, *The Arts of the Missions of Northern New Spain, 1600–1821* (Mexico City: Antiguo Colegio de San Ildefonso, 2009), 238, cat. 147.

30. Archivo Nacional de Chile (ANC), *Fondo Jesuitico* 7, f. 98b. For a reproduction of the Pardo painting, see Damián Bayón and Murillo Marx, *History of South American Colonial Art and Architecture* (New York: Rizzoli, 1992), 107. For the Felipe de Jesús painting, see Bargellini and Komanecky, *The Arts of the Missions of Northern New Spain*, 296.

31. María Celia Fontana Calvo, *Las pinturas murales del antiguo convento franciscano de Cuernavaca* (Cuernavaca: Universidad Autónoma del Estado de Morelos, 2011), 114–33. I am grateful to Dennis Carr for bringing this source to my attention.

32. See Carlos A. Cerqueira Lemos, *A imaginária paulista* (São Paulo: Pinacoteca do Estado, 1999): 134–35.

33. Gauvin Alexander Bailey, "A Mughal Princess in Baroque New Spain: Catarina de San Juan (1606–88), the China Poblana," *Anales del Instituto de Investigaciones Estéticas* 19, no. 71 (Autumn 1997): 37–86. The longest of the biographies is Alonso Ramos's three-volume *Prodigios de la omnipotencia y milagros de . . . Catharina de S. Joan* (Puebla: Imprenta de Diego Fernández de León, 1690).

34. Mercedes Meade de Angulo, "Doctor don Juan Manuel Rojo del Río Lafuente y Vieyra Arzobispo, gobernador y capitán general de Manila, protector de don Juan López Portillo," in María Cristina Barrón, ed., *La Presencia novohispana en el Pacífico insular* (Mexico City: Pinacoteca Virreinal, 1992), 159.

35. Pedro G. Galende and Regalado Trota Jose, *San Agustín: Art & History, 1571–2000* (Manila: San Agustín Museum, 2000), 9; René Javellana, *Wood and Stone for God's Greater Glory: Jesuit Art & Architecture in the Philippines* (Manila: Ateneo de Manila University Press, 1991), 23.

36. The Actopan stairwell is illustrated in Antonio Bonet Correa, *Monasterios Iberoamericanos*, (Madrid: Ediciones El Viso, 2001), 116.

37. J. W. Witek, "Belleville, Charles de," in *Diccionario histórico de la Compañía de Jesús*, ed. Charles E. O'Neill and Joaquín M. Domínguez, vol. 1 (Madrid: Universidad Pontificia Comillas, 2001), 404; Jean-Pierre Duteil, *Le mandat du ciel: Le role des jésuites en Chine* (Paris: AP Éditions-Arguments, 1994), 42; D. E. Mungello, *The Great Encounter of China and the West, 1500–1800* (Lanham, Md.: Rowman and Littlefield, 1999), 67.

38. José Roberto Teixeira Leite, *A China no Brasil: Influências, marcas, ecos e sobrevivências chinesas na sociedade e na arte brasileiras* (Campinas, Brazil: Editora da Unicamp, 1999), 171–78; Cécile Beurdeley and Michel Beurdeley, *Giuseppe Castiglione: A Jesuit Painter at the Court of the Chinese Emperors* (Rutland, Vt.: C. E. Tuttle, 1971), 194.

39. Gabriela Braccio located a baptismal certificate from San Bartolomé de Tambobong dated December 28, 1756, for an Estevan Luiz Mateo Samzon, in which the parents are listed as Mateo Samzon and María de la Concepción: "Esteban Sampzon, un escultor Filipino en el Río de la Plata" (unpublished paper presented at the 2009 conference of the Asociación de Estudios Latinoamericanos, Río de Janeiro, June 11–14), 3. For more on Sampzon, see Bailey, *Art of Colonial Latin America*, 66, fig. 29; Academia Nacional de Bellas Artes, *Historia general del arte en la Argentina*, vol. 1 (Buenos Aires: Academia Nacional de Bellas Artes, 1982), 336–43; Adolfo Luis Ribera and Héctor H. Schenone, *El arte de la imaginería en el Río de la Plata* (Buenos Aires: Instituto de Arte Americano e Investigaciones Estéticas, 1948), 85–87.

40. The quotation, from a 1780 document, is published in Héctor Schenone, "Imaginería," in Academia Nacional de Bellas Artes, *Historia general del arte en la Argentina*, 1:336.

41. San Bartolomé de Tambobong was founded by Augustinian friars in 1599; the church was begun in 1622.

42. It is now at the Isaac Fernández Blanco Museum. See Riberia and Schenone, *El arte de la imaginería*, 86.

43. Braccio, "Esteban Sampzon," 3, 8.

44. Christine Turgeon, *Le fil de l'art: Les broderies des Ursulines de Québec* (Quebec City: Musée du Québec, 2002), 89–106; Marius Barbeau, *Saintes artisanes*, vol. 1, *Les brodeuses* (Montreal: Editions Fides, 1943); Marius Barbeau, *Saintes artisanes*, vol. 2, *Mille petites adresses* (Montreal: Editions Fides, 1946).

45. Christine Cheyrou, "Points de prière et de beauté: L'art de la broderie au Monastère des Ursulines de Québec," in *Les arts en Nouvelle-France*, ed. Laurier Lacroix (Quebec City: Publications du Québec, 2012), 204–7; Turgeon, *Le fil de l'art*, 39–44; Dominique Deslandres, "In the Shadow of the Cloister: Representations of Female Holiness in New France," in *Colonial Saints: Discovering the Holy in the Americas, 1500–1800*, ed. Allan Greer and Jodi Bilinkoff (New York: Routledge, 2003), 130–32; Jean Trudel, *The Ursuline Chapel in Quebec City* (Quebec City: Monastère des Ursulines de Québec, 2005), 31–32; Barbeau, *Saintes Artisanes*, 1:23.

46. Turgeon, *Le fil de l'art*, 61; Lacroix, *Les arts de Nouvelle-France*, 74.

47. Turgeon, *Le fil de l'art*, 49–50; Gagnon, *La conversion par l'image*, 42–44.

48. Turgeon, *Le fil de l'art*, 60–65, 57–58.

Chinoiserie in the Colonial Americas

1. Hugh Honour, *Chinoiserie: The Vision of Cathay* (London: J. Murray, 1961), 130.

2. Robert Dossie, *The Handmaid to the Arts* (London: J. Nourse, 1758), v.

3. For Mexican chinoiserie, see Gustavo Curiel, "Perception of the Other and the Language of 'Chinese Mimicry' in the Decorative Arts of New Spain," in *Asia and Spanish America: Trans-Pacific Artistic and Cultural Exchange, 1500–1850*, ed. Donna Pierce and Ronald Otsuka (Denver: Denver Art Museum, 2009), 19–36. See also Manuel Carballo, "Influencia Asiática," in Carmen Aguilera et al., *El mueble Mexicano: Historia, evolución e influencias* (Mexico: Fomento Cultural Banamex, 1985), 115–32.

4. See Marcia Reed and Paola Demattè, eds., *China on Paper: European and Chinese Works from the Late Sixteenth to the Early Nineteenth Century* (Los Angeles: Getty Research Institute, 2007).

5. For a detailed description of the screen, see Teresa Castelló Yturbide and Marita Martínez del Río de Redo, *Biombos mexicanos* (Mexico: Instituto Nacional de Antropología e Historia, 1970), 61–65. See also *México en el mundo de las colecciones del arte, Nueva España*, vol. 2 (Mexico: Gobierno de la Republica, 1994), 12–14.

6. Two such screens were among the furnishings of the home of the Count of Xala in 1794; Manuel Romero de Terreros, *Una casa del siglo XVIII en México: La del conde de San Bartolomé de Xala* (Mexico: Imprenta Universitaria, 1957), 59–61. Though the original owner of this screen is not known, its history indicates that it was acquired in Mexico by the Alvear family, who took it to Spain in the mid-nineteenth century.

7. Early copies of these works appeared in Mexico in the seventeenth century, such as those in the seventeenth-century library of Juan de Palafox y Mendoza in Puebla, and in Boston by 1723, where they were sold by the bookseller Samuel Gerrish (see Evans, *Early American Imprints*, ser. 1, no. 39784), and in Philadelphia at the Library Company of Philadelphia by 1770 (see Evans, *Early American Imprints*, ser. 1, no. 11820. The Harvard College Library owned a copy of Montanus's other comparable work, *Atlas Japannensis "English'd by Ogilby"* in 1723; see *Catalogus bibliothecae: Collegij Harvardini quod est Cantabrigiae in Nova Anglia* (Boston, 1723). I thank Sarah Reusche for these references.

8. Quoted from the English edition issued by John Ogilby, credited as Arnoldus Montanus, *Atlas Chinensis: Being a Second Part of a Relation of Remarkable Passages in Two Embassies from the East-India Company of the United Provinces* (London: Thomas Johnson, 1671), 414, 417. This source drew heavily on firsthand accounts of Asia, including those of the Jesuit missionary Álvaro de Semedo, who had traveled extensively in China.

9. "Al Real sello leales/ Acompañan; no al metal/Y bien se veé, que son tales/Pues, pre-

cian mas lo Real Y menosprecian los Reales"; "Al que govierna mal/bien el salir le conviene/Con decoro, y po[m]pa igual/si a ser, qual Cristal viene/Sea mirado por cristal."

10. See Castelló Yturbide and Martínez del Río de Redo, *Biombos mexicanos*, 65, and *México en el mundo*, 12–14.

11. For a Mexican example, see Teresa Castelló Yturbide, *El mueble mexicano* (Mexico City: Artes de México, 1969), 21, cover; and Carballo, "Influencia Asiática," 128, 130.

12. Romero de Terreros, *Una casa del siglo XVIII*, 33–73.

13. Gustavo Curiel, *Los bienes del mayorazgo de los Cortés del Rey en 1729: La casa de San José del Parral y las haciendas del Río Conchos, Chihuahua* (Mexico: Instituto de Investigaciones Estéticas, Universidad Nacional Autónoma de Mexico, 1993), 32, 56

14. For a related desk-on-stand, although in a distinctly rococo style, see José Ignacio Conde y Díaz Rubín, "Un excepcional mueble mexicano del siglo XVIII," *Artes de México* 118 (1969): 34–37; the desk-on-stand is pictured with its original crest or headboard in fig. 12 on p. 16.

15. Gustavo Curiel and Dennis Carr, "Un 'parnaso tropical': Los mapas de la hacienda de Santa María Cuezpalapa, o la Estanzuela, en dos muebles novohispanos del siglo XVIII" (Mexico City: Universidad Nacional Autónoma de México, 2014).

16. John Stalker and George Parker, *A Treatise of Japaning and Varnishing: Being a Compleat Discovery of Those Arts* (Oxford, 1688), epistle.

17. See Morrison H. Heckscher, "English Furniture Pattern Books in Eighteenth-Century America," in *American Furniture*, 1994, ed. Luke Beckerdite (Milwaukee: Chipstone Foundation, 1994), 183. The marginalia and smudges of varnish and pigment in the copy of Stalker and Parker's *Treatise* owned by the Boston Athenaeum suggest extensive use.

18. Samuel Gerrish, *A Catalogue of Curious and Valuable Books . . . To Be Sold at Auction* (Boston: J. Franklin, 1719); see Evans, *Early American Imprints*, ser. 1, no. 39701.

19. Evans, *Early American Imprints*, ser. 1, nos. 8006 (Philadelphia, 1757), 9764 (Newport, 1765), 9794 (Philadelphia, 1765), 11596 (Charleston, 1770), 22066 (Philadelphia, 1789), 23618 (New York, 1791).

20. Ibid., no. 10137.

21. See Flavia Perugini, *Techniques of Chinese Lacquer: The Classic Eighteenth-Century Treatise on Asian Varnish* (Los Angeles: J. Paul Getty Trust, 2009).

22. In 1716 William Gent advertised, "Lately come from London, A Parcel of very fine Clocks . . . in Japan Cases or Wall Nut"; *Boston News-Letter*, April 9–16, 1716. An English-made japanned desk-and-bookcase descended in the family of New York Governor James DeLancey, who reportedly purchased the desk at auction in New York City in 1753 (Metropolitan Museum of Art, 39.184.1a–b). Three surviving English-style japanned wall clocks hung in New England churches during the eighteenth century: one signed by the clockmaker "William Clagget Newport" and installed in the Seventh Day Baptist Meeting House in Newport about 1732 (Newport Historical Society), one in the First Parish Meetinghouse in Dedham (Dedham Historical Society), and a third in the Brattle Street Church in Boston (Bowdoin College Museum of Art).

23. Robert A. Leath, "Jean Berger's Design Book: Huguenot Tradesmen and the Dissemination of the French Baroque Style," in Beckerdite, *American Furniture*, 1994, 136–61. For Berger's life before his moving to Boston, see François-Marc Gagnon, *Jean Berger, peintre et complice?* (Montreal: Concordia University, 2011).

24. For general sources on American japanning, see Esther Stevens Fraser, "A Pedigreed Lacquered Highboy," *The Magazine Antiques* 15, no. 5 (May 1929): 398–401; Joseph Downs, "American Japanned Furniture," *Bulletin of the Metropolitan Museum of Art* 28, no. 3 (March 1933): 42–48; Esther Stevens Brazer, "The Early Boston Japanners," *The Magazine Antiques* 43, no. 5 (May 1943): 208–11; Mabel M. Swan, "The Johnstons and the Reas—Japanners," *The Magazine Antiques* 43, no. 5 (May 1943): 211–

13; Dean A. Fales Jr., *American Painted Furniture, 1660–1880* (New York: E. P. Dutton, 1972), 58–69; Sinclair Hitchings, "Thomas Johnston," in Colonial Society of Massachusetts, *Boston Prints and Printmakers, 1670–1775* (Boston: Colonial Society of Massachusetts, 1973), 83–132; Dean A. Fales Jr., "Boston Japanned Furniture," in *Boston Furniture of the Eighteenth Century*, ed. Walter Muir Whitehill, Jonathan L. Fairbanks, and Brock W. Jobe (Boston: Colonial Society of Massachusetts, 1974), 49–69; Elizabeth Rhoades and Brock Jobe, "Recent Discoveries in Boston Japanned Furniture," *The Magazine Antiques* 105, no. 5 (May 1974): 1082–91; Richard Randall, "William Randall, Boston Japanner," *The Magazine Antiques* 105, no. 5 (May 1974): 1127–31; John H. Hill, "The History and Technique of Japanning and the Restoration of the Pimm Highboy," *American Art Journal* 8, no. 2 (November 1976): 59–84; Jonathan L. Fairbanks and Elizabeth Bidwell Bates, *American Furniture: 1620 to the Present* (New York: R. Marek, 1981), 129–38; Morrison H. Heckscher and Frances Gruber Safford, with a conservation note by Peter Lawrence Fodera, "Boston Japanned Furniture in the Metropolitan Museum of Art," *The Magazine Antiques* 129, no. 5 (May 1986): 1046–61; Ethan W. Lasser, "Reading Japanned Furniture," in *American Furniture, 2007*, ed. Luke Beckerdite (Milwaukee: Chipstone Foundation, 2007), 168–90; Phyllis Whitman Hunter, "Japanned Furniture: Global Objects in Provincial America," *The Magazine Antiques* 175, no. 5 (May 2009): 118–24; Alyce L. Perry, "The Best 'Blew': A Rare American Blue-Japanned Tall-Case Clock," *The Magazine Antiques* 175, no. 5 (May 2009): 125–27.

25. See John M. Cross, "The Joiners of Port Royal and Early Furniture Making in Jamaica," *Furniture History* 50 (2014): 137–45.

26. *Boston News-Letter*, March 31–April 7, 1712.

27. See Rhoades and Jobe, "Recent Discoveries in Boston Japanned Furniture."

28. *Boston Gazette*, April 4–11, 1726.

29. Swan, "The Johnstons and the Reas—Japanners."

30. I thank Tara Cederholm and Christine Thomson for kindly providing this information, which is based on their extensive ongoing study of Boston japanned furniture.

31. See Downs, "American Japanned Furniture," 46–47; Fales, *American Painted Furniture*, 61–65, 68. A copy of Stalker and Parker's *Treatise* was advertised for sale in a bookshop in Philadelphia in 1783; see Heckscher, "English Furniture Pattern Books," 183.

32. A set of at least nine Queen Anne chairs with early nineteenth-century japanned decoration descended in the family of Samuel Pickering Gardner (1767–1843), of which two belong to the Museum of Fine Arts, Boston (1981.16–17). See Fales, *American Painted Furniture*, 66–67.

33. Quoted in Rhoades and Jobe, "Recent Discoveries in Boston Japanned Furniture," 1088.

34. Caroline Frank has suggested that Gibbs might have been familiar with scenes of torture and capital punishment in engravings by Albrecht Dürer and Theodore de Bry, as well as those in Stalker and Parker's *Treatise*. See Caroline Frank, "Architectural Japanning in an Early Newport House," *The Magazine Antiques* 170, no. 3 (September 2006): 104–13; and Caroline Frank, *Objectifying China, Imaging America: Chinese Commodities in Early America* (Chicago: University of Chicago Press, 2007), 59–95. See also Antoinette F. Downing and Vincent J. Scully, *The Architectural Heritage of Newport, Rhode Island, 1640–1915*, 2nd ed. (1967; repr., New York: American Legacy Press, 1982), 453–54.

35. Inventory quoted in Frank, "Architectural Japanning," 108.

36. A description of the "curious old fresco" painted above the mantel on the second floor of the house appeared in the October 18, 1879, issue of the *Newport Mercury*; see Robert P. Foley, A. Bruce MacLeish, and Pieter N. Roos, *Extraordinary Vision: Doris Duke and the Newport Restoration Foundation* (Newport: Newport Restoration Foundation, 2010), 32–35.

37. See C. R. Boxer, *The Golden Age of Brazil, 1695–1750: Growing Pains of a Colonial Society* (Berkeley: University of California Press, 1962), 178; Sylvio de Vasconcellos, *Capela Nossa Senhora do Ó* (Belo Horizonte: Escola de Arquitetura da Universidade de Minas Gerais, 1984); Damián Bayón and Murillo Marx, *History of South American Colonial Art and Architecture: Spanish South America and Brazil* (New York: Rizzoli, 1992), 377–78; Sonia María Fonseca, "Orientalismos no Barroco em Minas Gerais e a circularidade cultural entre o Oriente e o Occidente," *Revista de Cultura* (Macau) 22 (1995): 113; José Roberto Teixeira Leite, *A China no Brasil: Influências, marcas, ecos e sobrevivências chinesas na sociedade e na arte brasileiras* (Campinas, Brasil: Editora da Unicamp, 1999), 143–45; Percival Tirapeli, *Igrejas Barrocas do Brasil* (São Paulo: Metalivros, 2008), 218–21; Rafael Moreira, "A arte Luso-Brasileira: Modelos, síntese, autonomia," in *História da Expansão Portuguesa*, vol. 3, *O Brasil na balança de império (1697–1808)*, ed. Francisco Bethencourt and Kirti Chaudhuri (Lisbon: Círculo de Leitores, 1998), 484–86; Eugénie M. Brajnikov, "Traces de l'influence de l'art oriental sur l'art brésilien de debut du XVIIIe siècle," *Revista da Universidade Federal de Minas Gerais* 9 (May 1951): 40–60.

38. See, for example, the chinoiserie-decorated bookshelves in the library at the University of Coimbra in Portugal, painted by the Portuguese artist Manuel da Silva in 1723.

39. For churches in Minas Gerais, see Tirapeli, *Igrejas Barrocas do Brasil*, 216–17, 232–35, 286–89; Luiz A. C. Souza and Cristina Avila, "Chinese Motifs in the Baroque Art of Minas Gerais, Brazil: Historical and Technical Aspects," in *Painted Wood: History and Conservation*, ed. Valerie Dorge and F. Carey Howlett (Los Angeles: Getty Conservation Institute, 1998), 206–16. On the church in Catas Altas, see Luiz A. C. Souza, Adriano R. Ramos, and Cristina Avila, "The Matriz of Catas Altas, Minas Gerais, Brazil: Techniques, Materials and Style," in *Conservation of the Iberian and Latin American Cultural Heritage*, ed. H. W. M. Hodges, John S. Mills, and Perry Smith (London: International Institute for Conservation of Historic and Artistic Works, 1992). For Brazilian furniture painted in this style, see Gauvin Alexander Bailey, *Art of Colonial Latin America* (London: Phaidon, 2005), 350–51, 354; Teixeira Leite, *A China no Brasil*, 235–44.

40. Tirapeli, *Igrejas Barrocas do Brasil*, 232–35. A second Arp Schnitger organ of similar design is in the Faro Cathedral in Portugal.

41. *South Carolina Gazette*, December 19, 1761, quoted in Leath, "After the Chinese Taste," 55.

42. *Boston Post-Boy*, October 31, 1763.

43. Another object is a tankard from about 1685 by Jeremiah Dummer of Boston, which bears chinoiserie chased decoration.

44. See Beth Carver Wees with Medill Higgins Harvey, *Early American Silver in The Metropolitan Museum of Art* (New York: Metropolitan Museum of Art, 2013), 248–53.

45. See Ellen Paul Denker, *After the Chinese Taste: China's Influence in America, 1730–1930* (Salem, Mass.: Peabody Museum of Salem, 1985), 1–15.

46. See Downs, "American Japanned Furniture"; Heckscher, Safford, and Fodera, "Boston Japanned Furniture," 1049–55.

47. Thomas Hancock's order of wallpaper from England in 1738 is mentioned in Honour, *Chinoiserie*, 134.

48. Kathryn C. Buhler and Graham Hood, *American Silver: Garvan and Other Collections in the Yale University Art Gallery*, 2 vols. (New Haven: Yale University Press, 1970), 1:121–22; Peter Kaellgren, "Chinese Yixing Stoneware Teapots as a Source of English Silver Design, 1675–1830," *Silver Studies* 26 (2010): 50–57.

49. See Pam Parmal, *Women's Work: Embroidery in Colonial Boston* (Boston: MFA Publications, 2011).

50. *Boston Gazette*, January 15, 1759.

51. *Boston Evening-Post*, February 8, 1747/8.

52. Grove Hirst advertised selling "India Counterpanes" at his warehouse in Boston in 1716; see *Boston News-Letter*, August 13, 1716. Surviving examples of Indian "tree of life" embroideries are known to have been owned in Boston in the eighteenth century, such as MFA 57.168.

53. See Heckscher, "English Furniture Pattern Books," 172–205.

54. Brock Jobe, ed., *Portsmouth Furniture: Masterworks from the New Hampshire Seacoast* (Boston: Society for the Preservation of New England Antiquities, 1993), 306–9. Governor Wentworth also had a room decorated with Chinese wallpaper in his Wolfeborough estate. His younger brother Thomas owned a set of English chairs with Chinese-style fretwork backs and arm supports, and his brother-in-law John Fisher owned "8 [wal]Nut Chineas fraime Chamber chairs, 2 with arms"; see Barbara McLean Ward, "Wentworth Chinese Chippendale Furniture," *Antiques & Fine Art* (January–February 2006): 278–79. The possessions of the Brattle Street Church in Boston included an eighteenth-century mahogany settee with a Chinese-style fretwork back similar to a design in plate CXCII of the 1762 edition of Chippendale's *Gentleman and Cabinet-Maker's Director*; see Patricia E. Kane, "Furniture Owned by the Massachusetts Historical Society," *The Magazine Antiques* 109, no. 5 (May 1976): 964.

55. See, for example, the Josiah Quincy House (built in 1770 in Quincy, Mass.), now owned by Historic New England. One printed source is J. H. Morris, John Crunden, and Henry Webley, *The Carpenter's Companion for Chinese Railings and Gates* (London, 1765), which was advertised for sale in the *Boston Evening-Post*, October 27, 1766, and *Boston News-Letter*, January 1, 1767. I thank Sarah Reusche for these references.

56. Fiske Kimball, *Domestic Architecture of the American Colonies and the Early Republic* (1922; repr., New York: Dover, 1966), 110, 131, 138.

57. See Luke Beckerdite, "Architect-Designed Furniture in Eighteenth-Century Virginia: The Work of William Buckland and William Bernard Sears," in Beckerdite, *American Furniture*, 1994, 33–34; and Luke Beckerdite, "William Buckland and William Bernard Sears: The Designer and the Carver," *Journal of Early Southern Decorative Arts* 8, no. 2 (November 1982): 6–41. I thank Caroline Riley for sharing information about the reinterpretation of this room.

58. Leath, "Jean Berger's Design Book," 56–59.

59. A remarkable Brazilian painted cabinet with chinoiserie decoration, blue and white on the outside, and brown and white on the inside of the doors, simulating Chinese ceramics, survives in the Church of the Third Order of Carmo in Cachoeira, Bahía; it is illustrated in Teixeira Leite, *A China no Brasil*, 240. See Maria Inês Lopes Coutinho, *Museu de Arte Sacra de São Paulo* (São Paulo: Museu de Arte Sacra de São Paulo, 2014), 169.

60. Honour, *Chinoiserie*, 130.

Select Bibliography

Artes de México. *El galeón de Manila*, no. 143. Mexico: Artes de México, 1971.

———. "La Talavera de Puebla." *Artes de México*, no. 3. Mexico: Artes de México, 1989.

Ávila Hernández, Julieta. *El influjo de la pintura china en los enconchados de Nueva España*. Mexico: Instituto Nacional de Antropología e Historia, 1999.

Bailey, Gauvin Alexander. *Art of Colonial Latin America*. London: Phaidon, 2005.

———. *Art on the Jesuit Missions in Asia and Latin America, 1542–1773*. Toronto: University of Toronto Press, 1999.

———. "Asia in the Arts of Colonial Latin America." In *The Arts in Latin America, 1492–1820*, edited by Joseph J. Rishel and Suzanne Stratton-Pruitt, 57–69. Philadelphia: Philadelphia Museum of Art, 2006.

Barber, Edwin Atlee. *The Maiolica of Mexico*. Philadelphia: Pennsylvania Museum and School of Industrial Art, 1908.

Bargellini, Clara. "Asia at the Spanish Missions of Northern New Spain." In *Asia and Spanish America: Trans-Pacific Artistic and Cultural Exchange, 1500–1850*, edited by Donna Pierce and Ronald Otsuka, 191–99. Denver: Denver Art Museum, 2009.

Bargellini, Clara, and Michael K. Komanecky. *The Arts of the Missions of Northern New Spain, 1600–1821*. Mexico City: Antiguo Colegio de San Ildefonso, 2009.

Benítez, Fernando, ed. *El galeón del Pacífico: Acapulco-Manila, 1565–1815*. Mexico: Biblioteca del Sur, 1992.

Bernal, Rafael. *México en Filipinas: Estudio de una transculturación*. Mexico: Universidad Nacional Autónoma de México, 1965.

Bethencourt, Francisco, and Kirti Chaudhuri, eds. *História da expansão Portuguesa*. 5 vols. Lisbon: Círculo de Leitores, 1998–2000.

Bonta de la Pezuela, María. "The Perils of Porcelain: Chinese Export Porcelain for the Mexican Colonial Market." In *At the Crossroads: The Arts of Spanish America and Early Global Trade, 1492–1850*, edited by Donna Pierce and Ronald Otsuka, 41–52. Denver: Denver Art Museum, 2012.

Boxer, C. R. *The Portuguese Seaborne Empire, 1415–1825*. New York: Alfred A. Knopf, 1969.

Boyajian, James C. *Portuguese Trade in Asia under the Habsburgs, 1580–1640*. Baltimore: Johns Hopkins University Press, 1993.

Brajnikov, Eugénie Miller. "Traces de l'influence de l'art oriental sur l'art brésilien de debut du XVIIIe siècle." *Revista da Universidade Federal de Minas Gerais* 9 (May 1951): 40–60.

Brown, Roxanna M. "Shipwreck Evidence for the China-Manila Ceramics Trade." In *Asia and Spanish America: Trans-Pacific Artistic and Cultural Exchange, 1500–1850*, edited by Donna Pierce and Ronald Otsuka, 59–68. Denver: Denver Art Museum, 2009.

Camman, Schuyler. "Chinese Influence in Colonial Peruvian Tapestries." *Textile Museum Journal* 1, no. 3 (1964): 21–34.

Carballo, Manuel. *El biombo de los cuatro continentes*. Mexico: Banco Nacional de México, 1975.

Castelló Yturbide, Teresa, and Marita Martínez del Río de Redo. *Biombos mexicanos*. Mexico: Instituto Nacional de Antropología e Historia, 1970.

The China Trade and Its Influences. Text by Margaret Scherer and Joseph Downs. Exh. cat. New York: Metropolitan Museum of Art, 1941.

La concha nácar en México. Mexico: Grupo Gutsa, 1990.

Curiel, Gustavo. "Los biombos novohispanos: Escenografías de poder y transculturación en el ámbito domestico." In *Viento detenido: Mitologías e historias en el arte del biombo: Colección de biombos de los siglos XVII al XIX de Museo Soumaya*, 24–32. Mexico: Museo Soumaya, 1999.

———. "Al remedio de la China: El lenguaje 'achinado' y la formación de un gusto artístico dentro de las casas novohispanas." In *Orientes-Occidentes: El arte y la mirada del otro*, edited by Gustavo Curiel, 299–318. Mexico: Universidad Nacional Autónoma de México, Instituto de Investigaciones Estéticas, 2007.

———, ed. *Orientes-Occidentes: El arte y la mirada del otro*. Mexico: Universidad Nacional Autónoma de México, Instituto de Investigaciones Estéticas, 2007.

———. "Perception of the Other and the Language of 'Chinese Mimicry' in the Decorative Arts of New Spain." In *Asia and Spanish America: Trans-Pacific Artistic and Cultural Exchange, 1500–1850*, edited by Donna Pierce and Ronald Otsuka, 19–36. Denver: Denver Art Museum, 2009.

Curtin, Philip D. *Cross-Cultural Trade in World History*. Cambridge: Cambridge University Press, 1984.

Denker, Ellen. *After the Chinese Taste: China's Influence in America, 1730–1930*. Salem, Mass.: Peabody Museum of Salem, 1985.

Desroches, Jean-Paul, Gabriel Casal, and Franck Goddio. *Treasures of the San Diego*. Manila: National Museum of the Philippines, 1996.

Dujovne, Marta. *Las pinturas con incrustaciones de concha nácar*. Mexico: Universidad Nacional Autónoma de México, 1984.

Los enconchados de la conquista de México: Colección del Museo Nacional de Bellas Artes de Argentina. Mexico City: Museo de El Carmen, 1998.

Estella Marcos, Margarita Mercedes. "Trafico artístico entre Filipinas y España, vía Acapulco." In *Extremo Oriente Ibérico*, edited by Francisco de Solana, 593–606. Madrid: Agencia Española de Cooperación Internacional, 1989.

Fales, Dean A., Jr. "Boston Japanned Furniture." In *Boston Furniture of the Eighteenth Century*, edited by Walter Muir Whitehill, Jonathan L. Fairbanks, and Brock W. Jobe, 49–69. Boston: Colonial Society of Massachusetts, 1974.

Fish, Shirley. *The Manila-Acapulco Galleons: The Treasure Ships of the Pacific*. Central Milton Keynes, U.K.: Author House, 2011.

Fisher, Abby Sue. "Trade Textiles: Asia and New Spain." In *Asia and Spanish America: Trans-Pacific Artistic and Cultural Exchange, 1500–1850*, edited by Donna Pierce and Ronald Otsuka, 175–90. Denver: Denver Art Museum, 2009.

Flynn, Dennis O., and Arturo Giráldez. "Cycles of Silver: Global Economic Unity through the Mid-Eighteenth Century." *Journal of World History* 13 (2002): 391–428.

Flynn, Dennis O., Arturo Giráldez, and James Sobredo, eds. *The Pacific World: Lands, People and History of the Pacific, 1500–1900*, vol. 4, *European Entry into the Pacific: Spain and the Acapulco-Manila Galleons*. Aldershot, U.K.: Ashgate, 2001.

Fonseca, Sonia María. "Orientalismos no Barroco em Minas Gerais e a circularidade cultural entre o Oriente e o Occidente." *Revista de Cultura* (Macau) 22 (1995): 109–16.

Frank, Caroline. *Objectifying China, Imaging America: Chinese Commodities in Early America*. Chicago: University of Chicago Press, 2011.

Freyre, Gilberto. "Orient and Occident." In *The Mansions and the Shanties: The Making of Modern Brazil*, 273–301. New York: Alfred A. Knopf, 1963.

El galeón de Manila. Exh. cat. Madrid: Aldeasa, Ministerio de Educación, Cultura y Deporte de España, 2000.

Los galeones de la Plata: México, corazón del comercio interoceánico, 1565–1815. Exh. cat. Mexico: Consejo Nacional para la Cultura y las Artes, 1998.

Gavin, Robin Farwell, Donna Pierce, and Alfonso Pleguezuelo, eds. *Cerámica y Cultura: The Story of Spanish and Mexican Majolica*. Albuquerque: University of New Mexico Press, 2003.

Gruber, Alan. "Chinoiserie." In *The History of Decorative Arts: Classicism and the Baroque in Europe*, vol. 2, edited by Alain Gruber et al., 225–323. New York: Abbeville, 1994.

Guzmán-Rivas, Pablo. "Reciprocal Geographic Influences of the Trans-Pacific Galleon Trade." PhD diss., University of Texas at Austin, 1960.

Gruzinski, Serge. *The Eagle and the Dragon: Globalization and European Dreams of Conquest in China and America in the Sixteenth Century*. Trans. Jean Birrell. Malden, MA: Polity, 2014.

Heckscher, Morrison H., and Frances Gruber Safford, with a conservation note by Peter Lawrence Fodera. "Boston Japanned Furniture in the Metropolitan Museum of Art." *The Magazine Antiques* 129, no. 5 (May 1986): 1046–61.

Huth, Hans. *Lacquer of the West: The History of a Craft and an Industry, 1550–1950*. Chicago: University of Chicago Press, 1971.

Jackson, Anna, and Amin Jaffer, eds. *Encounters: The Meeting of Asia and Europe, 1500–1800*. London: Victoria and Albert Museum, 2004.

Johnston, Patricia, and Caroline Frank, eds., *Global Trade and Visual Arts in Federal New England*. Lebanon, N.H.: University of New Hampshire Press, 2014.

Jornadas Culturales Mexicano-Filipinas. *El galeón de Manila: Un mar de historias*. Mexico: JGH Editores, 1997.

Knauth, Lothar. *Confrontación transpacífica: El Japón y el nuevo mundo hispánico, 1542–1639*. Mexico: Universidad Nacional Autónoma de México, 1972.

Krohn, Deborah L., Peter N. Miller, and Marybeth de Filippis, eds. *Dutch New York between East and West: The World of Margrieta van Varick*. New Haven: Yale University Press, 2009.

Kuwayama, George. *Chinese Ceramics in Colonial Mexico*. Exh. cat. Los Angeles: Los Angeles County Museum of Art, 1997.

Leath, Robert, "'After the Chinese Taste': Chinese Export Porcelain and Chinoiserie Design in Eighteenth-Century Charleston." *Historical Archaeology* 33, no. 3 (1999): 48–61.

Lechuga, Ruth, et al. *Lacas mexicanas: Colección uso y estilo*. Mexico: Museo Franz Mayer, Artes de México, 2003.

Leibsohn, Dana. "Made in China, Made in Mexico." In *At the Crossroads: The Arts of Spanish America and Early Global Trade, 1492–1850*, edited by Donna Pierce and Ronald Otsuka, 11–40. Denver: Denver Art Museum, 2012.

Leonardi, Victor. *Os navegantes e o sonho: Presença do Oriente na história do Brasil*. Brasilia: Paralelo 15, 2005.

Levenson, Jay A. *Encompassing the Globe: Portugal and the World in the 16th and 17th Centuries*. Exh. cat. Washington, D.C.: Arthur M. Sackler Gallery, Smithsonian Institution, 2007.

López Cervantes, Gonzalo. *Cerámica colonial en la Ciudad de México*. Mexico: Instituto Nacional de Antropología e Historia, 1976.

Luengo, Jose Maria S. *A History of the Manila-Acapulco Slave Trade (1565–1815)*. Tubigon, Philippines: Mater Dei Publications, 1996.

Martínez del Río de Redo, Marita. "Los biombos en el ámbito domestico: Sus programas moralizadores y didácticos." In *Juegos de Ingenio y Agudeza. La pintura emblemática de la Nueva España*, 133–45, 146–49. Mexico: Patronato del Museo Nacional de Arte, 1994.

———. "La influencia oriental en el mueble mexicano." In *El mueble mexicano*, by Teresa Castelló Yturbide et al., 15–25. Mexico: Artes de México, 1969.

McAlister, Lyle N. *Spain and Portugal in the New World*. Minneapolis: University of Minnesota Press, 1985.

McQuade, Margaret Connor. *Talavera Poblana: Four Centuries of a Mexican Ceramic Tradition*. New York: Americas Society, 1999.

Mexico: Splendors of Thirty Centuries. New York: Metropolitan Museum of Art, 1992.

Mudge, Jean McClure. *Chinese Export Porcelain in North America*. New York: C. N. Potter, 1986.

Museo Nacional de Historia. *El galeón de Acapulco*. Mexico: Instituto Nacional de Antropología e Historia, 1988.

Museu Histórico Nacional. *A carreira das Indias e o gosto do Oriente*. Rio de Janeiro: Xcrox, 1985.

Nagashima, Meiko. "Japanese Lacquers Exported to Spanish America and Spain." In *Asia and Spanish America: Trans-Pacific Artistic and Cultural Exchange, 1500–1850*, edited by Donna Pierce and Ronald Otsuka, 107–18. Denver: Denver Art Museum, 2009.

Obregón, Gonzalo. "Influencia y contra influencia del arte oriental en Nueva España." *Historia Mexicana* 14, no. 2 (October–December 1964): 292–302.

Ocaña Ruiz, Sonia. "Enconchado Frames: The Use of Japanese Ornamental Models in New Spanish Painting." In *Asia and Spanish America: Trans-Pacific Artistic and Cultural Exchange, 1500–1850*, edited by Donna Pierce and Ronald Otsuka, 129–50. Denver: Denver Art Museum, 2009.

Orientalismo em Portugal (séculos XVI–XX). Lisbon: Comissão Nacional para as Comemorações dos Descobrimentos Portugueses, Edições Inapa, 1999.

Palmer, Gabrielle G. *Sculpture in the Kingdom of Quito*. Albuquerque: University of New Mexico Press, 1987.

Parry, J. H. *The Spanish Seaborne Empire*. 1966. Reprint. Berkeley: University of California Press, 1990.

Peck, Amelia, ed. *Interwoven Globe: The Worldwide Textile Trade, 1500–1800*. New York: Metropolitan Museum of Art, 2013.

Pérez Carrillo, Sonia. *La laca mexicana: Desarrollo de un oficio artesanal en el Virreinato de la Nueva España durante el siglo XVIII*. Madrid: Alianza Editorial, Ministerio de Cultura, 1990.

Pérez Carrillo, Sonia, and Concepción García Sáiz. "Las 'Metamorfosis' de Ovidio y los talleres de la laca en Nueva España." *Cuadernos de Arte Colonial* 1 (1986): 5–43.

Phipps, Elena, Johanna Hecht, and Cristina Esteras Martín. *The Colonial Andes: Tapestries and Silverwork, 1530–1830*. Exh. cat. New York: Metropolitan Museum of Art, 2004.

Pierce, Donna. "'At the Ends of the Earth': Asian Trade Goods in Colonial New Mexico, 1598–1821." In *At the Crossroads: The Arts of Spanish America and Early Global Trade, 1492–1850*, edited by Donna Pierce and Ronald Otsuka, 155–82. Denver: Denver Art Museum, 2012.

Porcelana de la Compañia de Indias para México. Mexico: Instituto Nacional de Antropología e Historia, 2002.

Portell, Jean D. "Colored Glazes on Silver-Gilded Surfaces." In *Conservation of the Iberian and Latin American Cultural Heritage*, edited by H. W. M. Hodges, John S. Mills, and Perry Smith, 116–18. London: International Institute for

Conservation of Historic and Artistic Works, 1992.

Porter, David. *The Chinese Taste in Eighteenth-Century England.* Cambridge: Cambridge University Press, 2010.

Puig, Francis J., and Michael Conforti, eds. *The American Craftsman and the European Tradition, 1620–1820.* Minneapolis: Minneapolis Institute of Arts, 1989.

Reed, Marcia, and Paola Demattè, eds. *China on Paper: European and Chinese Works from the Late Sixteenth to the Early Nineteenth Century.* Los Angeles: Getty Publications, 2011.

Rinaldi, Maura. *Kraak Porcelain: A Moment in the History of Trade.* London: Bamboo, 1989.

Rishel, Joseph J., and Suzanne Stratton-Pruitt, eds. *The Arts in Latin America, 1492–1820.* Exh. cat. Philadelphia: Philadelphia Museum of Art, 2006.

Rivas, Estefanía. "El empleo de la concha nácar en la pintura virreinal: Estudio radiográfico de la colección de pintura 'enconchada' del Museo de América de Madrid." *Espacio, Tiempo y Forma,* ser. 7, Historia del Arte, t. 15 (2002): 147–67.

Rivas Pérez, Jorge. "Of Luxury and Fantasy: The Use of Japanese Ornamental Models in New Spanish Painting." In *Asia and Spanish America: Trans-Pacific Artistic and Cultural Exchange, 1500–1850,* edited by Donna Pierce and Ronald Otsuka, 119–28. Denver: Denver Art Museum, 2009.

Rivero Lake, Rodrigo. *Namban Art in Viceregal Mexico.* Madrid: Turner, 2005.

Rodríguez, Etsuko Miyate. "The Early Manila Galleon Trade: Merchants Network and Markets in Sixteenth- and Seventeenth-Century Mexico." In *Asia and Spanish America: Trans-Pacific Artistic and Cultural Exchange, 1500–1850,* edited by Donna Pierce and Ronald Otsuka, 37–58. Denver: Denver Art Museum, 2009.

Sales Colín, Ostwald. *El movimiento portuario de Acapulco: El protagonismo de Nueva España en la relación con Filipinas, 1587–1648.* Mexico: Plaza y Valdés, 2000.

Sanabrais, Sofia. "The *Biombo* or Folding Screen in Colonial Mexico." In *Asia and Spanish America: Trans-Pacific Artistic and Cultural Exchange, 1500–1850,* edited by Donna Pierce and Ronald Otsuka, 69–106. Denver: Denver Art Museum, 2009.

Santiago Cruz, Francisco. *Relaciones diplomáticas entre la Nueva España y el Japón.* Mexico: Editorial Jus, 1964.

Schurz, William Lytle. *The Manila Galleon.* 1939. Reprint. Manila: Historical Conservation Society, 1985.

Seijas, Tatiana. *Asian Slaves in Colonial Mexico: From Chinos to Indians.* Cambridge: Cambridge University Press, 2014.

———. "Transpacific Servitude: The Asian Slaves of Mexico, 1580–1700." PhD diss., Yale University, 2008.

Slack, Edward R., Jr. "The *Chinos* in New Spain: A Corrective Lens for a Distorted Image." *Journal of World History* 20, no. 1 (2009): 35–67.

Teixeira Leite, José Roberto. *A China no Brasil: Influências, marcas, ecos e sobrevivências chinesas na sociedade e na arte brasileiras.* Campinas, Brazil: Editora da Unicamp, 1999.

Torre Villar, Ernesto de la, ed. *Asia and Colonial Latin America.* Mexico City: Colegio de México, 1981.

Toussaint, Manuel. "La pintura con incrustaciones de concha nácar en la Nueva España." *Anales del Instituto de Investigaciones Estéticas* 5, no. 20 (1952): 5–20.

Tovar de Teresa, Guillermo. "Los artistas y las pinturas de incrustaciones de concha nácar en Mexico." In *La concha nácar en México,* by Virginia Armella de Aspe et al., 106–34. México: Grupo Gutsa, 1990.

Wier, David. *American Orient: Imagining the East from the Colonial Era through the Twentieth Century.* Amherst: University of Massachusetts Press, 2011.

Yuste López, Carmen. *El comercio marítimo colonial: Nuevas interpretaciones y últimas fuentes.* Mexico City: Instituto Nacional de Antropología e Historia, 1997.

———. *El comercio de la Nueva España con Filipinas, 1590–1785.* Mexico City: Instituto Nacional de Antropología e Historia, 1984.

List of Illustrations

Boldface numbers indicate objects in the associated exhibition.

1
Martin Waldseemüller (1470–1519)
Universalis cosmographia secundum Ptholomaei traditionem et Americi Vespucii alioru[m] que lustrationes (A Drawing of the Whole Earth Following the Tradition of Ptolemy and the Travels of Amerigo Vespucci and Others)
St. Dié, France (?), 1507
Woodcut; 12 sheets, overall: 128 x 233 cm (50⅜ x 91¾ in.)
Courtesy of the Library of Congress, Geography and Map Division, G3200 1507.W3

2
Detail of fig. 1

3
Abraham Ortelius (1527–1598)
Typus orbis terrarum (Map of the World)
Belgium (Antwerp), 1570
Engraving
© The British Library Board, Maps C.2.c.1 1

4
Abraham Gessner (1552–1613)
Double cup, globe, and armillary sphere
Swiss, 1580–90
Silver, partially gilded, 50.5 x 16.8 cm (19⅞ x 6⅝ in.)
Museum of Fine Arts, Boston, Museum purchase with funds donated anonymously, 2006.1178

5
Alternate view of fig. 4 (detail)

6
Vicente de Memije, preparer (active 1761)
Laureano Atlas, engraver (active 1761)
Aspecto symbólico del mundo Hispánico (Symbolic Aspect of the Hispanic World)
Manila, 1761
Engraving, 59 x 98 cm (23¼ x 38⅝ in.)
© The British Library Board, Maps K. Top. 118.19

7
José de Páez (born in 1727)
Ex-voto with the Virgen de los Dolores de Xaltocan
Mexico City, 1751

Oil on canvas, 210 x 205 cm (82⅝ x 80¾ in.)
Parroquia de la Virgen de los Dolores, Xaltocan, Xochimilco, Mexico
Conaculta-INAH-Mexico/Reproduced by permission of Instituto Nacional de Antropología e Historia
Photograph: Rafael Doniz

8
Kanō Naizen (1570–1616)
Southern Barbarians Come to Trade
Japan, about 1600
One of a pair of six-panel folding screens; ink, color, gold, gold leaf on paper, 160 x 360 cm (63 x 141¾ in.)
Private collection

9
Palace of the Viceroys biombo
Mexico City, mid-17th century
Oil on canvas with gilt decoration, 1.84 x 4.88 m (about 6 x 16 ft.)
Museo de América, Madrid, 00207

10
Altar with images of the Virgin of Guadalupe
Japan, late 16th century, and Mexico, 18th century
Lacquer and mother-of-pearl over wood, with added paintings in oil on copper, and silver mounts; open: 44 x 59 x 5 cm (17⅜ x 23¼ x 2 in.)
Fundación Cultural Daniel Leibsohn A.C.

11
Cover
Peru, late 17th–early 18th century
Wool, silk, cotton, and linen, 238.3 x 207.3 cm (93⅞ x 81⅝ in.)
Museum of Fine Arts, Boston, Denman Waldo Ross Collection, 11.1264

12
Panel with flowers, birds, and animals
China, 17th century
Silk, embroidered with silk and gilt-paper-wrapped thread, 254 x 203.2 cm (100 x 80 in.)
The Metropolitan Museum of Art, Bequest of Catherine D. Wentworth, 1948 (48.187.614)
Image copyright © The Metropolitan Museum of Art, image source: Art Resource, NY

13
Attributed to the workshop of Diego Salvador Carreto (died in 1670/71)
Basin with landscape in Chinese style
Puebla de los Ángeles, Mexico, second half of the 17th century
Tin-glazed earthenware, 16.5 x 52.5 cm (6½ x 20⅝ in.)
Philadelphia Museum of Art, Purchased with the Joseph E. Temple Fund, 1908, 1908-247
Photograph: Graydon Wood

14
John Bartlam (died in 1788)
Tea bowl
Cain Hoy, South Carolina, about 1765–70
Soft-paste porcelain, diam. 7.9 cm (3⅛ in.)
Private collection

15
Simeon Soumaine (about 1660 or 1685–1750)
Sugar bowl
New York, 1738–45
Silver, 10.6 x 11.9 cm (4⅛ x 4⅝ in.)
Yale University Art Gallery, Mabel Brady Garvan Collection, 1903.1056
Photograph courtesy of the Yale University Art Gallery

16
Desk and bookcase
Peru, 18th century
Wood, mother-of-pearl, bone, hardwood, cedar, metal, 226.1 x 113 x 58.4 cm (89 x 44½ x 23 in.)
Courtesy of Newport Restoration Foundation, Newport, Rhode Island

17
Pair of writing cabinets
Peru, first half of the 18th century
Spanish cedar, mother-of-pearl, polychrome, iron, each: 33 x 33 x 33 cm (13 x 13 x 13 in.)
Colección Patricia Phelps de Cisneros
Photograph: Carlos Germán Rojas

18
John Singleton Copley (1738–1815)
Nicholas Boylston
Boston, about 1769
Oil on canvas, 127.3 x 101.6 cm (50⅛ x 40 in.)
Museum of Fine Arts, Boston, Bequest of David P. Kimball, 23.504

19
Attributed to José de Alcíbar (active 1751–1803)
De Español y negra, mulato (From Spaniard and Black, Mulatto)
Mexico City, about 1760
Oil on canvas, 78.8 x 97.2 cm (31 x 38¼ in.)
Denver Art Museum, Collection of Frederick and Jan Mayer, TL-29337
Photograph: James O. Milmoe

20
Unknown artist
María Juliana Rita Nuñez de Villavicencio y Peredo
Mexico, about 1735
Oil on canvas, about 200 x 90 cm (78¾ x 35½ in.)
C de Ovando Collection

21
Plate with the arms of García Hurtado de Mendoza y Manrique and Teresa de Castro y de la Cueva
Jingdezhen, China, about 1590–95
Porcelain, diam. 20.3 cm (8 in.)
Thomas Lurie Collection, Columbus, Ohio

22
Charger with symbol of the Order of St. Augustine
Jingdezhen, China, about 1590–1635
Porcelain, diam. 50.8 cm (20 in.)
Peabody Essex Museum, Museum Purchase with funds donated anonymously and in memory of Joseph D. Hinkle, 1998, AE85571
Photograph courtesy of the Peabody Essex Museum

23
Platter
Jingdezhen, China, 1755–60
Porcelain, 45.7 x 38.1 cm (18 x 15 in.)
Private collection
Photograph: Gavin Ashworth

24
Madonna and child
Dehua, China, 1690–1710
Porcelain, h. 33.6 cm (13¼ in.)
Peabody Essex Museum, Museum Purchase, 2001, AE85957
Photograph: Dennis Helmar, courtesy of the Peabody Essex Museum

25
Teapot
Yixing, China, about 1750
Stoneware, 12.7 x 21 cm
(5 x 8¼ in.)
Peabody Essex Museum, Gift of
George Curwen, before 1900, 361
Photograph courtesy of the
Peabody Essex Museum

26
Gown and petticoat
Chinese textile, assembled in New
York, 1740–60, remodeled 1770s
Silk damask, width of material:
74.3 cm (29¼ in.)
The Colonial Williamsburg
Foundation, Museum purchase,
1985-143
Photograph courtesy of
the Colonial Williamsburg
Foundation

27
Baby's jacket
Indian textile, assembled in the
Netherlands, mid-18th century
Cotton, mordant- and resist-dyed,
and painted, lined with linen,
length 22.9 cm (9 in.)
Peabody Essex Museum, Museum
Purchase, the Veldman-Eecen
Collection, 2012, 2012.22.35
Photograph courtesy of the
Peabody Essex Museum

28
Bedcover (palampore)
Gujarat, India, first half of the
18th century
Cotton embroidered with silk,
338 x 260 cm (133⅛ x 102⅜ in.)
Museum of Fine Arts, Boston,
Gift of Mrs. Frank Clark, 57.168

29
Cristóbal de Villalpando
(about 1649–1714)
View of the Plaza Mayor
Mexico City, about 1695
Oil on canvas, 180 x 200 cm
(70⅞ x 78¾ in.)
Corsham Court Collection, U.K.
Photograph: Corsham Court/
Wiltshire/Bridgeman Images

30
Antonio Pérez de Aguilar
(active 1749–69)
The Painter's Cabinet
Mexico City, 1765
Oil on canvas, 125 x 98 cm
(49¼ x 38⅝ in.)
© D.R. Museo Nacional de Arte,
Mexico City/Instituto Nacional de
Bellas Artes y Literatura, 2014

31
Pedro Calderón (active early
18th century)
Christ of Chalma
Mexico, about 1750
Oil on canvas, 251 x 197 cm
(98⅞ x 77½ in.)
Museo Nacional de Historia,
Mexico City
Conaculta-INAH-Mexico/
Reproduced by permission
of Instituto Nacional de
Antropología e Historia

32
Unknown artist
Our Lady of Bethlehem
Cuzco, Peru, 18th century
Oil on canvas, 154.9 x 101 cm
(61 x 39¾ in.)
Private collection

33
Nicolás Correa (born about 1670
or 1675)
Miracle of the Wedding at Cana
Mexico City, 1693
Mixed media with encrusted
mother-of-pearl on panel, 58 x
75.5 cm (22⅞ x 29¾ in.)
The Hispanic Society of America,
New York, LA2158

34
Jar with floral pattern
Puebla de los Ángeles, Mexico,
early 18th century
Tin-glazed earthenware, 49 x
35 cm (19¼ x 13¾ in.)
Colección Museo Franz Mayer,
Mexico City
Photograph: Laura Cohen
Meusnier

35
Jar (tibor)
Puebla de los Ángeles, Mexico,
about 1700
Tin-glazed earthenware, 30 x
27 x 27 cm (11¾ x 10⅝ x 10⅝ in.)
Museum of International Folk
Art, Museum of New Mexico,
Santa Fe; Houghton Sawyer
Collection, Gift of Mr. and Mrs.
John Holstius, A.1969.45.23
Photograph: Polina Smutko

36
Cabinet
Lima, Peru, 1680–1700
Mahogany, mother-of-pearl, ivory,
tortoiseshell, Spanish cedar,
259.1 x 227.3 x 66 cm (102 x
89½ x 26 in.)
Dallas Museum of Art, Gift
of The Eugene McDermott

Foundation, in honor of Carol
and Richard Brettell, 1993.36
Photograph: Brad Flowers

37
Juan González (active late 17th
century–early 18th century)
*Saint Francis Xavier Embarking
for Asia*
Mexico City, 1703
Oil on wood inlaid with mother-
of-pearl, 113 x 91.8 cm (44½ x
36⅛ in.)
Private collection
Photograph: Jeff Wells, Denver
Art Museum

38
*Hasekura Rokuemon Tsunenaga
(1571–1622)*
Italy, 1615
Oil on canvas, 196 x 146 cm
(77⅛ x 57½ in.)
Private collection, Rome, Italy
Photograph: Archivo Basilico

39
Biombo with scenes of the
conquest of Mexico and view of
Mexico City
Mexico City, late 17th century
Oil on canvas, 2.1 x 5.5 m
(about 7 x 18 ft.)
Collection of Vera Moreira da
Costa Autrey, Mexico City
Photograph © Museum
Associates/LACMA

40
Circle of Bernardo de Legarda
(died in 1773)
*Virgin of the Immaculate
Conception*
Quito, Ecuador, 18th century
Polychromed and gilded wood,
79.4 x 41.5 x 29.3 cm (31¼ x
16⅜ x 11½ in.)
The Hispanic Society of America,
New York, LD2154

41
Unknown artist
Young Woman with a Harpsichord
Mexico, early 18th century
Oil on canvas, 156.5 x 102.5 cm
(61⅝ x 40⅜ in.)
Denver Art Museum, Gift of the
Collection of Frederick and Jan
Mayer, 2014.209
Photograph courtesy of the
Denver Art Museum

42
José de Alcíbar (active 1751–1803)
*Sor María Ignacio de la Sangre
de Cristo*
Mexico, about 1777

Oil on canvas, 180 x 109.2 cm
(70⅞ x 43 in.)
Museo Nacional de Historia,
Mexico City
Conaculta-INAH-Mexico/
Reproduced by permission
of Instituto Nacional de
Antropología e Historia

43
Miguel Cabrera (1695–1768)
De negro y de india, china cambuja
(From Black and Indian, *China
cambuja*)
Mexico City, 1763
Oil on canvas, 134 x 103 cm
(52¾ x 40½ in.)
Museo de America, Madrid,
00007

44
Bedcover (palampore)
India, 17th or 18th century
Plain-weave cotton, painted or
printed with mordants and dyed
with natural pigments, 221.9 x
143 cm (87⅜ x 56¼ in.)
Museum of Fine Arts, Boston,
Helen and Alice Colburn Fund,
27.559

45
Bedcover
Mexico, about 1775
Wool crewelwork embroidery on
cotton, 234.9 x 148.6 cm (92½ x
58½ in.)
Denver Art Museum, Neusteter
Textile Collection, Gift of Mrs.
Frederic H. Douglas Collection,
1956.54

46
Qero
Peru, 16th–17th century
Wood with mopa mopa inlays,
20.5 x 17.4 cm (8⅛ x 6⅞ in.)
Museo de América, Madrid, 07514

47
Coffer
Pasto, Colombia, about 1650
Wood with barniz de Pasto, and
silver fittings, 19.2 x 27.2 x 13.6 cm
(7½ x 10¾ x 5⅜ in.)
The Hispanic Society of America,
New York, LS2067

48
Portable writing desk
Pasto, Colombia, about 1684
Wood with barniz de Pasto,
brass fittings, and silver drawer
pulls, 20 x 31 x 36 cm (7⅞ x 12¼ x
14⅛ in.)
The Hispanic Society of America,
New York, LS2000

49
Lid of desk shown in fig. 48

50
Nested boxes
Ryukyu Islands, Japan, 17th
century
Lacquer with mother-of-pearl
inlay, outer box: 42.5 x 32.7 x
11.7 cm (16¾ x 12⅞ x 4⅝ in.)
Kaikodo, New York
Photograph: John Bigelow Taylor

51
Batea
Peribán, Mexico, first half of the
17th century
Wood with Mexican lacquer,
7.9 x 56.5 cm (3⅛ x 22¼ in.)
The Hispanic Society of America,
New York, LS1808

52
Detail of reverse of batea shown
in fig. 51

53
Antonio de Pereda (1611–1678)
Still Life with Ebony Chest
Spain, 1652
Oil on canvas, 80 x 94 cm
(31½ x 37 in.)
The State Hermitage Museum,
St. Petersburg, GE-327
Photograph © The State
Hermitage Museum; photography
by Pavel Demidov

54
Batea
Pátzcuaro, Mexico, about 1800
Wood with Mexican lacquer and
painted decoration, 11.5 x 86 cm
(4½ x 33⅞ in.)
The Hispanic Society of America,
New York, LS2135

55
José Manuel de la Cerda (Zerda)
(active mid-18th century)
Batea
Michoacán, Mexico, mid-18th
century
Wood with Mexican lacquer and
painted decoration, diam. 107 cm
(42⅛ in.)
Museo de America, Madrid, 06917

56
Coffer
Olinalá, Guerrero, Mexico, 18th
century
Wood with Mexican lacquer, 26 x
46.5 x 21.3 cm (10¼ x 18¼ x 8⅜ in.)
Colección Museo Franz Mayer,
Mexico City

57
Lectern
Japan, 1580–1620
Wood with lacquer and mother-
of-pearl, 35 x 31 cm (13¾ x 12¼ in.)
Peabody Essex Museum,
Museum purchase, 1989, E76703
Photograph courtesy of the
Peabody Essex Museum

58
Saint Rose of Lima
Philippines, 17th century
Ivory, h. 43 cm (16⅞ in.)
Private collection

59
Nativity
Ecuadoran, with Hispano-
Philippine ivory inserts, 18th
century
Polychromed and gilded wood
and ivory, Mary: h. 19.7 cm
(7¾ in.); Joseph: h. 21.6 cm
(8½ in.)
The Metropolitan Museum
of Art, Gifts of Loretta Hines
Howard, 1964, 64.164.174
Image copyright © The
Metropolitan Museum of Art,
image source: Art Resource, NY

60
Pulpit
Church of Saint Jerome, Mapusa,
Goa, second half of 18th century
Wood with polychrome and gilt
Photograph: JoeGoaUK

61
Unknown artist
Saint Paul Miki
Mexico, 17th century
Carved, polychromed, and gilded
wood, 149.5 x 30.3 cm (58⅞ x
11⅞ in.)
Museo Nacional del Virreinato,
Tepotzoltlán, Mexico, inv. 10-
12451
Conaculta-INAH-Mexico/
Reproduced by permission
of Instituto Nacional de
Antropología e Historia
Photograph: Museo Nacional
del Virreinato

62
Unknown artist
Saint Felipe de Jesús
Mexico, about 1650
Oil on canvas, 152.4 x 121.9 cm
(60 x 48 in.)
Museo Regional de Guadalupe,
Guadalupe, Zacatecas, Mexico
Conaculta-INAH-Mexico/

Reproduced by permission
of Instituto Nacional de
Antropología e Historia
Photograph: Francisco Kochen

63
Chinese temple lion
Church and Monastery of Santo
António, João Pessoa, Brazil,
about 1734
Photograph: Gauvin Bailey

64
Chinese temple lion
Church of San Agustín, Manila,
Philippines, 1587–1607

65
Sacristy ceiling (detail)
Church of Nossa Senhora do
Rosário, Embu, Brazil, 18th
century
Polychromed wood
Photograph: Gauvin Bailey

66
Antonio de Torres (1666–1731)
Saint Francis Xavier Baptizing
Mexico, 1721
Oil on canvas, 217 x 143 cm
(85⅜ x 56¼ in.)
Museo del Colegio de San Ignacio
de Loyola (Vizcaínas), Mexico City
Conaculta-INAH-Mexico/
Reproduced by permission
of Instituto Nacional de
Antropología e Historia
Photograph: Francisco Kochen

67
Facade
Church of Nuestra Señora de la
Porteria (Our Lady of the Gate),
Daraga, Philippines, 1773
Photograph: Gauvin Bailey

68
Charles de Belleville (1656–1730)
Altar of the Assumption,
Cathédral Saint-Front, Périgueux,
France, before 1688
Oak
Photograph courtesy of Les Amis
de Saint-Front

69
Charles de Belleville (1656–1730)
Sacristy ceiling
Church of Belém de Cachoeira,
Brazil, 1700–1710
Photograph: Christine Thomson

70
Dove of the Holy Spirit altar frontal
Ursuline workshop, Quebec City,
about 1700

Embroidery with silk, wool, and
gold and silk metallic threads,
trimmed with needle lace,
95.5 x 264 cm (37⅝ x 103⅞ in.)
Musée des Ursulines de Québec,
1995.1097
Photograph © Patrick Altman,
Musée national des beaux-arts
du Québec

71
Biombo
Mexico, last quarter of the 17th
century
Oil on canvas, 1.93 x 6.20 m
(6 ft. 6 in. x 20 ft. 4 in.)
Museo de América, Madrid,
2013/04/017.2

72
Panels 3 and 4 from biombo
shown in fig. 71

73
Headboard
Mexico, 18th century
Wood with polychrome and gilt
decoration
Private collection

74
José Manuel de la Cerda (Zerda)
(active mid-18th century)
Desk-on-stand, Mexico, about
1760
Linden wood with Mexican
lacquer and polychrome
decoration, Spanish cedar,
154.9 x 102.1 x 61 cm (61 x 40³⁄₁₆
x 24 in.)
The Hispanic Society of America,
New York, LS1642

75
Desk and bookcase
Puebla de los Ángeles, Mexico,
mid-18th century
Inlaid woods and incised and
painted bone, maque, gold
and polychrome paint, metal
hardware, 221 x 104.1 x 67.3 cm
(87 x 41 x 26½ in.)
Collection of Ann and Gordon
Getty

76
Jean Berger (active about
1718–1732)
Page from copy book
Boston, about 1718–32
Watercolor on paper, 14 x 12.7 cm
(5½ x 5 in.)
Historic Charleston Foundation,
Charleston, SC, gift of Mrs.
Henry M. Abbot, 92.5.1

77
Works by John Doane (1733/34–1801)
Tall case clock
Boston, 1738–41 (case); Scituate, Massachusetts (works)
Pine with japanned decoration, 241 x 43.7 x 23.5 cm (94⅞ x 17¼ x 9¼ in.)
Private collection

78
John Pimm (active by 1735, died in 1773), japanning attributed to Robert Davis (died in 1739)
High chest
Boston, 1730–39
Soft maple, black walnut, white pine, mahogany, with japanned decoration, 216.5 x 106.7 x 64.1 cm (85¼ x 42 x 25¼ in.)
Winterthur Museum, Gift of Henry Francis du Pont, 1957.1084

79
William Gibbs (died in 1729)
Painted wall mural
Vernon House, Newport, Rhode Island, 1710–29
Oil on plaster
Gibbs House, Newport Restoration Foundation, Newport, Rhode Island
Photograph © Newport Restoration Foundation, RI

80
Altar panel
Nossa Senhora do Ó, Sabará, Brazil, about 1718
Oil and gilt on board
Photograph: Günter Heil

81
Choir
Mariana Cathedral, Mariana, Minas Gerais, Brazil, about 1749
Oil, silver, and gilt on board
Photograph: Günter Heil

82
Cornelius Kierstede (1674–about 1757)
Candlesticks
New York, about 1705
Silver, each overall: 29.8 x 16.5 x 16.5 cm (about 11¾ x 6½ x 6½ in.)
Metropolitan Museum of Art, New York, Gift of Robert L. Cammann, 1957, 57.153a, b; Gift of Mrs. Clermont L. Barnwell, 1964, 64.83a, b
Image copyright © The Metropolitan Museum of Art, image source: Art Resource, NY

83
Cornelius Kierstede (1674–about 1757)
Snuffer stand
New York, about 1705
Silver, 20.8 x 13 x 13 cm (8¼ x 5⅛ x 5⅛ in.)
Metropolitan Museum of Art, New York, Gift of Mr. and Mrs. William A. Moore, 1923, 23.80.21
Image copyright © The Metropolitan Museum of Art, image source: Art Resource, NY

84
Jacob Hurd (1702–1758)
Teapot
Boston, about 1740
Silver, 13 x 22.5 cm (5⅛ x 8⅞ in.)
Yale University Art Gallery, Mabel Brady Garvan Collection, 1930.1350
Photograph courtesy of the Yale University Art Gallery

85
Bed curtain
Possibly Boston, early 18th century
Cotton twill, embroidered with wool, 188 x 135 cm (74 x 53 in.)
Colonial Williamsburg Foundation
Photograph courtesy of the Colonial Williamsburg Foundation

86
William Buckland (1734–1774) and William Bernard Sears (died in 1818)
Northeast Parlor of Gunston Hall, Mason Neck, Virginia, 1755–59
Gunston Hall, National Society of the Colonial Dames of America
Photograph © Steven Brooks Studios

Details
Pages 2–3: fig. 71; pp. 6–7: fig. 8; pp. 8–9: fig. 4; pp. 18–19: fig. 11; pp. 38–39: fig. 27; pp. 52–53: fig. 45; pp. 74–75: fig. 48; pp. 90–91: fig. 22; p. 108: fig. 68; pp. 110–11: fig. 73; p. 154: fig. 85

Acknowledgments

A PROJECT OF GLOBAL PROPORTIONS requires a global team of contributors, and I am tremendously grateful for the many contributions of generous colleagues, both near and far. For their expansive knowledge and expertise, I thank the contributors to the catalogue, Gauvin Alexander Bailey, Timothy Brook, Mitchell Codding, Karina H. Corrigan, and Donna Pierce. They added immeasurably to the story told in this book and the exhibition. I also thank members of the project's advisory panel, which in addition to those named above included a distinguished group of scholars from across the Americas: Jens Baumgarten, Universidade Federal de São Paulo; Edward S. Cooke, Jr., Yale University; Thomas B. F. Cummins, Harvard University; Gustavo Curiel, Universidad Nacional Autónoma de México; Evelyn Hu-DeHart, Brown University; Dana Leibsohn, Smith College; and Sonia Ocaña, Universidad Nacional Autónoma de México. The Chipstone Foundation provided support for the project in its initial stages by funding a meeting of scholars, attended by its director Jonathan Prown and curator Ethan Lasser.

For their guidance and support, I thank Malcolm Rogers, Ann and Graham Gund Director; Patrick McMahon, Director of Exhibitions; Gillian Fruh; our excellent design team, Keith Crippen and Tomomi Itakura; Emiko K. Usui, Director of MFA Publications; our skillful editor, Jennifer Snodgrass, and copyeditor, Ann Twombly; Terry McAweeney, Katherine Harper, Chris DiPietro, book designer Cynthia Randall, and book jacket designer Betsy Robichaud. This exhibition was the brainchild of the Art of the Americas Wing, and I am grateful to many colleagues at the MFA who shaped my thinking during that project, and who gave their support and encouragement through the various stages of this one, especially Katherine Getchell, Deputy Director; Elliot Bostwick Davis, John Moors Cabot Chair, Art of the Americas; Nonie Gadsden, Katharine Lane Weems Senior Curator of American Decorative Arts and Sculpture; Gerald W. R. Ward, Senior Consulting Curator and Katharine Lane Weems Senior Curator of American Decorative Arts and Sculpture Emeritus; Dorie Reents-Budet, Curator of Art of the Ancient Americas; Erica Hirshler, Croll Senior Curator of American Paintings; Karen Quinn, Kristin and Roger Servison Curator of Paintings, Art of the Americas; Caroline Cole, Ellyn McColgan Assistant Curator of Decorative Arts and Sculpture, Art of the Americas; Taylor Poulin, Curatorial Research Associate; Molly Richmond, department coordinator; as well as Carol Troyen, Heather Hole, Cody Hartley, and Kelly Hays L'Ecuyer, Director of Gifts of Art, who were there from the beginning.

This project has brought me closer to curatorial and conservation colleagues in departments across the Museum who have been extremely generous with their time and expertise: in particular, Ronni Baer, William and Ann Elfers Senior Curator of Paintings, Art of Europe; Nancy Berliner, Wu Tung Curator of Chinese Art; Michele Derrick, Schorr Family Associate Research Scientist; Jacki Elgar, Pamela and Peter Voss Head of Asian Conservation; Gordon Hanlon, Head of Furniture and Frame Conservation; Pamela Hatchfield, Robert P. and Carol T. Henderson Head of Objects Conservation; Frederick Ilchman, Chair and Mrs. Russell W. Baker Curator of Paintings, Art of Europe; Rhona MacBeth, Eijk and Rose-Marie van Otterloo Conservator of Paintings; Christopher Mazza, Andrew W. Mellon Fellow for Advanced Training, Textile Conservation; Philip Meredith, Higashiyama Kaii Conservator of Japanese Paintings; Jen Mergel, Robert L. Beal, Enid L. Beal and Bruce A. Beal Senior Curator of Contemporary Art; Thomas Michie, Russell B. and Andrée Beauchamp Stearns Senior Curator of Decorative Arts and Sculpture, Art of Europe; Meredith Montague, Head of Textile Conservation; Anne Nishimura Morse, William and Helen Pounds Senior Curator of Japanese Art; Liz Munsell, Assistant Curator of Contemporary Art and MFA Programs, position supported by Lorraine Bressler; Richard Newman, Head of Scientific Research; Pamela Parmal, Chair and David and Roberta Logie Curator of Textile and Fashion Arts; Jane Portal, former Matsutaro Shoriki Chair, Art of Asia, Oceania, and Africa; Victoria Reed, Monica S. Sadler Curator for Provenance; Edward Saywell, Chair, Linde Family Wing for Contemporary Art and Arthur K. Solomon Curator of Modern Art; Hao Sheng, former Wu Tung Curator of Chinese Art; Christine Storti, Assistant Furniture Conservator; Gerri Strickler, Associate Objects Conservator; Bodil Unckel, Sherman Fairchild Fellow, Furniture and Frame

Conservation; Tanya Uyeda, Associate Conservator, Asian Conservation; and Ben Weiss, Chair and Leonard A. Lauder Curator of Visual Culture, Department of Prints, Drawings, and Photographs. For their contributions to the success of the exhibition and publication, I also thank my colleagues in the departments of Communications, Creative and Interactive Media, Education, Exhibitions and Design, External Relations, Facilities, Finance, Intellectual Property, Protective Services, and Public Programs. I am proud to have worked alongside a number of talented graduate research interns who assisted the project in innumerable ways: Caitlin Greenhill Caldera, Adam Jasienski, Ana Haydeé Linares, Elsaris Nuñez-Méndez, Giustina Renzoni, Caroline Riley, Diana Rose, Leqi Yu, and in particular Katina Cardenas, Nicole Bass, Ana María Díaz Rocha, and Sarah Reusché, who served the longest and helped at critical moments.

Outside the MFA, I am grateful to the lenders and institutions that have generously shared their objects for the exhibition and their time, knowledge, and enthusiasm for the subject: Mitchell Codding, Margaret Connors McQuade, Marcus Burke, Monica Katz, and Daniel Silva at The Hispanic Society of America; David Roselle, Tom Savage, Linda Eaton, Amy Marks Delany, Brock Jobe, Joshua Lane, Lesley Grigsby, Ann Wagner, Maggie Lidz, Donald Fennimore, and Wendy Cooper at the Winterthur Museum, Garden, and Library; Christoph Heinrich, Donna Pierce, Alice Zrebiec, Julie Wilson Frick, and Laura Paulick Moody at the Denver Art Museum; Sylvia Yount, Morrison Heckscher, Luke Syson, Wolfram Koeppe, Melinda Watt, Amelia Peck, Beth Wees, and Peter Kenny at the Metropolitan Museum of Art, New York; Joseph Rishel, Alexandra Alevizatos Kirtley, David Barquist, Jack Hinton, and Mark Castro at the Philadelphia Museum of Art; Dan Monroe, Linda Hartigan, Karina Corrigan, Daniel Finamore, Dean Lahikainen, Christine Bertoni, and William Sargent of the Peabody Essex Museum; Jock Reynolds, Patricia Kane, John Stuart Gordon, and Lynne Addison at the Yale University Art Gallery; Tara Cederholm and Martha Small; Mr. and Mrs. Gordon Getty; Deborah Hatch and Claudia Rice of Vallejo Investments; Patricia Phelps de Cisneros, Gabriel Pérez-Barreiro, Jorge F. Rivas, and Skye Monson of the Colección Patricia Phelps de Cisneros; Vera da Costa Autrey and Eduardo Molina Dubost; Carlos de Ovando; Dr. Miguel Vallebueno; Daniel Liebsohn and María Luisa Hidalgo de la Garza, Galería Daniel Liebsohn; Frank Giustra; Thomas Lurie; Pieter Roos, Kristen Costa, and Bruce MacLeish at the Newport Restoration Foundation; Ruth Taylor, Bridget Sullivan, and Adams Taylor at the Newport Historical Society; Katharine Robinson and Brandy Culp at Historic Charleston Foundation; Barbara McLean Ward at the Moffatt-Ladd House and Garden, National Society of Colonial Dames in New Hampshire; Christine Cheyrou and Catherine Levesque, Musée des Ursulines de Québec; and an anonymous lender.

For their unwavering enthusiasm, I thank MFA Trustee Timothy Phillips and MFA Overseer Leigh Braude, who traveled to Mexico in support of the exhibition; Christine Thomson, who accompanied me to visit churches and private collections in Brazil; at the Dallas Museum of Art, Kevin Tucker, for his steadfast support; Michael Govan, Ilona Katzew, Sofía Sanabrais, Stephen Little, and Piper Severance, Los Angeles County Museum of Art; Roberta and Richard Huber for their generous support; Richard Aste, Brooklyn Museum; Héctor Rivero Borrell, Museo Franz Mayer; Miguel Fernández Félix, Museo Nacional de Arte; Cándida Fernández de Calderón, Fomento Cultural Banamex; Ana Martha Hernández Castillo, Museo José Luis Bello y González; Salvador Rueda, Museo Nacional de Historia; Rodrigo Rivero Lake; Bertha Cea, Antiguo Colegio de San Ildefonso; Hilda Urréchaga; Masako Yoshida, Kyoto City University of Arts; Meiko Nagashima and Aki Yamakawa, Kyoto National Museum; Jose Presedo and Pilar Pinto, Carteia Fine Arts; Jorge Coll and Nicolás Cortés, Coll & Cortés; José Rodríguez-Spiteri Palazuelo, Patrimonio Nacional, Spain; Máximo Gómez Rascón, Museo Catedralicio-Diocesano de Léon; José Antonio González Carrión, Museo Naval de Madrid; James Methuen-Campbell, Corsham Court; Michael Hulse, Breamore House; Angelo Oswaldo de Araújo, IPHAN; Marcelo Araújo and Ivo Mesquita, Pinacoteca do Estado de São Paulo; José Carlos Marçal de Barros, Museu de Arte Sacra, São Paulo; Beatriz Pimenta Camargo; Rui Mourão, Museu da Inconfidência; Caroline Frank, Brown University;

Joachim Homann and Laura Sprague, Bowdoin College Museum of Art; Stanley Ellis Cushing, Boston Athenaeum; Susan Robertson, Gore Place; Lisa Fischman, James Oles, and Eve Straussman-Pflanzer, Davis Museum, Wellesley College; Adriana Varejão and Cecília Fortes; Pedro Alonzo; Estrella Alves; María Cecilia Alvarez White; Mirta Linero Baroni; Ambassador Fernando de Mello Barreto and Maria Helena Pinheiro Penna.

The exhibition was made possible with generous support from the Terra Foundation for American Art, and in part by the National Endowment for the Humanities: Celebrating 50 Years of Excellence, with additional support provided by The Huber Family Foundation and the Jean S. and Frederic A. Sharf Exhibition Fund. Generous support for this publication was provided by the Andrew W. Mellon Publications Fund.

I also want to add a special note of thanks to Mary Miller, Sterling Professor of the History of Art, and Edward Kamens, Sumitomo Professor of East Asian Languages and Literatures, at Yale University. It was around their dining room table at Saybrook College at Yale that I first discussed Mexican biombos (folding screens), which fused their interests in Latin American and Japanese art. This conversation set me on the path of thinking more broadly about the Americas and the powerful influences from across the Pacific that changed the course of history. And finally, with love, this book is dedicated to my wife, Olga, and my son, Emilio, who opened the world to me.

DENNIS CARR
Carolyn and Peter Lynch Curator of
American Decorative Arts and Sculpture

Contributors

GAUVIN ALEXANDER BAILEY is Professor and Alfred and Isabel Bader Chair in Southern Baroque, Department of Art History and Art Conservation, Queen's University, Kingston, Ontario.

TIMOTHY BROOK holds the Republic of China Chair in the Department of History and Institute of Asian Research, University of British Columbia, Vancouver.

DENNIS CARR is Carolyn and Peter Lynch Curator of American Decorative Arts and Sculpture, Museum of Fine Arts, Boston.

MITCHELL CODDING is Executive Director, The Hispanic Society of America, New York.

KARINA H. CORRIGAN is H. A. Crosby Forbes Curator of Asian Export Art, Peabody Essex Museum.

DONNA PIERCE is Frederick & Jan Mayer Curator of Spanish Colonial Art, Denver Art Museum.

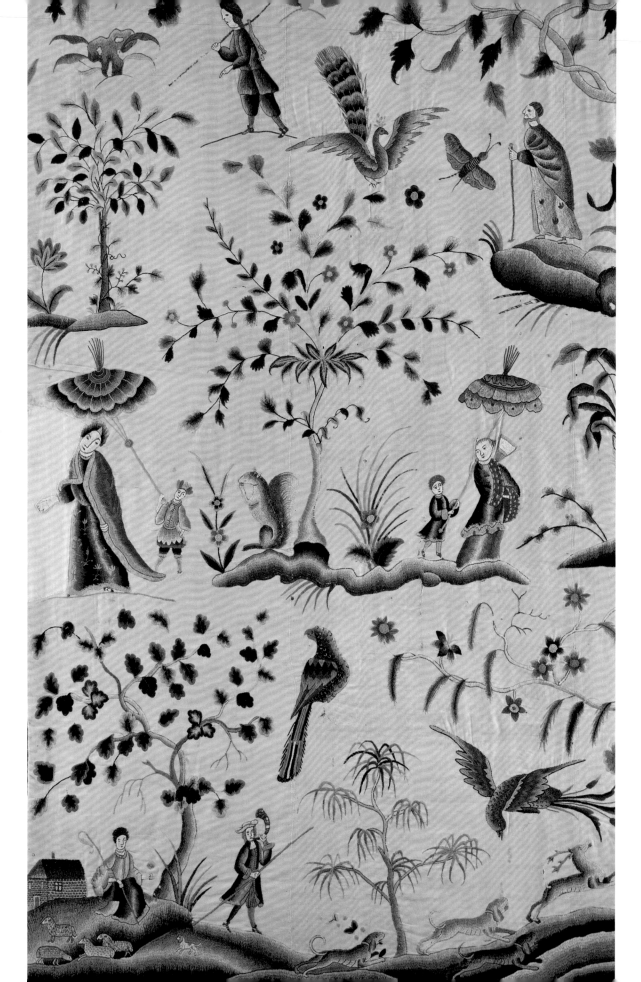

Index

MFA PUBLICATIONS
Museum of Fine Arts, Boston
465 Huntington Avenue
Boston, Massachusetts 02115
www.mfa.org/publications

Published in conjunction with the exhibition *Made in the Americas: The New World Discovers Asia*, organized by the Museum of Fine Arts, Boston.

Museum of Fine Arts, Boston:
August 18, 2015–February 15, 2016

Winterthur Museum, Garden, and Library, Delaware:
March 15, 2016–January 8, 2017

Exhibition presented with generous support from the Terra Foundation for American Art.

Made in the Americas: The New World Discovers Asia has been made possible in part by the National Endowment for the Humanities: Celebrating 50 Years of Excellence.

Additional support provided by The Huber Family Foundation and the Jean S. and Frederic A. Sharf Exhibition Fund.

Generous support for this publication was provided by the Andrew W. Mellon Publications Fund.

© 2015 by Museum of Fine Arts, Boston

ISBN 978-0-87846-812-6
Library of Congress Control Number: 2015934490

The Museum of Fine Arts, Boston, is a nonprofit institution devoted to the promotion and appreciation of the creative arts. The Museum endeavors to respect the copyrights of all authors and creators in a manner consistent with its nonprofit educational mission. If you feel any material has been included in this publication improperly, please contact the Department of Rights and Licensing at 617 267 9300, or by mail at the above address.

The Museum is proud to be a leader within the American museum community in sharing the objects in its collection via its website. Currently, information about more than 330,000 objects is available to the public worldwide. To learn more about the MFA's collections, including provenance, publication, and exhibition history, kindly visit *www.mfa.org/collections.*

For a complete listing of MFA publications, please contact the publisher at the above address, or call 617 369 3438.

All illustrations in this book were photographed by the Imaging Studios, Museum of Fine Arts, Boston, except where otherwise noted.

Edited by Jennifer Snodgrass
Copyedited by Ann Twombly
Proofread by Kathryn Blatt

Designed by Cynthia R. Randall
Production by Terry McAweeney
Production assistance by Katherine Harper

Printed on 135 gsm GardaPat Kiara
Printed and bound at Verona Libri, Verona, Italy

Distributed in the United States of America and Canada by
ARTBOOK | D.A.P.
155 Sixth Avenue
New York, New York 10013
www.artbook.com

Distributed outside the United States of America and Canada by
Thames & Hudson, Ltd.
181A High Holborn
London WC1V 7QX
www.thamesandhudson.com

FIRST EDITION
Printed and bound in Italy
This book was printed on acid-free paper.